History of Art
A student's handbook

Fifth Edition
Marcia Pointon

Routledge
Taylor & Francis Group

LONDON AND NEW YORK

Fifth edition published 2014
by Routledge
2 Park Square, Milton Park, Abingdon, Oxon OX14 4RN

and by Routledge
711 Third Avenue, New York, NY 10017

Routledge is an imprint of the Taylor & Francis Group, an informa business

First edition published by Allen & Unwin (Publishers) 1980
Fourth edition published by Routledge 1997

British Library Cataloguing in Publication Data
A catalogue record for this book is available from the British Library

Library of Congress Cataloging in Publication Data
Pointon, Marcia R.
History of art: a students' handbook / by Marcia Pointon.—5th edition.
pages cm
Includes bibliographical references and index.
1. Art—Historiography—Handbooks, manuals, etc. I. Title.
N380.P56 2014
709—dc23
2013035364

ISBN: 978-0-415-63925-5 (hbk)
ISBN: 978-0-415-63924-8 (pbk)
ISBN: 978-0-203-08359-8 (ebk)

Typeset in Times New Roman
by Book Now Ltd, London

MIX
Paper from
responsible sources
FSC
www.fsc.org FSC® C013056

Printed and bound in Great Britain by
TJ International Ltd, Padstow, Cornwall

For Thomas and Emily

Contents

Figures

Disclaimer

Although every effort has been made to trace copyright holders, this has not been possible in all cases. Any omissions brought to our attention will be remedied in future editions.

Acknowledgements

Many people have contributed to the revisions and to what amounts to the complete rewriting of large sections of this fifth edition of *History of Art: A Student's Handbook*. The five anonymous readers came up not only with much needed encouragement to me to return, again, to a text I originally wrote as a fledgling lecturer but also with a raft of excellent ideas for improvement and updating.

In addition I would like to thank, for their readiness to give me specific advice, James Benedict Brown, Mary Roberts, Marc De La Ruelle and Cordelia Warr. Without the advice of Nick Brown, librarian at the Courtauld Institute responsible for serials, I could not have written large sections of Chapter 5 relating to electronic resources, and without this the book would have been seriously deficient. Any lacunae or errors are, of course, entirely my own.

Chapter 6, an entirely new chapter on careers, simply could not have been written without the participants who, despite very busy lives, willingly sent me on request their succinct, informative and witty accounts of their professional lives since graduating in History of Art. I am deeply grateful for their generosity, as I am sure also will be the generations of students who stand to benefit from their example.

Caroline Osborne, Chair of the Association of Art Historians' Schools Group and a teacher of History of Art at secondary-school level, gave up an entire evening to instruct me on the intricacies and politics of the public examination system in secondary education as well as responding by email to numerous questions. I hope her pupils find this new edition useful.

Finally I would like to thank Natalie Foster for her patience in sticking with me. It is longer than I care to remember that she first approached me about undertaking this new edition. For many years other professional tasks and life events militated against my getting down to it. In the end it has been an enjoyable process, and I am hugely grateful to Natalie for her persistence.

London and Motrone 2013

Preface to the Fifth Edition

It was a relatively straightforward matter in 1978–9 when I was writing the first edition of this *Handbook* to describe what students would be likely to encounter if they entered a British university to study History of Art. There were comparatively few courses to choose from and those that there were tended to follow syllabuses that were similar. Design History was emerging as a distinctive discipline, but the now ubiquitous 'Visual Culture' and 'Visual Studies' were unknown, at least as terminology. The History of Art, following familiar routes, was taught to practising aspiring artists in what had been art colleges but were now for the most part polytechnics, and students in universities who were not practitioners focused on famous works of European art, mainly from periods prior to the twentieth century. By the time I was revising the fourth edition in 1997 the landscape had been transformed, with most higher-education institutions either having degree-awarding status or aspiring to that end. At the time of writing, in late 2013, a further group of erstwhile art colleges have become universities.

The introduction of student fees, and then the massive hike in those fee levels in 2012, has made the providers of courses in all arts and humanities subjects more aware of the competition they face and more ready to proselytize about what they see as the special strengths of what they offer. The study of recent and contemporary art has overtaken, in many institutions, the more familiar favoured periods. There has never been so much information available to prospective students, but simultaneously changes in the organization of 'A'-level examinations have meant that it has become extremely rare for state schools to offer an 'A' or 'AS' level in History of Art.[1] Moreover, at the time of writing, there is considerable confusion about where the future lies for 'A' levels and university entrance requirements. But there are also positive developments: the Roche Court Educational Trust, which works with schools, colleges, universities and special interest groups from its base at the New Arts Centre, three years ago established the ARTiculation prize – a public speaking competition about the arts for

school pupils (http://rochecourteducationaltrust.co.uk/). At the same time the Association of Art Historians, through its schools group, offers support to teachers and is planning an outreach programme for students to study towards an 'AS' level when it is not on offer at their school.[2]

Uncertainty about where the visual arts (artists and their work, galleries and museums, historic houses, the national heritage – what the French call the *patrimonie*) belong in national and party political priorities is writ large in the confusing and seemingly perpetual name-changing and realignment of responsibilities of the person who, when the first edition of this book was published, was called Minister for the Arts. In 2005 the title was changed to Minister for Culture and then in 2007 to Minister for Culture, Creative Industries and Tourism. In the year of the Olympics, 2012, the Department of Culture, Media and Sport enjoyed a high profile, but whether the arts received any benefit from the so-called cultural Olympiad remains doubtful. The Henley Report, entitled *Cultural Education in England*, published in 2012 focuses, predictably, on skills and vocational training and has virtually nothing to say about Art History as it is, or might be, taught in schools.[3] However, what is abundantly clear is the fact that studying for a degree in History of Art remains a popular option with students of all ages and that more adults than ever are seeking out short courses, lectures, and books about art and artists, as well as visiting galleries. Perhaps it is the very threat of austerity and the atmosphere of economic gloom that has prevailed since 2008 that has made people realize how much they value the arts.

It is now widely recognized that the so-called creative industries in the UK are major contributors to GDP: in 2006 they were valued at £57 billion, a £25.8 billion increase from 1997.[4] In 2013, in response to demands from government for an economic argument by arts organizations for their funding, the Arts Council adduced evidence that the sector of creative arts employed 110,600 full-time individuals and made up 0.4 per cent of GDP, meaning that for every £1 of subsidy there resulted a £7 contribution.[5] The vitality of the arts industries has had an impact on the jobs market for graduates in History of Art. This fifth edition of the *Handbook* includes therefore a new chapter in which graduates in the discipline describe how they made their way up the career ladder into their present jobs. I hope also, however, that this book as a whole will help to give confidence to those who just want to study the History of Art because they are intrigued by it: if you are going to spend three years at university and spend a lot of money doing it, you may as well study something you feel passionate about. As the career profiles in Chapter 6 demonstrate, having the courage of your convictions, and following your intellectual curiosity, yields positive results.

A further measure both of the expansion and of the changing nature of Art History as a discipline, along with the more recent but related areas

of Visual Culture Studies, is a cascade of books in the past fifteen years addressing the methods of Art History, critical terms used by art historians, introductions to Visual Culture, and guides to writing Art History. Many of these engage openly with what was written in earlier editions of this book, but all are, to my mind, pitched at a level that is likely to be challenging, if not discouraging, for a beginner. They vary in quality and difficulty, but a good many are cited in a list of further reading at the end of the book which students may find it useful to reconnoitre. And finally, but most momentously, there has been the extraordinary expansion of what I still like (in a deliberately archaising way) to call the World Wide Web. Few of us could have predicted in 1997, let alone in 1978, just how radically access to the internet would transform the teaching and learning process, from image banks to databases and from electronic library catalogues to the ever useful and equally ever problematic Wikipedia. Recognizing the import of this revolution, I have included in Chapter 5 a section on electronic resources for Art History students that contains practical guidelines as well as recommendations of reliable sites. All the revisions for this new edition have been undertaken by me personally (with invaluable advice from those I have acknowledged), mindful of the continuing need of students for hands-on and non-intimidating help into a discipline that very few schools now teach at sixth-form level.

Notes

1 At the present time AQA (Assessment and Qualifications Alliance) is the only board offering an Art History 'A' level in England. The new Cambridge Pre-U, a two-year alternative to the current 'A' level, does include History of Art but is offered by very few schools and those only in the independent sector. There is no 'AS' level with this board.
2 www.aah.org.uk/schools (accessed 28 January 2014).
3 https://www.gov.uk/government/publications/cultural-education-in-england (accessed 28 January 2014).
4 www.artsandbusinessni.org.uk (accessed 28 January 2014).
5 Report by the *Museum's Journal*, reported in the *Daily Telegraph*, 7 May 2013.

1 Engaging with art

Those of us who live in Western-style societies inhabit a world of visual communications: our eyes are focused on screens large and small, we absorb film and television, advertisements, traffic signs, signals alerting us in both rural and urban environments, graffiti on buildings and railway carriages, photographs on travel passes and passports, images in newspapers, paintings in galleries, serial strips and cartoons, the packaging on what we buy. Some of what we are looking at is ephemeral (here today and gone tomorrow) but much of it is long lasting. None of these forms of visual communication – the temporary or the seemingly permanent – is outside history; all are determined by how we live and interact with our environment, how big business and government (national or local) decides is the best way to attract our attention, and by what happened in the past. We may choose to be aware of what we see, or we may think we are just getting on with our daily lives, but, even if this is the case, it will impact upon us, forming memories and shaping expectations. All this seen and looked-at experience can be summed up under the term Visual Culture. You might reasonably ask: 'Well, what about nature and landscape?' Although we tend to be thinking mainly of a world made by humans when we speak of Visual Culture, it is also true that all the landscape that most of us are ever likely to see bears visible traces of human intervention, and some of it draws us precisely because that intervention – topiary, garden statues, planted avenues of beeches, flower beds – makes what we are looking at remarkable.

Art History – literally the study of the history of art – overlaps with the concerns of Visual Culture Studies. This book does not seek to define what art is; definitions of art vary over time and from one society to another, and much of what we now study as art (medieval manuscript illumination, for example) was not considered art at the time it was made. Art History is by no means exclusively concerned with Art with a capital 'A' (what we might expect to find in an art gallery). That is to say, it does not address *only* high culture or things that are made to be beautiful and non-functional. Titian's painting *Perseus and Andromeda*

(*ca.* 1550–62) in the Wallace Collection in London (Figure 1.1) seems like a miraculous object – a thing of inestimable visual allure – but Art History's remit stretches far beyond this – for example, to poster art from the past and present and, not inconceivably, the pictorial design of digital war games.

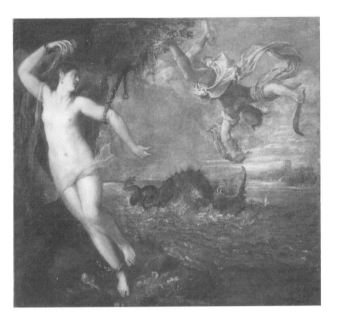

Figure 1.1 Titian (Tiziano Vecellio), *Perseus and Andromeda*, oil on canvas, Wallace Collection London. Reproduced by kind permission of the Trustees of The Wallace Collection.

Art historians are interested not only in objects but also in processes. To put this in a more recognizable historical framework, art historians concern themselves with visual communication whatever its intended audiences or consumers. Thus sixteenth-century German woodcuts, which probably cost less than a plate of herrings at the time they were produced (Figure 1.2), are of equal (though different) interest to, for example, the painting now known as the *Mona Lisa*, which is fixed to the wall of a gallery in the Louvre Museum, Paris, behind layers of protective glass. A further case might be a plastic toy invented by a Hungarian, the so-called Rubik's Cube (Figure 1.3), which became a major craze in the West in the early 1980s and was eventually exhibited at the New York Museum of Modern Art. Its bright colours and corresponding squares struck a chord with people familiar with the work of the artist Piet Mondrian and with the use of primary colours by Pop artists in the USA and Britain in the 1960s.

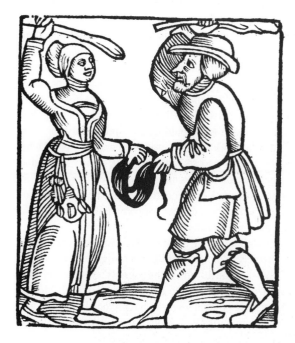

Figure 1.2 Anon., *Battle for the Trousers*, woodcut frontispiece to Hans Sachs's play *The Evil Smoke*, Stadtgeschichtliche Museen, Nuremberg.

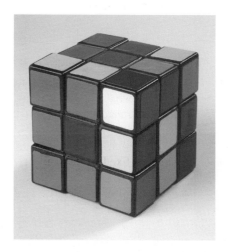

Figure 1.3 Rubik's Cube (designed by Ernő Rubik), 1985, plastic, moulded, Victoria and Albert Museum. © Victoria and Albert Museum, London.

Because Art History, as an area of scholarship and learning, exists in a relationship with other professions, such as those concerned with the display and sale of artworks (whether contemporary or historical) and those concerned with publishing and marketing attractive picture books, the practice of art historians is often misrepresented and misunderstood. Art History remains, at some level, the history of works of art and how they were made; the perceived gap between what artists do and the matters that preoccupy art historians has not infrequently been a source of amusement. But Art History is not only about artists and their works, it also takes (or should take) responsibility for trying to understand how and why the work of some producers gets discussed while the work of others does not, and why artists and their work signify, or produce meanings for people, in certain ways at certain periods in certain places. Art History addresses not only how a work by Leonardo came to be made and how it was received at the time it was produced, but why we think of Leonardo as Art and an advertisement in a magazine as Not Art.

This seam between Art with a capital 'A' and other kinds of imagery has been creatively and subversively exploited by billboard artists such as Barbara Kruger in the USA and by the graffiti artist known only, despite his fame and notoriety, as Banksy. The latter produced a 'conversation' with Monet's famous painting of his water-lily pond at Giverny but replaced the lilies with urban detritus, including a shopping trolley. From one point of view Banksy

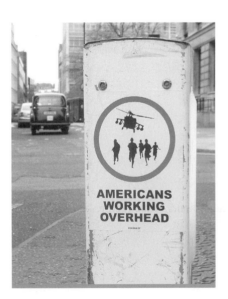

Figure 1.4 Banksy, *Americans Working Overhead*, digital print sticker, *ca.* 2004. Reproduced by kind permission of Pest Control. © Banksy, London, 2005.

is a vandal defacing property that does not belong to him. From another he is a hugely creative visual artist who engages with the politics of picture-making. By its very nature his work is (or was until recently) not collectible (thus setting it against even the seemingly most daring of contemporary artists such as Damien Hirst), but the Victoria and Albert Museum has none the less managed to collect some of his stickers, one of which, entitled *Americans Working Overhead* (*ca.* 2004) (Figure 1.4), is designed like a danger sign and shows silhouetted individuals running as a helicopter hovers overhead. Art historians investigate the origins, the connections between 'high' and 'low', and the ways in which imagery such as this contributes to our understanding of a period of historical time, whether in the present or in the far distant past.

We might observe therefore that the shelves of art books on individual artists (what we call monographs) that still predominate in bookshops from New York to Tokyo, and from London to Helsinki, or the kinds of art reviews that appear in, for example, the London *Evening Standard*, do not at all indicate what Art History these days is about. Moreover, the celebrity status of some contemporary artists – the photographs that appear of them in the company of dress designers and rock stars – as well as the kinds of review-writing in newspapers that tell us more about the reviewer than the works of art discussed, can offer a misleading picture of what it is to study Art History. Opinion is no substitute for scholarship, and the 'history' in Art History demands respect for facts and rigorous comparative research.

Having outlined the diversity of material that students might encounter in an Art History degree programme, it remains the case that much that is taught at undergraduate level in universities and colleges focuses on, or at least is based on, the traditional family of 'flat art' – that is, painting, print and photography, along with sculpture and architecture. People who enjoy paintings are sometimes reluctant to analyse them for fear of spoiling the richness and spontaneity of their experience. It has been suggested that some of the work done by sociologists or social historians of art, or by those whose concern is with theory rather than practice, ignores and indeed denies the aesthetic experience, the fundamental pleasure of looking as well as the very special act of artistic creativity. This view is a bit like the notion that knowing the ingredients of the recipe, recognizing the method of cooking and seeing the utensils employed detracts from the taste of the dish. But Art History does more than this; it seeks to explain why (to pursue the metaphor) certain foods are favoured in certain cultures – what the differences in cultural meaning are between, say, fast food eaten from a disposable carton, a picnic hamper prepared by Fortnum & Mason, or a cassoulet made according to a recipe by Elizabeth David and cooked in a Le Creuset cast-iron casserole.

Acknowledging the importance of enjoying something does not, of course, preclude a historical analysis of the object that is arousing pleasure. It might in fact be more pleasurable if we know more about the object we are viewing. Moreover, pleasure is not a simple matter. The arousal of our senses – and how we recognize and register it – is itself open to interrogation, as writers on the sublime in the eighteenth century recognized. Neuroscientists are interested in investigating this, but their approach is generally alien to Art History, focusing as it does on biology rather than on culture and history. The pleasure of looking is also historically located. Why we like particular characteristics of certain sorts of objects at any one time is not the result simply of our genes or our own particular personalities but is determined by values promoted within the society of which we are a part. So, while no one seeks to underestimate the importance of sensuous and instinctual responses to art objects, the notion that the sensuous is undermined by the intellectual is a legacy from a period in the past which promoted art as an alternative to thought and that split sensation from reason.

In fact we unknowingly engage all the time in forms of visual analysis that are not dissimilar to certain kinds of art-historical activity. Whenever we deliberately and consciously choose a style that we know to be of the past (a William Morris-type fabric, a 1930s-style tea cup or a 1950s tie) we are applying aesthetic and historical as well as functional criteria. We are motivated by an awareness of the symbolic as well as the utilitarian: a sports bag with a brand name emblazoned on it, a chrome towel rail instead of a pine one, a red mini Cooper roadster instead of a white Volkswagen Golf. Each time we stand for any length of time before a painting and find ourselves stimulated and provoked to think, to ask questions, we are engaged in criticism. Every time we look at a painting and then, moving to look at the one that is hanging adjacent to it, find ourselves noticing that it is different or similar in some way, we are involved in acts of discernment and discrimination (to use the word without its contemporary pejorative associations). Indeed, we are involved in analysis. Art criticism and art appreciation are near neighbours, and both are ways into Art History.

Acquiring an aptitude and a skill in looking critically at the artefacts of the past and the present that surround us is not necessarily easy. But learning to look in a conscious and self-conscious way is enjoyable. We might be looking at a piece of modern sculpture situated in one of those tiny gardens in the midst of towering skyscrapers where New York office workers enjoy a lunchtime sandwich; or at one of the now almost obsolete red British telephone boxes preserved in a 'sensitive' rural location that attracts our attention; or at an object whose original function was part of an African tribal rite but which now is to be seen in a glass case in a museum such as the Pitt Rivers Museum in Oxford. Many of us are able to say with conviction

and sincerity that we like art but would find it extremely difficult to say precisely what we like and why we like it. Even when we plan to visit a museum or gallery, we find ourselves confused, unable to fit things together, though we may be aware that there is a tantalizing pattern that we cannot identify, and, above all, we find it impossible to express adequately in words what our experience of looking has been like.

I referred earlier to 'Visual Culture' as a descriptive term for a terrain of objects of looking, a terrain to which Art History connects but by which it is not defined. A comparable relationship exists with 'Material Culture', a term that used to be used most commonly by anthropologists (examining, for example, cooking vessels alongside oral testimonies of the society they were investigating) or archaeologists (looking at bronze dress ornaments alongside the traces of living accommodation from the far distant past). During the past two decades 'Material Culture' has crept into use by art historians; its virtue as a term is that it avoids the evaluative connotations of 'art'. So, for example, someone researching eighteenth-century French court culture during the time of Louis XIV might consider jewellery, porcelain and textiles, alongside portraits, as material evidence, with paintings not being taken in any way as more important historically than these other 'used' artefacts from the past. Whatever the objects of our study – courtly or vernacular, three- or two-dimensional – the discipline of looking, and in some circumstances of touching, is paramount.

As children, we learn to draw before we can write, but very soon literacy and numeracy become, through school, the criteria of our achievement. Only when we look into the children's dental clinic and see the walls covered with posters of crocodiles with bright, gleaming teeth and rabbits nibbling nuts, or when confronted with a photograph showing a starving child in a famine-stricken region of Africa, do we recognize that, in some cases, the pictorial image is more powerful than words to convey to us a complex mass of information and ideas. Art History requires us, at some level, to regain and cultivate our ability to respond to all forms of visual expression in whatever medium or shape they may appear.

If you think looking and seeing are simple and straightforward matters that are instinctive to everyone, try looking at a picture and describing what you see. Or, even better, look hard at a picture, a building, or any kind of manufactured or crafted object and then go away and try to remember precisely what was before you and what it meant to you when you looked at it. Thurber's witty cartoon (Figure 1.5) is a clever inversion of the usual 'I don't know anything about art but I know what I like', the layperson's defence against the 'expert'. Just as liking is a vital part of knowing, so knowing is essential to liking. It is the relationship, and the developed, cultivated balance between the two, that is difficult to achieve. In *Pride and Prejudice*, Jane Austen's heroine Elizabeth

He knows all about art, but he doesn't know what he likes.

Figure 1.5 James Thurber cartoon, 'He knows all about art, but he doesn't know what he likes.' © 1939 by Rosemary A. Thurber. Reprinted by arrangement with Rosemary A. Thurber and The Barbara Hogenson Agency. All rights reserved.

Bennett visits a great historic English mansion. She knows that the apartments are full of 'good' pictures, but she walks past them in search of something with which she can identify on a personal level. The terms 'good' and 'bad' are problematic for art historians, who are concerned more with whether artworks fulfil and satisfy the purposes for which they were created than with whether they are estimable according to an assumed universal standard.

Powerful constituencies in every society construct a notion of what is best. This is called a canon, and it is like a football team; its members may be promoted or demoted, it may be relegated to a different division, and it is controlled as much by international finance as by individual or collective merit. Scholars and 'experts' (the name the art trade prefers to describe the people who authenticate works intended for sale) often disagree, with one generation cancelling out the findings of another. The most notorious example of this is the Rembrandt Research

Project (RRP). Rembrandt was such a popular painter in his own time and thereafter that he had many imitators. In the late 1800s, his paintings were numbered at more than 1,000. In the 1930s that number dropped to around 700, and in the 1960s, as a result of the establishment of the RRP, it again dropped, to close on 400. So many museums and private collectors lost their 'Rembrandts', as they were not included in the 'corpus' (the word means 'body'). There remain many disagreements, but whether having your 'Rembrandt' demoted in this way makes it less fascinating as a painting is a question more of psychology than of Art History – though art historians might take this as an example of the history of how people have judged and authenticated art – what is called connoisseurship.

Museums and galleries (many of which were established in the nineteenth century with the aim of mass education) offer access to artworks in physical conditions which, though increasingly crowded (and often no longer free), are none the less still generally favourable. The institutional atmosphere of some museums may be daunting, but, on the other hand, the more fashionable 'user-friendly' approach is not necessarily more conducive to serious study. Racks of clothes made available for children to dress up as portrait subjects, interactive video games encouraging exploration of the collections, and toy trollies signal commendable efforts by curatorial staff to encourage young visitors and to help their parents plan a day out. Whether or not these inculcate an interest in visual history and a love of museums is an open question, and, unless confined to a particular space in the gallery, they can be distracting to someone trying to think seriously and quietly about what they are seeing. When the café and bookshop are the most prominently signposted locations in a museum complex, and when other people's audio tours of the exhibition are readily perceptible as you stand trying to concentrate on examining a painting, you may begin to wonder about priorities. Though an awareness of why we like certain objects may help in visits to museums, the knowledge that authorities have said that a certain object is 'important' can make us, the uninformed viewers, feel excluded and inadequate or simply exasperated.

For all these reasons, it is important when we enter any institution that displays visual culture to remind ourselves that what we are seeing is not a natural selection but a carefully orchestrated arrangement which results from a series of decisions and, in many cases, from accidents of history. These may have been made on grounds of finance or spatial provision or through intellectual considerations. Why some things are there and others are not, why objects are labelled in certain ways, and why certain artefacts

are placed next to each other are all questions we need to bear in mind and be aware of. If we train ourselves to be conscious of these things, we are then active participants in the collective process of looking rather than bodies being processed through a museum space, enhancing the admission figures rather than our own experience.

For people who live in towns and cities, exhibition and museum spaces are still the best and most convenient places to acquire experience of artworks. The fact that visitors to galleries seldom spend more than two or three seconds before any single object suggests that, while great numbers of people desire to acquaint themselves with works of art, the relationship between the object itself and a reproduction with which they may be familiar is a problematic one. It also confirms that looking is a matter of self-education. By 2012, Tate, the group of galleries in London and the regions that come under that heading, had raised £45 million to refurbish and rehang its historic British collections in its building in Millbank, London. It was announced that:

> As a museum where visitors will always see British art from the last 500 years to the present day, Tate Britain will present the story of British art in a continuous semi-permanent display – a walk through time – allowing familiar and less familiar works of the same period to sit together. This is part of a two-tier approach; firstly a route for visitors to walk through an open chronological presentation, and secondly Focus displays which will give more in-depth perspectives on particular artworks, artists or themes.[1]

This carefully worded announcement veils a profound controversy about how art that is shown to the public should be organized. Living British artists (who are of course also part of history) might prefer their work to be across the River Thames at the fashionable converted power station at Bankside that is Tate Modern. If visitors want to see works by celebrated artists they have read about, how can they rely on their work always being on display rather than in store or loaned elsewhere? Should art be displayed chronologically and according to national identity, implying a natural process of evolution, or is it better to hang it in groupings of artists with common interests that cross national boundaries? What about thematic hangs in which, for example, all the works in the collection that feature animals are shown together? All ways of display impose a narrative or argument; simply by the very fact of putting things next to each other, comparisons are invited and tacit dialogues and visual conversations are constructed. Sometimes the traditional chronological hang can produce surprising results. In 2011 the Städel Museum in Frankfurt was being rebuilt, but it did not want to

close its doors completely. So in a modest sequence of spaces in an area unaffected by building work was displayed, in close proximity and packing the rooms, a chronological sequence of works including famous artists and works from storage that had not been seen for many years. The effect was extraordinary, as, for example, paintings by the early twentieth-century group of artists called Die Brücke (The Bridge), which looked very modern and abstract, were hung next to paintings by academic artists working in an idiom familiar since the early nineteenth century but painted in the same year. A timeline gave the dates of major events year by year.

The arrangement, conservation and documentation of the permanent collections in museums, and the choice and arrangement of temporary exhibitions, give precedence to certain cultural forms. Thus oil paintings are much more accessible than prints, drawings and photographs or mass-produced visual material such as posters. An exhibition (whether it be a display of objects loaned or part of the institution's permanent collection) is always much more than the sum of its contents; while organizers of exhibitions often feel they are responding to popular taste in promoting a large display of, say, the work of Renoir or Chagall, the total effect of such a show, paradoxically, may be to render the paintings less, not more, accessible. Backed by prestigious sponsors from the world of business or finance, displaying and cataloguing popular favourites, the exhibition severs such artists from their community and time and enshrines them in a Temple of Art, where carefully inscribed labels convey to us a reading assumed to be the single and correct interpretation for each work and arrows tell us where to commence and where to finish. So the process of exploration through looking and interrogating works of art needs to be accompanied by other kinds of study, which will be dealt with later in this book.

When visiting any gallery or museum, but especially large national collections of art, whether in Britain or in other countries, it helps to think in advance about the visit. Consult a plan of the gallery beforehand (paintings are usually still hung in chronological and national groupings of 'schools') and select what you intend to see. You may change your mind when you get there and find yourself so impressed by something you had not planned to see that you devote all your time to it. It is often much more useful if you can make several short visits (and where entrance fees are involved this can be a sore point) than spending an exhausting day trying to see everything. Mix a bit of looking at things you already know about with things you have never heard of. The familiar is not only reassuring but revelatory if you know it only from digital images or reproductions. The new can set you off on a course of intellectual enquiry that you will never forget. In the case of a temporary display, go early in the day and early in the period of the

exhibition's showing at that particular venue. As press reviews of big exhibitions proliferate, it becomes very much the thing to have been to see such and such a show, and not only are queues involved, but conditions inside can militate against being able to concentrate. Occasionally – but increasingly rarely – one can find a collection that remains relatively off the tourist map and have a blissful experience of uninterrupted viewing. Thirty years ago it was possible to stand alone in the Czartoryski Museum in Kraków with Leonardo's *Lady with the Ermine*. Now, that is unlikely to be possible (though January and February remain the best months for visiting). However, while a visit to the Borghese Gallery in Rome has to be booked in advance, the collections of the beautiful Palazzo Doria Pamphilj remain mainly peaceful.

Now that so much art is available as digital imagery at the click of a mouse, we might reasonably ask why we should bother going to see the originals. It is certainly true that we can now stroll through virtual galleries of paintings from Los Angeles to Paris and search for objects in the British Museum or the Victoria and Albert Museum. After a few basic formalities, we can also increasingly download these for our own private use. In instances – of which there are many in contemporary art – where an installation (a sort of temporary three-dimensional or live compendium in a gallery) is there only for a certain period, the photographic record is invaluable. In 1995 the actress Tilda Swinton lay in a glass case at the Serpentine Gallery in Hyde Park for up to eight hours a day in an installation conceived by sculptor Cornelia Parker called *The Maybe*. For obvious reasons, this is now accessible only in the form of film and still images.

It is hard to overstate the revolution that digital imagery on the internet has wrought for the study of the history of art, and more will be said about this later, in Chapter 5, when I discuss electronic resources for Art History students. But, while we are talking about engaging with art in museums and galleries, it is imperative to make a few simple points. Firstly, there is no substitute for seeing an original artwork: digital imagery and reproductions in books reduce everything to more or less standard dimensions, so that a tiny Vermeer and an enormous painting by Tintoretto both appear to be the same size. Moreover – and this can easily be seen by comparing images of any famous painting accessed via a search engine – photography often distorts colour. Secondly, all artefacts (paintings, prints, drawings, applied arts such as ceramics and jewellery, textiles and furniture, African masks and Chinese ivory carvings) are distinguished by their surfaces, their textures, their three-dimensionality, and the marks of their making. These can be fully apprehended only when seen in actuality. And this is true even of works made by mechanical

interventions. Thirdly, when an image comes up on your screen, you are looking at it frontally from the angle at which it was photographed. It is not only Tracy Emin's notorious *My Bed* (1998, Saatchi Gallery) that needs to be viewed from many positions and preferably walked around to be appreciated; the ability to move in close and see the marks of a palette knife or brush in an Impressionist painting makes a world of difference. With respect to architecture and three-dimensional art such as sculpture, even the most technologically innovative virtual experience is no substitute for first-hand experience. Fourthly, there is the magical law of serendipity: you go to a gallery looking for one thing, but you may find something you have never heard of before and never imagined existed. Context is important: the Isabella Stewart Gardner Museum in Boston has an extremely fine collection of Old Master paintings, but the philanthropist who collected them and built the museum named after her also collected what might look more at home today in a classy junk shop – manuscript fragments, bibelots (small ornaments), fake Renaissance manuscripts and old velvet textiles – and these comprise the period context for understanding the collection as a whole, arranged in the tenebrous corners of this pseudo-Venetian palace.

It may seem from what has been said so far that Art History is essentially a metropolitan activity and that only people who live in large urban centres or people who travel abroad can use the kind of museum facilities I have been describing. This is far from being the case. It is not possible to move the Acropolis from Athens or the Banqueting House from Whitehall for the benefit of students who live elsewhere. Nor will it be possible to see a big loan exhibition of, say, German Expressionist art without visiting one of the big European capitals that is playing host to it. Virtually every area of Britain (and the same applies to other countries where Art History is on the educational syllabus) offers something worthy of attention to the art historian, whether it be the ruins of a Norman castle, a Second World War memorial in a Nottinghamshire village, a set of standing stones in Orkney, an adventurously designed new house, a local library that has inherited a collection of objects accumulated by a former serviceman in India, a disused railway station in Yorkshire, or a stately home run by the National Trust. There are now some amazing sculptural works situated in remote places – though you will probably need to pore over bus timetables or have a car to get there. One example is Kielder Water and Forest Park in Northumberland, where you can see sculpture by contemporary artists such as James Turrell (Figure 1.6), while, in a remote mountainous area of Provence, British sculptor Andy Goldsworthy has created a walking trail that can be followed only on foot and, as one reviewer affirmed, in boots.[2]

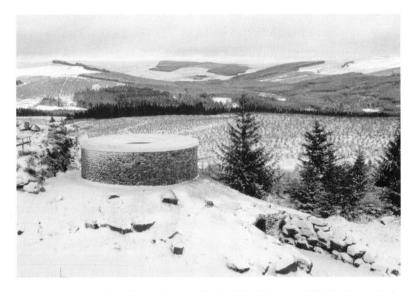

Figure 1.6 James Turrell, *Cat Cairn: The Kielder Skyspace*, Kielder Forest Park, Northumberland, 2000. Image credit: Peter Sharpe.

Knowing one's own locality, discovering works of art in local collections, getting to know the work of a local architect or a designer, identifying the idiosyncrasies of a local collector, making a study of any location where visual communication is important (such as a sports stadium or a department store) – these may be as worthwhile for a student as devoting quantities of time and money travelling to a big city to see a special show. While it would be absurd to deny that there are certain events which should be regarded as priorities and which it is worth making an enormous effort to see, the extent to which a journey to London, Paris, Munich or Milan to view a once-in-a-lifetime retrospective exhibition (covering all the works of an artist to date) is rewarding will be determined largely by how much has been learnt about looking and analysing focusing on material available locally. For example, the Isle of Wight is renowned more for its natural beauty than for its galleries of art, but Osborne House, Queen Victoria's summer residence, now administered by English Heritage, is packed with fascinating objects, and down the road is Dimbola Lodge, the home of photographer Julia Margaret Cameron and now a gallery where her works as well as loan exhibitions are shown. While the word 'gallery' covers a multitude of different spaces (some of them showing craft and

amateur artists' work of exclusively local interest), websites such as www. undiscoveredscotland.co.uk/uslinks/galleries.html may be helpful if you live in a remote area of the British Isles. It is clearly the case that more geographically accessible material for study is for the most part European, and that anyone wanting to study pre-Columbian art and architecture (the name given to the civilizations of Central and South America before the Spanish imperial voyages of the sixteenth century) needs at some stage to go to Mexico, Peru, Bolivia and neighbouring countries. None the less, as a consequence of the imperial past of Western European nations, many cities contain extraordinarily rich repositories of artefacts from Africa, Asia and South America. These may be held in a well-publicized location such as the British Museum, but many university museums and galleries (East Anglia, Manchester, Edinburgh) hold ethnographic collections full of non-Western artefacts, as do cities such as Birmingham and Liverpool as well as Oxford and Cambridge.

Most of us are astonishingly ignorant of the wealth of visual art available to us within walking distance of where we live. There are many ways in which it is possible to become informed about what to look at and what to look for. A notebook and pencil, to be carried at all times, form the basic equipment for an art historian. A quick sketch of an architectural detail, a note made of a painting in a saleroom or a public place, an analytical drawing of the particular layout of a page in a newspaper or an illustrated magazine help us to develop a good visual memory and may be useful in providing the focus of a piece of research in a local library. Writing down what you notice about the object you are looking at is, probably, the most efficient way of learning to direct your attention and of acquiring the habit of posing questions even if no answers are immediately forthcoming. If you take a digital camera, make sure to remember to download the pictures you have taken and file them in a way that will ensure you can easily locate them again.

For those reasons of cultural history and pressures of public display we have already mentioned, a gallery or museum is not, then, the only place to start learning about looking. However, in many galleries and museums there is a person or group of people especially responsible for what is loosely termed 'education'. Sometimes, in large national museums for example, this is a considerable body of people, covering everything from the needs of primary-school children to scholarly symposia on topics related to exhibitions or the permanent collection. The museum education officer's responsibilities normally include liaising with local schools and other institutions. The events that are put on by education departments – usually geared to different levels of familiarity and expertise – are an excellent way of getting to know about aspects of the museum's holdings and familiarizing oneself with the

different ways in which people discuss objects from the past and their histories, for every object will be a part of more than one (hi)story.

No museum or gallery ever has all its holdings on display at once. It used to be relatively easy, provided notice was given in advance, to get to see objects from the store, but, with cuts in staffing levels at virtually all institutions and the imposition of rigorous notions of cost-effectiveness obliging cultural institutions to function like businesses, provisions of this kind have been severely eroded. One may have to wait for months in order to get to see something in store at a big London museum. For the reasons outlined above, it is also not possible to rely on finding open the particular room in the gallery that one has come to see. It is often the large, 'important' museums, such as the British Museum and the Victoria and Albert Museum, that tend to close certain spaces as they focus their staff on a publicity-attracting event elsewhere in the building. Although all cultural institutions are under government pressure to obtain sponsorship from business and industry, the fact remains that it is we, through our taxes, who have the primary funding responsibilities for cultural institutions, and it is, therefore, our right to have free access to their contents. The National Lottery raises large amounts of money, most of which goes to the Exchequer. Because the lottery has proved so popular, however, the funds devolved to 'good causes', including the arts, have been considerable, at least until the Olympics of 2012 had to be paid for. The Department for Culture, Media and Sport allocates a proportion to the Arts Council, which claims to be disbursing £1 billion to the arts between 2011 and 2014. However, the overall budget was cut in 2011, and hundreds of arts organizations (especially the smaller and more experimental ones) consequently lost their funding and have since closed.[3] Moreover lottery money is not without strings, and its overall long-term benefits to the arts are open to question. For the most part applicants must be institutions (not individuals),[4] and those applying are expected themselves to raise a proportion of the total needed. A large part of the money goes on capital projects, so there are many gallery extensions, cafeterias and theatre restaurants under construction; whether those same galleries will be able to conserve their holdings in appropriate conditions and pay their staff, let alone promote new art and acquire new objects, is another matter. We should never forget that the treasures housed in public museums and galleries (often there as a result of the generosity of someone long dead who wished the pleasure of their collection to be extended gratis to a wide audience) belong to everyone and, while one of the curators' and keepers' responsibilities is that of safeguarding, researching and improving collections, it is equally their responsibility to answer questions from the public and help people to acquaint themselves with works of art.

There is increasing sympathy for the view that a person can know a Mies van der Rohe chair only by sitting in it or a sculpture only by touching it and

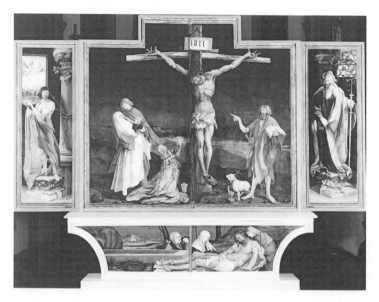

Figure 1.7 Niclaus of Hagenau and Matthias Grünewald, the Isenheim Altarpiece, 1512–16, Unterlinden Museum, Colmar. Reproduction by permission of the Syndics of The Fitzwilliam Museum, Cambridge. © The Fitzwilliam Museum, Cambridge/Bridgeman Art Library.

handling it. Clearly there is a problem here. If everyone wanted to experience the physicality of delicate items in collections, the function of the museum as guardian would have to take precedence over the function of the museum as educator. The Isenheim Altarpiece in Colmar (Figure 1.7) can be properly understood as an object possessing a whole series of viewing possibilities with overlapping and intersecting meanings only if it is comprehended as a three-dimensional object with panels which open and close, revealing and concealing, offering an inside and an outside in a complex interplay of signifiers. The use of diagrams, models and mirrors can sometimes help to compensate for the fact that we cannot see this movement from stage to stage, and no one would argue for the right to handle an object of such antiquity and physical vulnerability. Ironically, some of the most celebrated works of art produced in the past thirty years, a period during which ideas about access and popular appeal have been promulgated by arts impresarios and government aficiona- dos, have been among the least touchable. Objects such as Damien Hirst's *For the Love of God* (2007), a human skull encrusted with diamonds, are rarely seen and then only in an environment controlled as much as or more

strictly than that of the crown jewels in the Tower of London. Yet this is a work of art that has become so popular that it is manufactured as a fridge magnet. Tino Sehgal's Tate Modern exhibition, funded by Unilever in 2012, involved training hundreds of participants to interact with the 'viewing' public who were visiting the turbine hall. This ephemeral show was ostensibly about community and personal engagement over and above consumerism and materialism, but, it could be argued, the training of volunteers produced a hierarchy with at its apex the artist and at the bottom the visitors, who had no choice as to whether someone would speak to them, or on what topic.

The staff of museums and galleries outside London frequently have at their disposal useful information about artworks and buildings of interest in the area covered by their institution's service. For obvious reasons of confidentiality, they are not always willing to impart this information, but it is certainly worth approaching them for details. Other important sources of information are local history libraries (usually a department of the central municipal library where they still exist) and county record offices. Regional gallery and library websites, however useful, seldom go into sufficient detail for an art historian. Organizations such as English Heritage, the National Trust, the Georgian Group and the Victorian Society (like the county record offices, all easily accessed on the web) will provide information about buildings of interest in your area. If there happens to be a site of special historical interest in the locality, this may be covered by the activities of a local civic society or preservationist pressure group. By joining one of these groups, it is possible not only to gain access to art-historical material that may be experienced at first hand but also to do a useful job for the community and acquire expertise in research, records and presentation. For those working in medieval art, local archaeological societies are often a fruitful source of information.

It is advisable, having selected an area of study, to narrow it down as much as possible. It is usually more rewarding to get to know one Norman church in your area or one aspect of the work of an artist than four churches or the whole of one person's oeuvre. In the same way, studying one painting in a gallery rather than viewing a roomful of pictures is the best way to acquire skills in looking. Many people take holidays abroad and use guidebooks, which often list major historic sites of interest. The *Rough Guides* and the *Lonely Planet* series are two that can generally be relied on. However, none but the most specialized books of this kind offer any detailed information. It is possible, however, to plan in advance what to see in galleries and institutions outside Britain by consulting the *International Directory of Arts* (see Chapter 5, pp. 115–116). It includes information on the location, contents and opening times of thousands of museums and galleries around the world. There are now many famous galleries where, even if you are willing to queue, you may need to make a reservation online in advance,

especially if it is the high season: the Uffizi in Florence and the Borghese Gallery in Rome are cases in point.

It may be that what you have chosen requires no special access; an analysis of the visual arrangement employed to attract customers into a competitive market and an evaluation of the meanings and associations produced in that arrangement (baked beans by a certain manufacturer equals a happy child-hood; a brand of underwear makes you a real man) might require a number of visits to a shopping centre which is conveniently open during extended working hours. A study of style in clothing of any group (football fans abroad, visitors to Ascot, teenagers in a club) would require a very clear set of definitions of that group and a sense of the geographical location of their self-presentation. Work of this kind would be considered as belonging more to Design History and Visual Culture Studies than to Art History as traditionally understood. However, as much contemporary art draws on commercial technologies, this is not a bad way to cultivate a habit of critical looking.

Practical considerations are important. Plan a programme of work involving several visits to a site, some relevant reading, and consideration of the method and approach to be used. If relevant, ascertain opening hours before setting out, and if your destination is a church or a country house (many of which are closed from October to March), or if you are likely to want to see something not normally shown to the public, try to contact in advance the vicar, the estate manager or the curator to request permission to view your chosen material. It can be particularly frustrating to reach a remote country church to find it all locked up and whoever holds the keys away on holiday or visiting in another parish. Certain objects are shown only at certain times of the year. The National Gallery of Scotland shows its Turner watercolours only in January, when daylight (a destructive agent to which watercolour is particularly vulnerable) is weakest. Avoid peak holiday periods if possible and choose clear, bright days. The stained glass in a church will not be seen in all its brilliance on a wet, dull day. Although in the interests of preservation many galleries are now lit completely artificially, there are still major picture collections housed in galleries with glass roofs (for example, Dulwich Gallery) and, in these cases, the better the natural lighting conditions, the better the experience of looking.

A preliminary look at your chosen object – or a reproduction of it – will not only help you to establish a visual relationship with it but will also assist in identifying the questions that need to be asked about it. Go away after an initial session and work out a questionnaire or a series of headings under which to work. The discussion in Chapters 2 and 3 should help direct your study. Though you will want in due course to tackle the question of what others have said and written, it will help you in dealing critically with that published material if you have sorted something out for yourself first.

Art historians need equipment; most of all they need their critical faculties, but when they are engaged in 'fieldwork' more practical tools may also be useful. Geologists take hammers with them and entomologists take nets. A hard-backed notebook of the 'Moleskine' type (or an inexpensive equivalent) that has one page lined and one page plain can be very useful for the kinds of recording I have described earlier. The antiquarians of the seventeenth and eighteenth centuries, the predecessors in an important sense of today's art historians, relied on drawing as a way of making a record but also as a way of registering, or noticing, all the important elements in an object under scrutiny. A camera does not impose that discipline but rather inclines us to feel that we have looked at something when, in fact, we have merely looked through a camera lens. A camera may be a great asset, though it may also be a considerable nuisance. A cell phone or an iPad is no substitute – images produced by these means do not have adequate definition to be of use for anything except a rough reminder. Today's art historians do not have to carry around a lot of photographic equipment – small digital cameras can produce high-resolution images – but it is important to be aware of the danger that the camera will make you intent more on taking the photograph than on examining the object. Many art galleries will not permit visitors to take photographs, and buying good quality digital images is expensive. Postcards, which are useful and available in gallery and museum shops, tend to be restricted to a small range of the most popular items. Increasingly, the system known in the USA as 'creative commons' is allowing us to download images from the web for teaching or research. You can read more about the resources for this in Chapter 5.

Photography is, like drawing and writing, a medium of communication, and in Chapter 4 you will find some examples of how art historians approach and write about photography as an art form. Whenever we record anything, however 'objective' we aim to be, we are interpreting, and our medium (photography, pencil, ballpoint) will mediate what gets on the record. So think about this as you position yourself to take a photo or begin a sketch. Elsewhere in our art-historical engagements we may want to think more closely about these modes of communication – the way the apparently scientifically accurate and truthful account is also always an act of interpretation. But this does not preclude our recognizing that, in so far as art historians in one aspect of their work examine and evaluate historically objects which have a physical existence, in doing this they have to record what they see in order to be able to compare it with what other people claim to have seen.

There is a lot of footwork involved in looking, whether in a museum, in a city street or in the countryside. It goes without saying that comfortable shoes can make all the difference to the day and, if you happen to be exploring Stourhead Gardens (landscaped in the eighteenth century) in spring or out in the cold evaluating the extraordinary impact of Anthony Gormley's 20-metre

high *Angel of the North* (1998) in winter, waterproof boots are a good idea. A tape-measure is a useful piece of equipment for the art historian, even if it is not going to help you with the *Angel of the North*. A ruler is very convenient for measuring the dimensions of a painting or drawing and a dressmaker's tape-measure for recording the girth of a column. A pocket magnifying glass and a pair of binoculars can be very useful too. It is possible now to get an inexpensive LED torch that makes all the difference to being able to see a painting hung in a dark corner or the detail of a moulding high up in the interior of a building.

Obviously, to look at stained glass through binoculars is never to see it as it was intended to be seen. On the other hand, the full quality of colour and the effectiveness of technique cannot be appreciated without a closer look. The art historian wants to know not only what it is but how it has been made. Similarly, the magnifying glass is not only used by art historians to authenticate a work or to examine a signature but can also assist towards knowledge about how a work was constructed (what sorts of pigments and brushes or knives were used in the case of a painting) and how it was produced (how many woodblocks were used to make up a plate for a magazine, indicating how many engravers may have been at work on that one task). It may perhaps seem that these things are superfluous for someone who is not writing a definitive study or making some kind of report. But the fact is that apprehending the material existence of an artefact should involve a comprehension of it as a three-dimensional and concrete presence.

Looking at buildings requires its own discipline. Architectural history attends to the growth of a building (whether large or very modest) from its inception, probably as an idea on a piece of paper. The relations of architects such as the notoriously ruthless Bernini with patrons and contemporaries is a part of understanding a building, as are the various purposes to which it has been put over time. When usage changes, so does the building's meanings and its cultural and historical associations: the Hagia Sophia in Istanbul (Figure 1.8) was erected as a church, then became a mosque and is now a museum, while, in Spain, Córdoba's great thirteenth-century mosque became the city's cathedral. The history of architecture is also the history of buildings never erected or never completed. A student, learning to look, will want to take into account considerations like the season and the weather and the time of day. Is a building being seen under typical conditions? This is an important question. The relationship of a building to its surroundings, whether natural or man-made, might appear different in winter from in summer. At certain times of the day architecture, particularly public buildings, has a more obvious function than at other times. If you are visiting an office block, study it as a working active edifice rather than as a place in repose. Make sure you know what it feels like at 9 o'clock in the morning and at 5 o'clock in the evening, when those who work there are arriving or leaving.

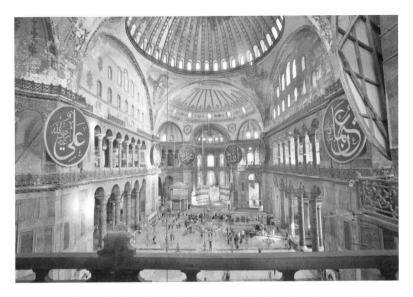

Figure 1.8 Hagia Sophia (Hagia Sofia, Ayasofya), Istanbul, Turkey. Built as a church in the sixth century, it was used from 1453 as a mosque and since 1935 has been a museum. Credit: Ken Welsh/Getty Images.

Many modern buildings take on a quite different appearance with the introduction of human movement and colour. The Lloyd's building in the City of London (designed by Richard Rogers and completed in 1972) offers a very different appearance after dark than in the day, when its gleaming surfaces are enlivened by colourful moving figures. The needs and characteristic patterns of movement of the population have to be taken into account when studying architecture. Sometimes, for example, it is possible to observe that, in laying out paths and walkways, the architects or planners have made inappropriate or inadequate provision for the consumers, and the scarred turf or broken balustrade bear witness to the pedestrian's natural routes.

The relationship of exterior to interior is fundamental to architectural study, as is the relationship of the building to its environment. It is necessary to do more than merely look from the outside. Request admission and move about inside the building. Find out what the experience of the building is for those who work in it and make enquiries as best you may to find out what adaptations have been made in the construction of the building since its erection and what changes in function have taken place.

Is life in the building easy or difficult, pleasant or unpleasant, for those who travel in its lifts, deliver materials to its loading bays or look out of its windows? What must it have been like in the past? Consider the structure as a whole, taking into account the furnishings and fittings as well as the actual fabric. In the case of country houses, and also with some museums, your route is prescribed for you; this makes it all the more imperative to try to imagine other routes and other viewing positions. For today's students, in whatever part of the country, there are rich opportunities for studying architecture both old and new – and in some cases the two are merged. The Baltic Centre for Contemporary Art in Newcastle, for example, provides an excellent object of study for anyone interested in evaluating different kinds of architectural form and the inventiveness of architects in converting spaces designed for one function to serve another. In cases like this where alternative use has been found for a building, even one less grand in scale than The Baltic (cinemas and churches are now frequently in use as anything from private houses to bookstores), it is important to arm yourself with the clearest possible information about what it was like in its original state. Recourse to the local library is the best first step. Here early histories and photographs of the locality, as well as maps and plans, can often be found. By bringing together current, on-the-spot observation and a little personal research, an interesting reconstruction can be made.

In looking at sculpture, one of the most important considerations is where the sculptor intended the work to be placed. Column figures from Gothic cathedrals have found their way (in the interests of preservation) into museums, where their precise function and their role as part of a total structural concept have disappeared. The figures from Etruscan tombs carved in the sixth century BC are now largely in museums. Monumental sculpture, which may have been seen, when *in situ*, from 100 feet below and which was, therefore, designed to be seen in daylight from a distance, may now be placed in artificial lighting in a cramped corner of a museum. Sculpted figures that were made for specific religious purposes – as, for example, with Hindu sculpture from India or Buddhist cult objects from China – are difficult to understand when placed in a glass case in a Western museum, however much their beautiful shapes and the skill used in their making inspire admiration. The loss of function (whether practical or symbolic) sometimes leads to aestheticization – to the promotion of the object as a thing beautiful to look at and tinged with an aura of antiquity but lacking any history. The fashion for museum displays of material culture in the USA has often produced a situation in which, for example, a shop sign or a piece of agricultural machinery is exhibited suspended in isolation on a whitewashed wall.

Naturally it is necessary when looking at sculpture and architecture to be conscious of the changing viewpoint. Walk around and examine the object of your attention from every side. Touch it, feel it, and look through it, above it and below it. If the sculpture is placed out of doors, make sure you see it in different weather conditions. Rodin's *Burghers of Calais*, one version of which stands in the Place du Soldat Inconnu in Calais, presents a very different aspect when the bronze figures are wet and reflective from when it is gleaming dully on a sunny day.

With works of applied art, it is especially important to see the object in its appropriate surroundings. This can be problematic. A chair or a length of textile conveys a different visual message to the viewer according to its setting and the nature of the objects placed around it. One Biedermeier chair may be a beautiful object on its own, but its special characteristics of design and the way it works visually can be appreciated only if it is seen in historical context – that is, in a total Biedermeier interior. Unfortunately, it is seldom possible to do this, but one can go some way towards establishing the relationship of an object to its surroundings. If you cannot, for example, view a vase by Emile Gallé (Figure 1.9)

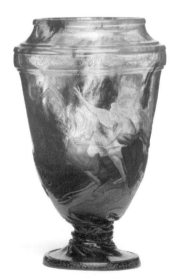 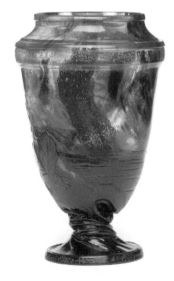

Figure 1.9 (a and b) Emile Gallé (with figures by Victor Prouvé), *Orpheus and Eurydice*, 1888–9, Nancy, blown glass, engraved and gilded, height 26cm, diameter at opening 12cm, Musée des Arts Décoratifs, Paris. Photo Les Arts Décoratifs, Paris/Jean Tholance. All rights reserved.

in a contemporary setting, then try to find an art nouveau interior of the period to which the vase belongs and study it alongside the object. Failing that, there are always photographs and descriptions which may be of considerable help.

Audio guides are now a commonplace not only in big exhibitions but also in the permanent collections of major galleries. For those with serious aspirations to art historical activity, audio guides used to be despised as fit only for those who didn't know what they wanted to see. They still vary enormously in sophistication and quality, but some large galleries have now developed multimedia platforms and offer podcasts and other very useful preparatory tools.[5] Commentaries are intelligent and by no means condescending, they are available in a variety of languages and, most importantly, they permit viewers to select which individual paintings they wish to examine. The National Gallery offers a series of audio tours (www.nationalgallery. org.uk/audio-guides), including one that covers the whole collection and for which the visitor types the painting's accession number in, as well as a series of 'trails' and a 60-minute tour which is available in languages other than English. There are also printed tours that can be downloaded from the gallery's website before you visit.

Certain kinds of contemporary sculpture and installation art – some of the most controversial productions of contemporary artists fall into this category – pose distinctive problems for viewers. Indeed, one of the salient features of this kind of art is precisely that it does make seeing difficult, both in the sense that whatever is offered may be ephemeral and in the sense that visitors' traditional ideas about where to stand and how to look are undermined and challenged. Richard Wilson's work *20:50* (1987) in the Saatchi Collection, consisting of a steel walkway extending between two shoulder-high vats filled with black sump oil with reflective qualities, demands from viewers a series of decisions which are quite different from, say, those required of a statue by the Italian Renaissance sculptor Donatello.

Each year the Serpentine Gallery in Kensington Gardens, London, commissions an architect or an architectural practice to design and build a temporary pavilion on a site just outside the gallery. In 2012, the Chinese artist Ai Weiwei and the architectural firm Herzog & de Meuron worked together to produce a small pavilion of great elegance and beauty: circular in form, and with a sunken bowl with variegated steps carved of cork and a roof superimposed by water that reflected the sky, it remained in place from 1 June to 14 October 2012. Its temporary nature and the materials that ensured it could easily be dismantled were part of its attraction (as long, of course, as you were able to be in London to see it during that period). However, it is undoubtedly the photographs of the pavilion taken from the air and showing its stunning symmetry that will be remembered

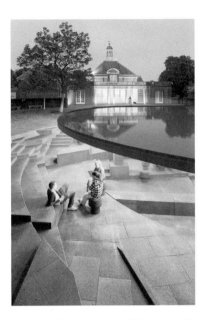

Figure 1.10 Serpentine Gallery pavilion by Herzog & de Meuron and Ai
Weiwei, London, 2012. Photo credit © Iwan Baan.

(and they are accessible to all) (Figure 1.10).[6] We think of it as solid
and permanent, but this reminds us that architecture, also, is temporary;
if you are examining architecture, you might find yourself looking not
only at buildings that can be visited and entered but also at architectural
designs for structures never built (and in some cases never intended to
be built), as well as those that once existed but are now known only from
documentation.

Performance art is, of all media, the most ephemeral, involving a one-off
event or sequence of events, often necessitating the actual destruction of the
material components used. When, for example, in 1974 Marina Abramović
performed *Rhythm 5* (in Belgrade), the props consisted of a large five-
pointed star constructed of wood and wood shavings and soaked in petrol.
Passing around the construction, Abramović threw a lighted match that set
it aflame and then, after cutting off her long hair and dropping bunches of it
into each point of the star, lay down in its centre. However, the desire to pre-
serve the memory of something, the whole point of which was its ephemeral
nature, appears to be overwhelming, and so, in November 2005, in a series
called *Seven Easy Pieces* that was put on at the Guggenheim Museum in

New York, Abramović re-enacted performances given by her peers from the 1960s and 1970s.

I have concluded this chapter with things that compellingly invite our engagement but which are equally not always available to be seen. I make no apology for this: one of the things which an art history student has to understand early on is that you have to work hard to see what you want to see. Of course you can look at the pictures on the web (and I have generally included addresses in the footnotes to help my readers here), but one of the things we quickly learn is that all art is ephemeral (the overnight disappearance in 2011 from a South London park of a large bronze sculpture by Barbara Hepworth was a shocking reminder, were one needed). We appreciate that, as art historians, we have to take advantage of access when it is on offer; if we wait, the artwork may have been destroyed by vandalism, theft, war or accident. Our evidence is pieced together from what survives the ravages of time. In the next chapter we will look at some of the ways in which we do that.

Notes

1 www.tate.org.uk/about/press-office/press-releases/tate-britain-reaches-ps45-million-funding-goal (accessed 28 January 2014).
2 Jane Ure-Smith, 'High Art and Hiking Boots', www.ft.com/cms/s/2/64f7ab4c-e858-11e1-8ffc-00144feab49a.html#axzz2TReh8BEJ (accessed 28 January 2014).
3 'Hundreds of Arts Groups Lose Funding', www.bbc.co.uk/news/entertainment-arts-12892473 (accessed 28 January 2014).
4 It is worth reading the Arts Council's guidance for applicants to get a sense of what is regarded as appropriate: www.artscouncil.org.uk/funding/apply-for-funding/grants-for-the-arts/. The Council insists that it is quite independent of government.
5 See, for example, www.tate.org.uk (accessed 28 January 2014).
6 www.serpentinegallery.org/2012/02/serpentine_gallery_pavilion_2012.html (accessed 28 January 2014).

2 How art historians work
Training and practice

An art historian is a person who is engaged in exploring and analysing the construction and form of artefacts and their functions, both practical and discursive, at the time they were produced. So, what do art historians actually do in the world of work? In Chapter 6 you will find a discussion of the kinds of career opportunities that have traditionally been available to students graduating with good honours degrees in History of Art, as well as some first-hand accounts of the career paths taken by graduates. Although these are many and varied, it is still the case that a degree in History of Art or another humanities discipline is the major prerequisite for entry into the professional world of art galleries and museums if your interest is with arts and artefacts (as opposed to science, technology or medicine – or with the specialist areas of conservation). In later chapters, we shall see how we can most readily discover what we want to know, and we shall examine ways of organizing our looking at historical artworks and how to structure our reading to the best advantage. First let's look at what the education system offers, because the whole subject is very confusing for those who are wondering whether to take a degree course in art or to pursue the study of the history of art on their own or in an organized group. To begin with, 'fine art' is a term that has often been used in the past in a general way to describe painting, music, drama, sculpture and other art forms. In this sense, the fine arts are those generally that are distinguished from the useful or mechanical arts, but in the contemporary British education context Fine Art usually means the practice of painting for its own sake. Some universities offer degrees in practical art and Art History in the same department or within the same organizational unit (a school or a faculty), and it is possible in such institutions to take a degree course that combines history with practice. It is, however, relatively uncommon, and most students opt either for a degree course that is essentially historical and theoretical (though, of course, the focus may be on the modern and contemporary) or for a degree course in some aspect of art practice,

normally preceded by a foundation year. It is, however, worth noting that it is not uncommon for students to take a foundation year and then to realize that their interests lie more with the historical and theoretical aspects of art and hence to proceed to an Art History degree. Several of the real-life individuals profiled in Chapter 6 describe how they did precisely that. Some degree courses combine history of art, in the traditional sense of painting, sculpture and architecture, with history of design, and many institutions offer not only single honours History of Art but combinations with other disciplines (a modern language is common, but also available is, for example, Art and Archaeology of the Ancient World at Manchester University). At the University of Northumbria, History of Modern Art is offered along with History of Modern Design and Film, and many universities now group Art History, 'Screen' Studies and Visual Studies as a cluster, even though the actual course modules recognize the distinctive demands of each area. Most institutions now participate in the enormously successful EU student exchange scheme (Erasmus) whereby individual students from one country may take part of their course at a university in another member country. Departments will state in their online prospectuses with which institutions in which countries they have partnership arrangements. It is very important when considering applying for a course to look very closely at course descriptions as well as at overall provisions (libraries, fieldwork, gallery tuition) within the institution.

The term 'visual culture' may be used to include a considerable range of periods and objects of study. If you are keen to devote most of your time to art-historical study, you need to make sure that the institution to which you are applying offers enough modules for you to attain your objective. A small department may offer a degree course that concentrates on a particular area or period, whereas a large department may offer not only a considerable chronological span but also several different degrees. In good American universities it is unusual not to find an Asian or Far Eastern specialist but no architectural historian; in the UK the reverse is the case. If you know you want to study Chinese art, you should look very carefully at the prospectuses of the various institutions to ascertain where tuition in that specialism is offered. Not all major universities offer History of Art, but it is now very easy to check which ones do by searching online.

Being a good researcher and a distinguished scholar doesn't necessarily mean you are good at communicating to undergraduates; departments of History of Art (as with those of any discipline) are only as good as the creativity and learning of the people who teach in them. The results of the peer assessment of university research, conducted subject by subject at the behest of government every six years or so, are in the public domain, as

also are the results of teaching quality evaluations.[1] Institutions are in keen competition for good students, especially now fees are such a serious consideration. Although, if you are sitting school exams, you may not feel like the proverbial consumer with a market choice, this is precisely what you are and, since this purchase will affect your whole life, you need to do your homework and be sure to get it right.

Art History is now taught as an 'A'-level subject in very few schools (and those are almost exclusively in the independent sector), although the Association of Art Historians (AAH) has calculated that more than 2,000 students take 'AS' level each year and almost half then take the full 'A' level.[2] The absence of Art History in the maintained sector is a great pity and very short sighted, as the expanding arts and heritage sectors of the economy need good graduates and any perception that Art History is not an intellectually demanding discipline is readily challenged. The fact that the model Lily Cole, who graduated in History of Art from Cambridge, has engaged publicly in discussions about employment for arts graduates[3] and that the Duchess of Cambridge, who has a degree in the subject from St Andrews, accepted a post as a trustee of the National Portrait Gallery (responsible with her peers for the collections held there in trust for the nation) has in some ways been good news. But in other ways it may have endorsed the erroneous impression that History of Art is a subject for privileged young women. That this is far from the case you will discover on the open days arranged by universities for prospective students and by reading the testimonies of those who have studied in the subject that you will find in Chapter 6.

If your 'A' levels or IB exams are in subjects other than History of Art, this in no way prevents your being admitted to study it as a degree subject; it is not a prerequisite, though of course it is useful. If you are within reach of an urban centre, other organizations also offer Art History courses: the Workers' Educational Association, many centres for continuing education, gallery and museum education departments, and the National Association of the Decorative and Fine Arts Societies all run courses on topics connected with the history of the arts – though some may be quite expensive. In London, the Architectural Association and the auction houses Christie's and Sotheby's all run short courses as well as providing postgraduate tuition. The Courtauld Institute of Art runs short courses and a summer school, while Birkbeck College, University of London, where teaching takes place in the evenings and which caters especially for part-timers, offers a range of short non-award courses which are ideal preparation for degree work. In some centres, access to higher-education courses is available in history of art (for this see Chapter 6, p. 137).

The fees charged by these organizations vary hugely, as does the level at which tuition is provided, so check carefully that what is on offer is what you want. People who already have a degree (or commensurate experience) in another discipline can sometimes find that a postgraduate diploma course will provide a 'conversion' for them, introducing them to Art History but at a more advanced level than the first year of an under-graduate degree.

Art historians often get asked: 'Do you paint as well?' While the view may be held that only those who make their own art can really give an authoritative view of the art of the past, it is more generally the opinion of art historians that the discipline is in itself a creative activity and those who are artists as well as art historians can be wholly committed neither to the one nor to the other. It is certainly true that artists have always studied art and creatively exploited the work of their predecessors (whether con-sciously or not). How they did this has fed into the debate about education and the National Curriculum, with the argument that all children should know the names of 'great artists' such as Raphael and Michelangelo. The artists who appear in this canon are, indeed, often those who have had an 'influ-ence' on other artists simply by virtue of the fact that the canon is formed in a long, cumulative process. The trouble is that there were no named great artists in the Middle Ages, though I suppose you could teach a class to recite the names of the great Burgundian cathedrals, rather like Victorian children learning the Seven Wonders of the World.

More importantly, this sort of systematization grossly simplifies history, substituting names as answers where questions about *historical process* and *agency* should be asked – that is, how does what happens take place and what makes it happen? Moreover, it is not always the canonical artists who have been influential. The artist who features most prominently in the art criticism of Baudelaire in nineteenth-century Paris, and whom he admired beyond measure, is a man called Constantin Guys, whose work is scarcely known today and who in his own time was regarded as a menial illustrator. John Flaxman's illustrations to classical texts (Figure 2.1) were run-of-the-mill work in their own time. Now they are of particular interest as the engraver employed was a little-known craftsman called William Blake, and on account of the fact that these designs probably distributed more pictorial motifs around Europe in the 1800s than any other work of art, ancient or modern. The work of Botticelli, so admired by visitors of all nationalities to the National Gallery in London today, was 'forgot-ten' for several centuries and 'rediscovered' only in the late nineteenth century, suggesting that the idea of abiding quality and permanent value is a chimera.

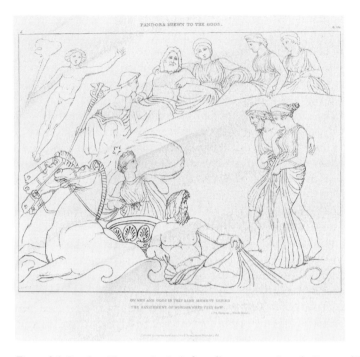

Figure 2.1 *Pandora Shown to the Gods*, from *Compositions from the Days and Theogony of Hesiod*, 1816, William Blake after John Flaxman, stipple, etching and engraving, British Museum. © The Trustees of the British Museum.

The relationship of artists to their predecessors – the contact between practice and history – is no simple matter and needs to be understood in terms of a two-way process. When we see a famous portrait of the pope represented in a painting by Francis Bacon, it affects not only the way we think about Bacon but also the way we think about Raphael's Pope Julius II. The use by artists of earlier material and motifs is always at some level an interrogation of culture, of painting's aftermath. The French nineteenth-century artist Jean Auguste Dominique Ingres, in *Raphael and the Fornarina* (Figure 2.2), establishes a complicated conversation with the Renaissance artist Raphael, whose own portrait of his mistress (*La Fornarina*) is shown on the easel. Ingres' actual method of painting, which lends this picture its clarity of form and sharpness, is much closer to the manner of a fifteenth-century Flemish artist such as Van Eyck. In painting this subject and in this way, Ingres may be said to be comparing himself with these earlier masters. Thus Ingres' image makes overt and apparent the complex engagement of parody, commentary, commemoration and incorporation that occurs when the practising artist self-consciously adopts the historian's position.

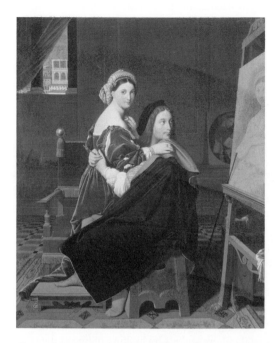

Figure 2.2 Jean-Auguste Dominique Ingres, *Raphael and the Fornarina*, oil on canvas, 1814, Fogg Art Museum, Cambridge, MA. Reproduction by permission of the Syndics of The Fitzwilliam Museum, Cambridge. © The Fitzwilliam Museum, Cambridge/Bridgeman Art Library.

The issues raised by this discussion are clearly of relevance to today's students of art. For them the controversy centres, not surprisingly, on whether art students can be 'taught' the art of the past or whether they have to discover unaided what might contribute to their own effort to create. But the teaching of the history of art to students of practical art is based, rightly or wrongly, on the assumption that a helping hand, a discipline within which to organize encounters with works of art, and the proffering of material the student might not otherwise come across are generally enriching and can be directed specifically towards the individual's own area of artistic practice, whether that be ceramics or graphic design.

The origins of Art History are variously located. Some people would argue that they lie in the nineteenth century, when those responsible for assembling national collections of art in Germany and England began cataloguing and writing the histories of the works they were purchasing (or obtaining by military conquest) and when the German philosopher G. W. F. Hegel began offering his lectures on aesthetics in 1820. Others

would put the date very much earlier, in the Renaissance, with Giorgio Vasari's *Lives of the Artists*, or even earlier, in Roman times, with the accounts of the artists of antiquity left to us by Pliny the Elder, who died in the eruption of Vesuvius in AD 79. As a profession, with its own methodologies, Art History originated in Germany and Austria at the end of the nineteenth century and the beginning of the twentieth. One of the consequences of the movement of refugees from Central Europe in the twentieth century was the introduction of many distinguished individuals and libraries connected with Art History into the UK and the USA. One of the most famous of the immigrant scholars to Britain was Sir Nikolaus Pevsner, whose series *The Buildings of England*, organized county by county, remains the richest architectural survey available. The resources of the Warburg Library in Bloomsbury, a rich repository of books and images with special reference to the classical tradition, were the bequest of Aby Warburg, a Jewish refugee from Hamburg.

Design History is of even more recent origin. It is a discipline in its own right, with a specialist literature and its own journal, the *Journal of Design History*. It overlaps with the study of material culture (i.e., artefacts which may be utilitarian and functional as well as/rather than aesthetic) that takes place in the context of Social and Economic History, Anthropology, Cultural Studies and Art History. You can get a good idea of the areas covered by Design History and by material culture studies by looking online at the contents of different numbers of the *Journal of Design History* and the *Journal of Material Culture*; in 2005, for example, there appeared in the latter an article entitled 'Observed Decay: Telling Stories with Mutable Things', about the degradation of cultural artefacts, while a recent special edition of the former is devoted to 'shininess' (as in polished and gleaming things). There are many crossovers between Art and Design History, but the latter tends to focus on post-industrial societies and their products from *ca.* 1900 and encompasses a somewhat different range of objects from Art History. While the two might share a concern with, say, the organization, layout and contents of the Great Exhibition of 1851 held in the Crystal Palace, Design History addresses consumer culture in a much broader way, looking not only at the shape and form of manufactured objects but also at the economics of distribution, the psychology of marketing and the dissemination of so-called iconic objects. Design History students might find themselves examining how environments (the 1930s kitchen, the 1950s office) are shaped and constructed in meaningful ways. The Art History student, on the other hand, might require comparable skills to understand the making, decoration and formal usage of the Sistine Chapel in the Vatican.

History of Art students can expect to do at least some of their learning, supervised or unsupervised, in art galleries and museums. Provisions are

usually available (upon prior request) for small classes to take place in front of paintings. Some, for example Tate and the National Gallery, provide stools to enable groups to sit while they study a painting, and some organize special day events around an 'A'-level syllabus or an exhibition. The National Portrait Gallery has been at the forefront of providing course material for secondary teachers of History of Art.[4] Patience and tolerance are prerequisites for on-site study of works of art; art historians reap the consequences of their own success as popularizers as galleries become ever more crowded with keen viewers of paintings. All galleries require pre-booking for parties and large groups. No one benefits if there is a queue in front of Botticelli's *Mars and Venus* in the National Gallery or if one is unable to perceive the pointillist brush-strokes of Seurat's *Une Baignade, Asnières*.

Postgraduate courses may be built around a special relationship with a museum department. The London Consortium (comprising the Architectural Association, Birkbeck, the ICA, the Science Museum and Tate) offers joint Masters and Doctoral programmes.[5] Other institutions outside London (such as the universities of Glasgow, East Anglia and Manchester) have galleries where material can be made available for classes at both undergraduate and graduate level. There are limited but worthwhile possibilities for voluntary work in many museums and galleries for students interested in careers in museums and prepared to devote a regular time each week or a part of the summer vacation to work experience (see, for example, some of the accounts of such work in Chapter 6). If you want to do this, a first step is usually to contact the curator responsible for whatever department you think you would like to work in. The students' group of the Association of Art Historians sometimes has information about 'intern' positions available in museums and galleries. They have an excellent website, and anyone intending to become an art historian should not only have a good look but consider joining the AAH students' group.[6]

Writing Art History is the common responsibility of all art historians. The research and documentation of paintings and other objects – as well as research into ideas about art and its functions, the examination of constellations of events such as exhibitions, or revolutions, or technical discoveries, and enquiries into audience responses and artistic creativity – take art historians into galleries, libraries, archives and a multitude of repositories of information about societies, past and present. It may take them also into the studios of artists, into film and television studios or into factories and stores. There is an orthodoxy that argues that the composition of catalogues, whether for special exhibitions or for permanent collections, provides the foundations upon which art-historical research, writing and teaching are based. This no

longer works very well, since many contemporary artists, and those who are less well known, have not (yet) received this accolade, and in any case the objects of art-historical study are so much more diverse than they were fifty years ago. While some art historians may concentrate on interpretation or reception rather than documentation, the act of identifying an object and writing about it (even if the objective is so-called recording of facts) is already interpretative. The idea of an infrastructure of empirical research and a super-structure of theory and interpretation is a falsification and results in a failure to recognize the difficult and complex relationship between an artefact and the meanings it generates.

A specialist in another discipline, somebody who asks questions and searches for answers quite independently of any job or organization or, most significantly, a practising artist may also be engaged in art-historical activity. The architectural historian needs to learn from the construction engineer or the bricklayer or welder the properties of different materials if he or she is going to look at the man-made environment as a totality, considering where it is, who uses it, and what is to be expected in the future rather than simply viewing it as an object or series of objects to be looked at. Similarly, the art historian must ask about colour and materials, whether it is ancient works of art or contemporary productions that are being addressed, bearing in mind that there is a history of pigment to be taken into account. The analysis of the pigments of old paintings is a highly specialized activity conducted in laboratory conditions and requiring considerable knowledge of chemistry, but art historians cannot afford to ignore in general the actual process of making the work of art. There are examples of this kind of work given in Chapter 4.

Frequently the only way is to try out the materials. If it is a question of why polystyrene sculpture has immediately recognizable characteristics, it is necessary to try working with that material. Similarly, there is no better way of appreciating the qualities of watercolour as a medium than actually painting with it. The purpose of the art historian in these enterprises will differ from that of the artist, because the primary concern will be not with creating art but with observing the behaviour of the materials from which the artwork is made.

The principle of learning from the artist applies not only to materials but also in some cases to subject matter. In painting, for example, the particular problems (whether visual or practical) experienced by the artist may sometimes be understood best by the art historian who is prepared humbly to put herself or himself in the artist's place. If the subject under discussion is Rembrandt's or Bonnard's depictions of children, the art historian will find it helpful to spend some time actually trying to draw children, because only

then is it possible to appreciate that children never stay still for more than a minute except when they are asleep (notice how many artists have drawn children asleep!) and that the proportions of a child's body in relation to its head are quite different from those of an adult. We may know this to be a fact, having read it in a book. It is only by trying to draw a child that we realize it.

If we are interested in the still-life paintings of Chardin or Matisse, it is well worthwhile ourselves trying to isolate or assemble a group of objects for a still life, moving round it, looking closely at it, working out how many different ways we might see it or how we could express our knowledge of the objects involved. A child, asked to draw a group of objects, looks at each one separately and draws each one independently. We may think that we are more advanced than this, but it is surprisingly difficult to see and understand the relationship of function, shape, size, colour and texture of a group of disparate objects.

Similarly, in thinking about landscape painting, it is a helpful exercise to sit down and try to draw or paint a view. The problems of organizing elements into a composition, as well as the difficulties created by curious passers-by, inquisitive cattle, the weather, and telegraph poles that do not fit into the rural idyll we were intending to depict, soon become apparent. What such exercises teach us is the constructed and artificial nature of all forms of representation, not least those that we tend to name as 'realist' or 'naturalist'. However, if we move away from Western landscape representations to think about, for example, the great landscape depictions produced in China over many centuries, we have to take into account quite different rules of engagement, cultural expectations and disciplines of drawing. As Craig Clunas has remarked of some of the long-hand scrolls produced in China in the fourteenth century, artists were advised to carry a brush with them to record strange rocks and trees they came across; however, this was not an advocacy for drawing from nature (such as we find in John Constable) but more a general principle.

> The special brush-strokes used in representing rocks and trees, called *cun* in Chinese, were by the fourteenth century one of the chief focuses of scholarly writing. There was an extensive technical vocabulary to describe their forms. They were often named after their putative discoverers; for example, wet horizontal dots of ink were called 'Mi dots' after Mi Fu, even though it is known they were being used in tomb mural painting as early as the seventh century CE.[7] (Figure 2.3)

Figure 2.3 Hua Yan (1682–1756), *Landscape in the Style of Mi Fu*, hanging scroll,
 ink on paper, 129.5 × 61.0cm, Qing dynasty (1644–1911), China, Art
 Gallery of New South Wales. Photo AGNSW/Christopher Snee.

There is no prescribed method for art historians, as will by now have
become clear. Like those in other disciplines, how the art historian works
depends very much upon the nature of the material addressed and the
questions posed as well as upon the method adopted. What we can do in
this chapter is to describe the resources most commonly used and indicate
the processes of research through which many art historians will go on
their way to communicating to us what we have come to know as Art
History. A diagram (Figure 2.4; and a series of questions) can help us with
this discussion, though the precise order in which the questions might be
posed needs to remain fairly open. My artwork, for the sake of clarity, is
a painting, but it could be a piece of sculpture, an oriental vase or a group
of objects, or a combination of the natural and the man-made, such as
Stonehenge or the Statue of Liberty. Or, indeed, it might be an event such

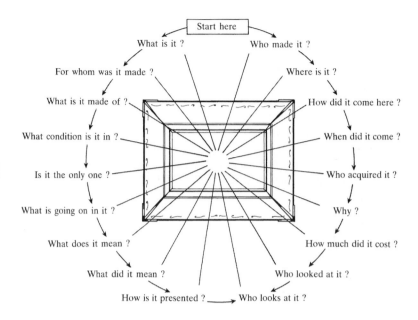

Figure 2.4 Interrogating the work of art

as the foundation of a national museum or a policy towards the arts, such as that of a local government in any given year. Clearly the kinds of question posed would vary according to the kind of object or event under discussion. My questions are based on the assumption that we are dealing with a post-medieval, Western painting; the schematic nature of this exercise conceals, of course, the complex relationships between different kinds of questions and does not indicate why these particular questions get asked, but I have tried to show how one kind of question may lead to another.

The painting as physical object

One of the first questions the art historian asks him- or herself is: 'What am I looking at?' This may seem to be stating the obvious, but it is surprisingly easy to forget that a luminous picture on a website, a colour reproduction or a projected power-point image is not the original work of

art. Clearly we cannot normally take an Indian miniature or a Van Gogh home with us, and we must take advantage of modern reproductive technology, but we should also be aware of the dangers inherent in using these materials.

Most art historians use photographs of some kind, even when the original work of art is to hand. Photographs are necessary for comparative purposes. We may want to compare our picture with others by the same artist or with similar works by other artists, and the only way we can do this, unless we happen to have access to a big exhibition, where we can see all the known works of the artist and lots of comparative works hung side by side (though remember even then that someone has chosen them to demonstrate his or her particular view of the artist), is to take along our photographs and hold them up alongside the painting. Or, we may want to set them alongside illustrations in books in a library in our search for visual connections. It sometimes happens that art historians find themselves trying to reconstruct the appearance of lost or destroyed works of art. In this case, photographs, engravings and any other sort of reproduction have a very special and important relevance to the study in hand. The quality of such reproductions – however high their resolution and however digitally sophisticated – should be borne in mind. Just try 'googling' the title of a famous painting such as 'Raphael Sistine Madonna' and go to the 'Images'. Notice the enormous range of different colours in reproductions of a single painting and observe how in some images the margins are cropped, so you might not realize that the famous pensive putti (cherubs) at the foot are actually leaning on a ledge or that the curtain hangs with rings from a cord rather than simply descending from above the picture space. Remember also that much of the information that appears on the internet is incorrect. Rely where possible on official museum and gallery sites if you need to find something out about a work of art. For the twentieth century, with its emphasis on technology, the definition of a work of art is an extraordinarily complicated matter. We can no longer talk in simple terms about 'originals' and 'reproductions', since many artists are themselves using those very methods of reproduction in their work. For this and for other reasons, some scholars avoid the use of the term 'work of art' altogether.

The materials from which a work of art is made are called the medium. It may seem a simple enough matter to decide what the medium of a picture is. In fact, questions of technique can be very complicated. Those concerned with conservation and restoration need a very detailed knowledge of materials and how they behave under certain conditions. What happens with the passage of time to medieval altarpieces painted on wood, when they are exposed

to damp or heat, and what happens to a contemporary work of art in mixed media (plastic, old rags, wire netting and acrylic paint, for example) are questions for the professional conservator. However, every art historian, student, teacher and researcher should be able to recognize the medium of the work of art. In the case of a painting, this includes not only the type of paint (oil, watercolour or gouache, acrylic, for example) but also the ground on which it is painted. The specialist art historian working in a more advanced field may, in some cases, require a knowledge of chemistry, an ability to read a technical treatise in Latin or Italian, and access to a good microscope and infra-red photographic equipment.

At the same time as he or she is considering the medium of the picture (to continue with my hypothetical example), the art historian will also be examining its condition. Paintings and other works of art have often suffered considerable damage through accident, neglect, over-painting or well-intentioned but brutal cleaning. Trying to decide how the painting looked when it was first executed requires judgement and intuition. If the picture in question is unfinished, it may be necessary to consider other works by the same artist which appear to relate closely to the painting in question and then to reach a conclusion based on reasonable speculation.

Photographs tend to create the impression that everything from the most enormous canvas by Gilbert & George to the smallest seventeenth-century miniature is the same size. It is, therefore, imperative that the art historian record the dimensions of the work under consideration. If it is a framed painting, the frame may be contemporary with the picture and may tell us something about the painting or the artist. The frame should not be ignored, but we must be clear whether the dimensions recorded are those of the work with or without frame, those of the paint area or those of the total canvas.

As for the frame, it sometimes happens that the artist has designed and made the frame to reflect and reinforce the statement of the painting. The Pre-Raphaelite artist William Holman Hunt arranged for the frames of many of his pictures to bear texts and emblematic designs that help the viewer to interpret the meaning of the picture. Even when we are dealing with an unframed recent painting (as, for example, with Mark Rothko), the closest scrutiny of the borders and edges is necessary in order to discover where and how the paint surface terminates.

In art galleries and sale catalogues we frequently come across the words 'attributed to' or 'school of' preceding the name of the artist. Providing answers to the questions 'Who painted the picture?' and 'When was it painted?' is probably the oldest and the most traditional occupation of the art historian. At one time, art historians made attributions exclusively on

grounds of style. It might be said, for example, that a drawing could not possibly be the work of Rubens because in all the other known Rubens drawings the feet of all the figures had enlarged big toes, or that a painting must be the work of Tintoretto because the trees were painted in the same manner as in all the other known pictures by this artist.

Today, with the wider application in all branches of the humanities of technology and the increased emphasis on the history in Art History, the pure study of style tends to be given less prominence. Everyone should be able to learn to see and recognize, but there has been in the past a tendency to surround the skill of looking and knowing with mystique. The important thing is not only to see but also to understand. A friend of mine once likened the connoisseur to an expert train-spotter who did not know how an electrified line worked, who the driver or passengers were or, indeed, where the trains came from or where they were going.

Stylistic analysis can blind a viewer to the broader understanding of a painting and can result in a failure to recognize the variety and complexity of expression and meaning within the work of any one artist. Nevertheless, we should still be ready to recognize the intuitive ability of the connoisseur, the person who has spent years becoming familiar with the characteristic and subtle differences between one artist's method of execution and another's and who is able to make an attribution by eye alone. Not a few works of art have been rescued from oblivion and even from the bonfire by the timely exercise of a connoisseur's skill.

Assuming we are able to say who executed our painting, the next question is 'When?' If the artist's studio or logbook survives, or if the painting was exhibited during the artist's lifetime, we may be able to say fairly definitely when it was painted. Otherwise we have to rely on whatever details concerning the artist's life are available in biographies, letters or critiques, printed or in manuscript. Comparing our picture with all known and dated works by the same artist (taking into account style, subject and technique) may also help us to decide when it was painted.

Our picture may be anonymous, or it may be associated with a group of painters rather than with an individual. In this case, the question 'Where?' is as important as the question 'When?' If it can be shown that the picture was painted in a particular place at a particular time (maybe it is inscribed 'Roma, 1790' or 'Munich, 1930'), and all the other evidence of subject, style and technique points to a master working in that particular place at that particular time, the argument may be strong enough for us to use that label 'attributed to'.

As a document, the painting may not only provide us with information about the overall development of the artist but also tell us about the age in which it was painted. The critical response to a work of art is part of its

history and, therefore, we want to know how the painting was received by those who saw it at the time it was executed and how it has been regarded by people ever since. The wider the range of opinion we consult the better: the patron, the critic, other artists, friends, relatives. Perhaps it was painted in an age from which few records have survived. Nevertheless, by reconstructing the circumstances and the social milieu in which it was created, the painting can be of inestimable value and interest as a document and, most importantly, we can begin to understand how beliefs and attitudes are not merely reflected in pictures but are constructed and disseminated in imagery.

The painting as text and its consumption

I have called the painting a text here not because I think it is the same as a piece of writing but in order to indicate that it may be interrogated or questioned for meanings. Some of these will be self-evident (this is an image of a house or a horse) and some will be located only by drawing out sets of associations (the house may be more of a castle than a cottage and suggest a relationship of power, as in Rubens's *Landscape with the Castle of Het Steen* (Figure 2.5), which shows his own grand house). Furthermore, by calling the painting a text we are indicating that not everything can be explained by reference to marks on a surface; we are avoiding the presumptions attached to the word 'painting'. These might be things such things as colour, brushes and oil or acrylic, a particular surface, something valuable – all of which will also be relevant. This separation is by way of a useful manoeuvre rather than a judgement, since we know that how something is painted is part of the way we recognize it. However, here the emphasis is on making it possible to recognize that the meanings of the painting will be determined by where, how and by whom it is consumed. This word, 'consumer', similarly, is associated more with food and luxury goods than with paintings and helps us to focus on viewers and patrons rather than artists. For the sake of argument, let's propose this painting viewed by a group of EU farmers, a Belgian who has emigrated to the deserts of Arizona, an ecologist with an interest in history, and an expert in the mathematics of perspective. Each of these individuals would perceive a different set of meanings in this painting. Imagine the painting exhibited not in the National Gallery, London, where it now hangs, but in a deprived inner-city ghetto in Chicago, in a millionaire's castle in Liechtenstein, or as part of a travelling exhibition in Mexico City. Think of it hung in a room all on its own; think of it hung in a sequence of landscapes by Rubens; or think of it hung as part of a collection of images that feature artists' houses.

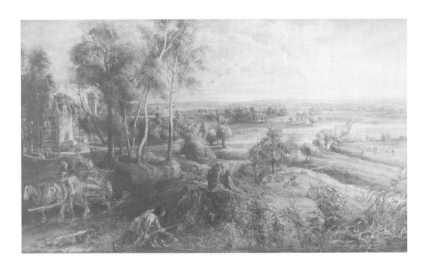

Figure 2.5 Peter Paul Rubens, *Landscape with the Castle of Het Steen*, reproduced
by courtesy of the Trustees, The National Gallery, London.

We are dealing here with a figurative image – that is to say, it represents
something we recognize from the world around us. So our analysis will
concentrate on what the various parts of the painting seem to convey via
this imagery. If the painting is non-figurative or abstract, we would be
discussing it in terms of the visual and sense-arousing qualities of pigment
and colour as well as in relation to shapes and forms which relate one
to another and which produce for viewers sets of associations, whether
material or immaterial. A figurative image is therefore a painterly sign that
corresponds to something we recognize or have an idea about. One way
of defining this is to say it is 'indexical' – that is, the representation cor-
responds to the 'real thing'. A group of images – say, houses, colonnades,
a child, a dog – constitute an original visual language when placed side
by side or in combination. Discussion of the painting may refer to this as
the field of vision, to distinguish it from a frame of reference outside the
painting. In order to point out the fact that the image *represents*, rather than
reflects, the seen world, the thing or things depicted may be termed 'the
referent' of the image. Discussion of the painting as text is thus a way of
analysing these signs in order more fully to comprehend the idea or ideas
communicated. Understanding how and why they function as they do is as
important as locating any given meanings. In other words, examining the

painting as text is at one level studying how ideas are encoded. At another and interconnected level, it is studying how these codes are 'read' by consumers of imagery in different conditions, places and times.

Dutch seventeenth-century paintings have long been enjoyed and admired for the apparently clear and precise way they allow us to enter into the domestic world of the Netherlands in the seventeenth century. Such pictures can be taken as stories in paint. The girl with the beautiful profile who reads a letter – who is it from? A serene middle-aged woman is washing dishes in a back kitchen, while through the door we see a tempting vista along paved passageways into cool interiors or airy courtyards, inviting us into the world of the picture. At the same time, we may, without being very consciously aware of the world that the artist is describing, find ourselves immersed in contemplation of the fold of a dress, the gleam of polished tile juxtaposed with the rough texture of earthenware, or the way in which the artist has used various shades of red and gold in different parts of his painting. These qualities are in no way disconnected from the 'story' of the painting. Indeed, the 'story' is told through them, but it is sometimes enriching to appreciate the making of the image without deliberate reference to its meaning. In that way we can concentrate our attention and reduce distractions.

There is, however, another equally important aspect to the painting as text. This concerns the meanings that the painting produced for audiences at the time it was executed, meanings which may have been occluded or obscured by popular or erudite readings of the image by subsequent generations. Paintings are not puzzles to be solved, and in a sense nothing is 'hidden', because the evidence is always available if the appropriate modes of enquiry are brought into play. But we may not notice or be aware of the importance of a text or of the way in which we apprehend it until someone has pointed it out.

To continue with our previous example, many of the Dutch paintings to which we have already referred are, it is now realized, far more than mere mirror reflections of everyday life in the Netherlands of the seventeenth-century. They may or they may not be that – some very strict comparisons have to be made before even that point is convincing, since we have no photographic record and not a great deal of reliable documentary evidence about what Dutch seventeenth-century interiors actually looked like. But, in any case, if we compare the images in some of these pictures with the appearance of objects or groups of objects in contemporary literary works, we find that they have very particular meanings.

A mirror may be depicted in a room because the artist actually saw it there. We cannot be sure about this unless he has left a precise account of how he painted the picture or unless someone else who knew him well and saw him painting has left a record. Equally, he may have introduced a mirror

into the room because he wanted to show us what was at the other end of the room, or he wished to offer an alternative view of a figure, or because he enjoyed the variation in colour values offered by the objects in the room reflected in glass, or because he was interested in a virtuoso display of his own dexterity in being able to paint reverse images.

There may also be a further reason why the artist introduced a mirror. In the seventeenth century a mirror was a sign of vanity, a worldly attribute. We know that mirrors possessed meaning in the period because whole books were published containing precise instructions about this sort of sign language and telling writers and artists the meaning of certain images in conjunction with others. So the presence of a mirror in the room may be an important clue to how the subject of the painting should be interpreted on a moral level.

If the painting we are discussing is a non-figurative work – that is to say, an abstract work – then our approach will vary slightly. We are still concerned with the way separate parts of the painting work independently and as a whole, but we are not looking for any story to be told or any explicit instructive meaning in the picture. This is not to say that the picture does not convey ideas or that it is not instructive. Simply, in an abstract painting the images are not descriptive. They may convey to us qualities such as, perhaps, brutal strength or determination of purpose or waywardness or acquiescence. They may equally well, however, have no such 'meaningfulness' and operate in relation to the viewer purely through a language of shape, line and colour. The very absence of recognizable features from the familiar external world often makes this experience all the more powerful.

Life is never simple, however, and many paintings are neither wholly representational nor wholly abstract but a combination of the two. At all events, what is most important is for us to remain alert to what the image, or the shape of the brush-stroke, or the piece of paper stuck on the canvas contributes to the whole. To use a common expression, we need to decide how it *works*. To do this we need also to have some method for understanding how we respond over and above the simple 'I like it' or 'I don't like it'. Thinking about ways of doing this is to tackle methodology – the systematic and self-aware employment of method.

The painting as possession

The idea of the artist as an eccentric genius living in isolation in a garret and painting masterpieces which are not bought by anyone and, finally, dying of starvation or tuberculosis is, for the most part, far from the truth. There has always been a strong element of fantasy and fiction in narratives of artists' lives; it is as though societies invest in the idea of unfettered creativity, making the marginalized artist a repository for the irrational which cannot

be tolerated at the centre of society. These constructions – which have been analysed extensively through biography and film as well as in novels and plays – also set up a model of sexual difference which leaves little or no place for the woman artist, although, as we now know, there have been many female practitioners in the past and there are certainly a huge number in the present. The artist is the creator and the woman is his model and/or his muse in such accounts. This is one clear illustration of how the 'facts' of a person's life come to us already mediated and interpreted.

This is not to dismiss the idea of exceptional creativity or to deny that there have, indeed, been many artists who lived out their working lives in hardship largely unrecognized. It is merely to draw attention to the need to identify the mythologies to which the personalities of artists are central. Most artists painted pictures for people. Some commanded very high prices for their work during their lifetimes and some – Rubens, for example – led extraordinarily interesting lives in the midst of political intrigue, continental travel and court diplomacy.

The history of the painting is not only the state of the canvas (or of whatever it is made from) and all the other things we have talked about but also its physical history as a piece of property. As soon as we ask for whom it was painted we become involved in the question of patronage, finance and commerce. We need to know where the painting has been for all the years since it was executed, partly in order to be sure that it is the painting we think it is (this is especially true in the case of authenticating lost works of art) and partly because one of the responsibilities of the art historian is to chart the history of taste and consumption and try to account for that history.

Works of art represent capital investment as well as visual pleasure or nostalgic record. They circulate in markets according to the laws of supply and demand, and as a consequence of fluctuations caused by war, invasion, economic changes in family fortunes, religious controversy, fiscal laws, family feuds and myriad other reasons. The usual way in which contemporary artists sell their work is through a representative who normally has sole rights. When Damien Hirst bypassed his gallery and auctioned his works at Sotheby's in 2008 he raised a record £111 million, which led to his being described as an astute businessman. But the phenomenon of artists as businessmen is not new; Anthony Van Dyck in the seventeenth century and Sir Edwin Landseer and Sir John Everett Millais in the nineteenth were similarly astute in managing markets for art. What we can be sure of is that the aesthetic quality of the work (something which is not historically fixed) will only ever be one part of the reason works of art are bought and sold. Paintings are purchased (by pension funds, for example) and disposed of, transported across continents, used for purposes for which they were not originally intended (held as bargaining chips by criminals), lost and found again. There are also notable examples of paintings that have remained in

the same place and have passed down from generation to generation. For the most part, however, tracing the original owner of a painting (it may have been commissioned or it may have been chosen from an artist's atelier) involves determined detective work on the part of the art historian.

We may need to consult manuscripts such as the artist's account book, his letters, or contemporary documents relating to his life. We may also turn to the putative owner and find our hypothesis confirmed by the discovery that he kept a record of the commission and the purchase, which is extant in a county record office or in his family's archives. If the canvas has not been relined and is still in its original state (that is, without having been cut down in size), it may help to look at the back of the painting to see if there are labels from dealers or exhibitions or inscriptions of any kind. Sale catalogues from long-established auctioneers and dealers such as Christie's or Agnew's, especially if someone at the time of the sale bothered to make notes in the margin, will furnish us, if we are lucky, with information about the fortunes of our picture through the years. The prices that pictures have fetched in the past indicate to us the relative popularity of the artist or his or her work at any one time.

It is sometimes possible for researchers to consult dealers' stock books to find out about legal owners and purchasers. Old exhibition catalogues, wills and other legal documents as well as older art-historical essays can be very informative, but great care is needed in conducting these searches, for any one painting may have been attributed to a dozen different artists in the space of a hundred years. There were, for example, an astonishing number of works by 'Raphael' and 'Mantegna' sold in London during the nineteenth century.

It is not only the artist but also the titles of paintings that change with time. People tend to give a painting in their possession the sort of title which suggests how they feel about the picture. Critics and writers often assist in this process of accretion. Thus, for example, the picture which John Constable painted and exhibited as *Landscape: Noon* is now known by everyone as *The Hay Wain*. Such changes of title are inconvenient when one is trying to trace a painting, but they can also be extremely instructive in so far as they point to the way in which people have responded to the picture in the past. Clearly, the hay wain which is crossing the pond in the foreground of Constable's picture – that is, the narrative part of the picture – rather than the landscape which is a much larger part of the canvas was what attracted people's attention.

The artist may have painted the picture for her- or himself without regard to any patron, but it is usually the case that works of art are, to some extent, the result of a relationship between the artist and other people. It may be the general public for whom the artist is deliberately painting, it may be a particular social or political group, it may be the jury of some competitive enterprise or it may be a private individual. In all cases the relationship of

the artist with his or her proposed audience is profoundly important both for what it tells us of the period itself and for what it tells us of the painting. It is, of course, very difficult for us to know who the artist thought of as an audience and whether he or she even thought of it at all. The medieval artist painting a mural in a church may have believed it to be his task to communicate with a great variety of people, most of them illiterate, with a range of capacity for response. He may, however, have thought of the clergy or God as his audience. Illiteracy itself may have ensured a value placed upon oral communication unknown in our own day. Thus the conditions of viewing anything in the Middle Ages must be not only taken into account but penetrated by historical enquiry.

If the artist is painting for a particular social or political group, his or her work may have elements of propaganda, and we must be very sure that we understand what we are looking at. We can adequately understand the profound revulsion expressed in the graphic work executed by the German artist Käthe Kollwitz only in terms of the audience she hoped to arouse in Germany in the 1930s.

In the eighteenth and nineteenth centuries, when the academies had immense influence and prestige, many artists painted in a way that they knew would be favourably regarded by those judging their pictures and deciding whether they should be shown in what was virtually the only public exhibition of the year. Individual critics such as Diderot in France in the eighteenth century or Clement Greenberg in America in the twentieth might be said to have exerted a powerful influence on the way their generation strove to express ideas in visual form.

If the patron is a private individual, questions of human relationship as well as questions of finance will occupy us. Certainly there have been extraordinary cases of patrons who have simply bought up what the artist produced without discussion or question and have thus provided consistent and invaluable material support. The French colour merchant Père Tanguy, who acquired so many Impressionist canvases in the second half of the nineteenth century in exchange for paint, often rescuing Pissarro and his friends from near starvation, seems to have done exactly that. At the other extreme, however, are the insistent and demanding patrons with a clear idea of what they want who will continue to nag until they get it. Patronage clearly carries for the artist both constraints and advantages. The art historian collects the evidence and endeavours to gain a true picture of the situation.

The History of Art embraces such an enormous range of different aspects of our visual environment that it would be impossible to describe in one chapter how all art historians work. We have posed a series of questions about

a hypothetical work of art in order to demonstrate some of the ways in which scholars work. The discussion has been limited because Art History in many of its facets challenges the very relationship between artist and object produced that is posited in much art-historical writing and which forms the basis of this exposition. To what extent, if at all, the artist's intentions are relevant to an art-historical enquiry is open to debate. For some it is the *how* of communication rather than the *what* that matters. Nevertheless, the kinds of procedure described here are those that are still commonly met with, and, in one way or another, they underlie even the most provocative and innovative challenges to the discipline.

So it would now be helpful to remind ourselves that most Art History is not conducted with one object alone, though sometimes a case-study of an individual work of art is worthwhile and helpful. Art is not created in a vacuum, and most valuable art-historical studies are to a greater or lesser extent comparative. This does not mean necessarily that art historians are always comparing objects from different periods of time in order to demonstrate some kind of development. An art historian may start the other way round, by looking at something late and moving back from that to examine precedents or connections. Equally valuable may be a discussion that is based on theme or subject regardless of historical concurrence or chronological development. While one art historian might be concerned with a study of the development of Fernand Léger's art in the early years of the twentieth century, another might take the subject of one of his paintings, *The Card Players*, and consider what card players meant to Léger, what they meant to Cézanne and what they meant to the seventeenth-century French artist Matthieu Le Nain. Similarly, one art historian's work might be concerned with the methods used by Robert Motherwell (1915–1991), while his colleague's work might be on the significance through the ages of black paintings in the Western tradition.

Art historians often talk about movements. At worst, the term 'movement' in Art History is simply a lazy way of avoiding serious consideration of individual artists or of historical events. To say that Théodore Géricault was a part of 'the Romantic movement' is to place him in the nineteenth century with an amorphous mass of artists, writers and musicians generally believed to have subscribed to a vague artistic philosophy based on individuality and nature. This sort of art-historical Happy Families is not very helpful. On the other hand, the art historian is bound to ask questions about why and how one person, one group of people, one event or one work of art provokes reactions which might be classed as artistic, political or social but which will, in all probability, be all three. Here, the art historian will be exploring a 'movement'. Why Cubism should have evolved at a particular moment is a question which exercises the art historian and necessitates considering not merely one or even a series of works of art but many events, both national and individual, and many artefacts, books, poems, paintings and sculptures.

The art historian who is interested in Cubism as a visual and historical phenomenon will need to become immersed in the period of time when this movement took place. Anything and everything will be important: the day and even the hour when Picasso met Braque, the materials they bought, found, made and used, who their friends and acquaintances were, the places they visited and the books they read. It would be impossible to prescribe a single method for all Art History. Each scholar has to formulate his or her own questions and find means of answering them according to the needs of the subject being researched. A couple of examples may help to illustrate the point.

The art historian who chose to make a detailed examination of sculptures of the heads of open-eyed Hindi deities from the sixteenth century would be missing a large part of the special character of these works unless they asked questions about not only the appearance of the objects but also their context. They would expect to know where they were placed in a temple or in a household shrine and how they were adorned with garlands and jewellery, used in a procession, offered food and honoured in religious rites. We can easily ask what we think are purely academic questions about such sculptures of gods, goddesses and spirit figures because they are remote in time and, perhaps, to many, in belief and function. We need to have an awareness of the meanings of these statues as living presences for believers. And from here we need to ask ourselves why these qualities are of particular interest (whether acknowledged or not) to scholars and audiences at the present time.

Many basic books about art speak of 'movements' (such as Cubism). Students of Art History may find themselves encountering a challenge to the very idea of a movement. At a theoretical level the question of identifying and naming may be the stimulus to enquiry. It has been argued, for example, that powerful forces at work in our interpretation of historical change lead us to attribute importance to certain individual figures at the expense of groups and, furthermore, that as human subjects we require father figures to lend legitimacy to our accounts of human productivity. History, it is argued, is not continuity but fragmentation and discontinuity. Dependent as everyone is on language, we are perpetually looking for certainties when there can be only a variety of uncertainties. In the past three decades, the clarity and forward-looking confidence of the early twentieth century has given way to a preoccupation with fragmentation, the break-up of order and the rupture of certainties. While there remain pockets within the discipline of Art History where the task is understood to be to resist all change, the more enlightened aspects of art-historical activity have responded to these global changes in possible ways of viewing the world.

The traditional methods of art-historical study derive from the accumulated cultural experience of the past, but they are overly influenced by the narrowly defined parameters of Western art, privileging oil painting over drawing, flat surfaces over three-dimensional objects and fine art over material culture. These methods remain the bedrock of what most students will encounter in their studies, and they are surprisingly resilient and adaptable. But, as art historians have taken on board globalization (albeit at times reluctantly), the objects of their study have shifted and their methods have adapted to accommodate this. Pattern and ornament were seen as decorative and therefore inferior but, for example, a recognition of Islamic art's beauty and special capacity to communicate meanings across different levels (pattern and script working together) or the acceptance of Aboriginal bark painting (Figure 2.6), with its intense and total coverage, have radically altered our concept both of the objects we study and of how we study them. This is good – a healthy discipline is constantly reassessing and evolving. Moreover, charities and philanthropic organizations increasingly orientate their giving towards areas perceived as having been neglected. The Getty Foundation (described by a friend of mine as

Figure 2.6 Unknown artist, untitled painting, natural earth pigments on eucalyptus bark, *ca.* 1956, National Gallery of Australia, Canberra. Reproduced by permission of the National Gallery of Australia.

like the World Bank for Art History) has recently focused on 'Art History as a global discipline' and has funded initiatives in Latin America and South-East Asia. The art historian, like the scholar in any other discipline, has constantly to examine his or her position in relation to the past and in relation to his or her own identity and identification. It is necessary to ask why this particular work has been selected for study in this particular way and to think constantly of new methods and combinations of methods for investigation.

Notes

1 Research Excellence Framework is administered by the Higher Education Funding Council (www.ref.ac.uk); teaching quality is the responsibility of the Quality Assurance Agency (www.qaa.ac.uk).
2 Letter to the Russell Group from the AAH and signed by thirty-seven senior art historians, 27 April 2013.
3 London *Evening Standard*, 15 May 2013, p. 26.
4 www.npg.si.edu/education/exhibitresource.html.
5 www.londonconsortium.com/.
6 www.aah.org.uk/.
7 Craig Clunas, *Art in China* (Oxford: Oxford University Press, 1997), pp. 150–51.

3 Art History as a discipline

In the following pages I shall try, without smoothing over the differences and complexities, to build on the points made in the previous chapter by introducing readers in greater detail to some of the different methods and approaches currently practised by art historians. In this book, 'Art History' is the term employed to denote the discipline that examines the history of art and artefacts. So History of Art is what is studied and Art History is the cluster of means by which it is studied. To complicate matters, those who want to be precise about their use of language – recognizing that the words and phrases we use are not neutral and suggest the relative importance and values we attach to the things of which we speak – talk not of History of Art but of histories of art. Losing the capital letters and replacing the singular by the plural thus enables writers or speakers to distance themselves from the notion that there is, by something like a process of natural selection, one unquestioned and universally accepted view of what constitutes history. Whose history, and art by whose definitions? These would be the kinds of questions posed to challenge magisterial accounts such as Sir Ernst Gombrich's *The Story of Art.* First published in 1950, Gombrich's best-seller was relaunched in 1995 with a cover (which all subsequent reprintings have retained) replicating a stone tablet on which the author's name and the title appear as incised letters, an effect calculated to suggest the authority of Old Testament law. This marketing strategy plays on the idea of a singular authority; it is precisely this notion, along with the idea that art has one easily accessible story to tell, that is challenged in works with titles such as *Women, Art, and Society* by Whitney Chadwick (published in 1990 and revised in 1996) or *Painting for Money: The Visual Arts and the Public Sphere in Eighteenth-Century England* by David Solkin (published in 1993).

Art History is concerned with no single class of objects. As we have established, every 'man-made' structure and artefact, from furniture and ceramics to buildings and paintings, from photography and book illustrations to textiles and teapots, comes within the province of the art historian,

though traditionally Art History in educational institutions has concen-
trated on the trio of painting, sculpture and architecture that goes back to
Renaissance writers such as Alberti and Vasari. Similarly there is no one
identifiable Art History; individuals and groups of scholars develop inter-
ests, and methods to pursue the questions raised by those interests, that are
often fiercely oppositional. Approaches to the documentation, analysis and
evaluation of visual material, as with any other form of human production –
music, literature, politics, agriculture – can be very disparate.

There is, for example, a mode of enquiry that has as its premise a view of
cultural history or communications in which the particular objects studied –
paintings included – are examined as commodities within a system. The impor-
tant thing here is to understand the system and how it works, not merely in
terms of how it is organized but also in terms of the symbolic values it gener-
ates. Such an analysis is fundamentally concerned with power, with control and
with economics. Thus, for instance, the art auction might be an object of study
not for the individual items that are being sold there but for what we can learn
about the transaction and exchange of values in Western society. Money is spent
at auction, but what is purchased has a value and a symbolic meaning within a
political economy that extends beyond economic and monetary value. Why do
people buy old things? When Andrew Lloyd Webber, millionaire composer of
musicals, 'saved' a view of London by the eighteenth-century artist Canaletto,
a painting destined for export, what exactly did he get with his money, and on
behalf of whom was the purchase made? What status do acquisitions offer the
people who buy them? What rules are followed? What rituals are practised?
And what social and class boundaries are crossed through the acquisition of
objects? The collecting of Fabergé eggs by the millionaire American newspaper
tycoon Malcolm Forbes might, in this sort of study, be understood to accumu-
late meaning from the fact that such luxury products of the celebrated
St Petersburg goldsmith working in the early years of the twentieth century are
associated with the tsar of Russia, one of the world's great hereditary rulers.
Abbot Suger of Saint-Denis in Paris in the middle of the twelfth century left
a detailed account of the vast expenditure lavished on the abbey church in his
care. It is possible to read this account (and the letters to him from St Bernard,
who disapproved of lavish display by the clergy) as a discourse upon conspicu-
ous consumption and asceticism in a feudal Roman Catholic society.

On the other hand, maintaining the traditional concerns of the discipline
(concentrated increasingly in museums or in reviewing for newspapers and
magazines) are art historians for whom not only is the object or artefact of prime
importance but that the object offers up its own answers. These art historians
work on the assumption that paintings and other works of art 'speak' directly
to us as viewers, that our access to them is unmediated by the historical and
social positioning of ourselves as viewing subjects. By responding to purely visual

characteristics (form, colour, composition, brushwork) we may, is the implied assumption, gain access to the essential genius of the artist and thence to an understanding of the summary characteristics (the 'tendency') of an artist, a school or a whole period. This approach is particularly favoured by those who present themselves as experts with a quasi-religious capacity to mediate the art for us, whether in the popular press or on radio. Here, for example, is a passage discussing two paintings from a review of an exhibition entitled 'Becoming Picasso: Paris 1901' at the Courtauld Gallery, London:

> The apotheosis, The Burial of Casagemas and his translation to a heavenly brothel, is easily taken for a deplorably crude and clumsy joke mimicking the ancestral Renaissance formula of holy ascensions and assumptions, its various zones ill-fitting, its drawing coarse, the brushwork slapdash, interesting only in that its compilation of ideas for mourners offers a foretaste of so many figures in later paintings of the Blue Period. The portrait, on the other hand, is overwhelmingly imbued with feeling, the extraordinary profile affectionately recalled in heavy outline, the bullet wound in the temple conspicuously omitted to maintain the memory, the shroud a mass of flickering brushstrokes, blue and white; here art does indeed emanate from pain and sadness.[1]

In this passage two works of a completely different kind by the same artist are set alongside each other, the first to be dismissed because it fails in the author's eyes to live up to what he identifies as an earlier precedent (Renaissance religious art). Its only value therefore is for some discernible signs in it of what is to come later from the hand of the artist. This teleological critique is then used to bolster a work in a different genre. All this is according to a twenty-first-century critic who offers these views as truth and not as opinion. There is no reference to anything outside of the cultural objects discussed, which are thus linked together in a continual chain of circular reference with the sensibility of the writer authorizing the interpretation. I shall deal with the different ways that art historians write about art in much more detail in Chapter 4.

 The issue of quality is of immense importance in this kind of art-historical practice (is this a 'good' Cézanne or a 'less good' Cézanne?), which works on the assumption that there is an agreed scale of values that operates universally and across time. The aesthetic experience (the personal emotional response to the artwork) is an important starting point, though tracing the history of the object, and thus establishing its authenticity, is equally necessary. It might be a painting, a bronze figurine, a drawing or another kind of artefact. As this kind of enquiry is essentially object-based, the art auction and dealer's premises in this instance provide the means of an analysis of individual items. They are

not of interest as phenomena in themselves. Thus an art historian practising in this particular way would locate in an auction, or with a dealer, a work which may have been 'lost' – may have disappeared from public view for several generations. Supposing it was, say, a painting by Rubens, it would be possible then to slot this into the pattern of Rubens's lifetime's work (his oeuvre is what it would probably be called by art historians) like a missing piece in a jigsaw puzzle. Filling the gap might change how the surrounding bits look, or it might raise questions about bits which looked all right before. This slotting of a work of art into its proper place in time, in the context of the corpus (body of work) of the artist who made it and in the context of the world in which it was made, has been described as typically the first job of the art historian.[2]

Object-based art history does not have to preclude a consideration of function (whether practical use or symbolic purpose) but in actuality it does. Moreover, it tends to be in contradistinction to the approach that, evolving in the late 1970s in response to major rethinking in the human sciences, was sometimes called 'New Art History'. The notion that there is one group of people finding out the facts about objects (often people based in museums) and another group of people dependent on this work and producing interpretations has been well and truly challenged in the last three decades. It has been argued that the conceptualization of 'facts' and the decision about what questions to ask of an object are also matters of interpretation. The notion of academic objectivity has been doubted by many art historians, who acknowledge that reading paintings (the term is significant because it recognizes that the viewer plays a part in interpretation and that any form of representation may be seen as a text to be 'read') involves multiple meanings which will be to an extent determined by the constitution and environment of the individual doing the reading. An interpretation of imagery in these accounts necessitates not only ranging widely but also bringing to bear concepts such as 'memory' that are non-quantifiable. These are brought into play to build bridges between the scrupulously observed empirical data that can be extrapolated from a composition and the meanings of the image that are irreducible to that data. In other words, representation is never taken to be a straightforward matter. At the same time, the motifs are understood to be informed by the artist's own individual history. Here, for instance, is a complex (but accessible if read carefully) passage analysing a self-portrait painted in 1553 by Maerten van Heemskerck having a view of the Colosseum in the background taking up half the picture space (to give it a basic descriptive title), an image that we might at first glance take to be a kind of unproblematic sixteenth-century tourist portrait (Figure 3.1):

> The Colosseum in Van Heemskerck's work constitutes the definitive, justifying exemplum of the elite artist. It is, if you like, his Holy Sepulchre, a building in which death and immortality are inextricably

combined [this is a reference to an earlier work by the same artist]. Although the artist 'in the present' is separated from this hallowed edifice (as if he were a viewer in front of a picture), the alter ego drawing in the presence of the monument suggests that it remains accessible to a self distant in time and space through memory and representation. This is emphasized by the *cartellino* [the little paper seemingly stuck to the front of the picture] which, inscribed with the artist's name, age and the date, repeats in its essentials the texts beneath Jerusalem pilgrim portraits. In Van Heemskerck's painting, the body of the portrayed painter slightly overlaps this *cartellino*, establishing both a distinction and a connection between the two visual experiences: the present portrait and the memory of Rome. Yet the depicted text, seemingly projecting forwards from the surface of the 'memory' to which it is pinned, transcends the difference between past and present: the age and date refer not to the artist's visit to Rome in the 1530s but to the creation of the painting in 1553. These penned words, juxtaposed to the artist's pen drawing as an instance of *disegno* [invention], invite the viewer ... to recognize the continued authentic presence of Rome, ancient and modern, almost two decades after the artist had returned home to his native Netherlands.[3]

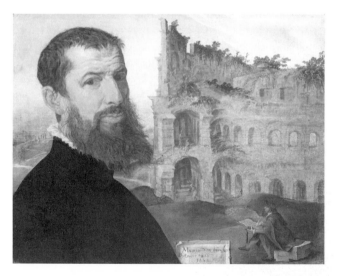

Figure 3.1 Maerten van Heemskerk, *Self-Portrait with the Colosseum, Rome*, oil on wood, 1553, Fitzwilliam Museum, Cambridge. Reproduction by permission of the Syndics of The Fitzwilliam Museum, Cambridge. © The Fitzwilliam Museum, Cambridge/Bridgeman Art Library.

There is much overlap and interrelated activity among different art-historical practices, and the examples I have given are intended only to suggest different types of engagement. The discussion that goes on between different areas is itself a part of the attempt to define and redefine ways of dealing with visual communication. The traditional art historian's concern with quality, the implicit belief that some things are better than others, is constantly a matter of debate. Few would argue that a sculpture by Bernini has more capacity to delight the viewer with a range of sensations and interests than a Barbie doll. But that does not mean that the role of the doll in the formation of American ideas of childhood, femininity and masculinity in the 1960s is less worthy of investigation than Bernini's relationship with the Barberini family in Rome in the seventeenth century. What is more difficult is the argument about whether a photograph by Robert Mapplethorpe, with its calculated effects of dark and light and its challenge to expected notions of how the human body is represented for social consumption, is a quality work whereas a pin-up from a pornographic magazine is not. The question is: who decides whether something is good or not, on what criteria are such judgements based, and to what uses are the judgements put?

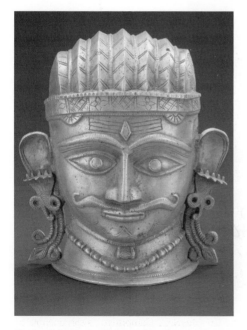

Figure 3.2 Mask of Khandoba, eighteenth century, Peabody Essex Museum, Salem, MA.

Authenticity is an issue that, at a general level, distinguishes Art History from comparable disciplines such as English Literature. Certainly some poems are anonymous, particularly works from earlier periods, but by and large we know who produced what, which is more than can be said for many visual works of art. The very term 'art' is anachronistic when applied to works produced in certain periods and cultures when the concept of 'art' as we know it today did not exist. For this reason, some historians of medieval and non-Western art prefer to use the terms 'visual culture' or 'material culture'. The devotional metal mask of the Hindu god Khandoba (Figure 3.2) had a specific function in processions and pilgrimages. When Gislebertus signed his name on the portal of the great cathedral of Autun in France under the marvellous carvings executed there in the twelfth century (Figure 3.3) this was a most unusual act, a turning point in the history of art. The identity of the artist became a matter of increasing interest in Western culture, so much so that the signature has become invested with almost magical powers; it is understood to guarantee the reality of the artist as a person, and it stands as a defining mark which ensures a market value. It also ensures, of course, that an artwork is open to imitation or even to copying with the intention to deceive – that is, to fake.

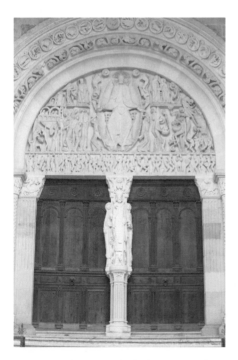

Figure 3.3 Autun Cathedral, France, the tympanum of the great west door. 'Gislebertus hoc fecit' is carved under the feet of Christ. Photo: Conway Library, Courtauld Institute of Art/Getty Images.

As a result of workshop practice (from the Renaissance to the nine-teenth century, Western artists worked in groups around a master) it is often difficult to distinguish who was responsible for what. Even when, in more recent times, the status of artists and sculptors became more elevated, and they were gradually regarded less as artisans and more as specially gifted and respected members of society, many artists have pre-ferred not to sign their works. David Hockney has challenged the very notion that originality and authenticity lie in the work of art as unique object by enthusiastically embracing first the fax and then the iPad as a means of making art. Sometimes, for legitimate as well as dishonest reasons, later generations have added signatures to works of art which can be very misleading to scholars and dealers alike. There have also been many cases of misattribution; some of the work of the seventeenth-century Italian artist Artemesia Gentileschi, for example, was until quite recently attributed to her father.

It is certainly true that students of English Literature will at some stage con-front bibliographical problems: the mistakes made by printers, the variations on a single line which appear in manuscripts or proofs of poetry, the emendations of editors through the ages, the piecing together of incomplete documents, and so on. There is great uncertainty among scholars as to which is the 'original' text of Shakespeare's plays. But grappling with these problems is a highly special-ized procedure, and most teaching of English at sixth-form and undergraduate level assumes a permanent body of literature by known authors that can be read and enjoyed and analysed. The question of authenticity is, however, of major importance to art historians and necessitates modes of enquiry that have little relevance to studies in literature. It is of importance even when, or espe-cially when, it is being presented as unimportant (as, for example, with Marcel Duchamp's notoriously exhibited urinal of 1917, entitled *Fountain*).

It is because traditionally one of the characteristics of the visual work of art has been its uniqueness that art historians are sometimes preoccupied as much with locating and authenticating as with interpreting. It is mainly in connec-tion with painting and sculpture that technology plays an important role. The examination of paintings through infra-red photography, the process (known as dendochronology) through which the age of a wood panel can be assessed by counting the rings on the wood, and many other technological and scientific processes are used in the search to identify and accurately to date works of art. Contemporary art, as I have just pointed out in relation to David Hockney, is often involved in challenging these assumptions. Ideas of time, decay and natural (as opposed to artistic) processes are, on the other hand, the very things which are explored in the installations of the German artist Joseph Beuys, whose work with animal corpses and other natural material sealed into glass containers incorporated built-in possibilities of physical change, or in Damien Hirst's (in)famous *The Physical Impossibility of Death in the Mind of Someone*

Living (1991), in which a shark floating in formaldehyde solution was placed in a steel glass panelled case (Saatchi Collection).

The apparent uniqueness of many works of visual art is something that has often been seen, therefore, as setting Art History apart from its fellow and interdependent disciplines. The student of English may feel a thrill of excitement on first reading a play by Samuel Beckett and may be moved to go and read Beckett's other work, just as the student of History of Art who is stirred by the sight of Titian's *Bacchus and Ariadne* may seek out other paintings by the same artist. The student of English may not immediately and conveniently be able to attend a performance of *Waiting for Godot*, but the text of this, and Beckett's other work, will be readily and cheaply available to her or him through any good bookshop. If our interest is with paint applied to canvas, photographic imagery downloaded or found in books can provide at best a very inadequate substitute. It is likely that other works by Titian will be scattered in collections around the world. However, while Beckett's *Waiting for Godot* will never be lost, natural disasters, armed conflict, ideological zeal and indifference to the consequences of industrial development can result in total destruction of artworks for which no replicas (and sometimes little in the way even of records) survive.

Engravings, photographs and any form of print – of which there are normally more than one copy – may also be regarded in art-historical study as original objects. In fact, each photographic print or the state of an engraved plate will be physically slightly different from all the rest in the series even though the image may be identical. Moreover, it is the legitimate and worthwhile task of art historians to engage with reproductive art forms in which the very fact of multiplication and dispersal may be of the greatest interest. How are Benedikt Taschen reproductions marketed? Who buys Van Gogh's *Sunflowers*, and for what purpose? Why do some images get reproduced many times? The historical importance of these questions is huge, and this is reflected in the careful accumulation of certain categories of so-called ephemera by museums and galleries. The British Museum owns a unique collection of trade cards from the eighteenth century onwards, while the Victoria and Albert Museum has an interesting collection of posters, including the contentious Benetton posters produced in the early 1990s. The University of Sussex Library possesses a collection of ephemera gathered from the streets of Paris by someone who happened to be there during the student uprisings of 1968 and recognized the historical significance of these spontaneous and short-lived material acts of communication. Although, of course, much less survives from earlier periods, interest is not confined to print produced since the great technological changes of the nineteenth century.

Now, and at all times in the past, artists and publics have frequently encountered works of art primarily through copies or reproductions rather

than through an 'original'. The 'portrait' of Socrates that was known throughout the ancient world and from which the philosopher has been recognized and identified ever since is a copy after an original executed hundreds of years after his death. The art of Renaissance Italy was known to Northern artists and craftsmen first and foremost through engraving. Since the development of photography and cheap printing methods (and now 3D scanning) it is customary for us to encounter an original only after having become very familiar with its photographic reproduction. For art historians, then, the dissemination of imagery through mass reproduction, its transformations and transmutations, may be as important as paying attention to the original. One might well ask which is more 'real', the Venus de' Medici in the Uffizi or the many copies to be found throughout the gardens of Europe and North America from the eighteenth century to the present day. The study of film and video as a medium involves, inevitably, an experience of viewing that has been, and will continue to be, replicated anywhere in the world in public venues and private homes. But it has to be emphasized that what appears on YouTube is generally fragmentary and of such poor quality that it is no substitute for an authorized copy, and students should be aware of this. The analysis of narrative and imagery will not be determined by whether you see the film in Tokyo or Toulouse, but it may, of course, be affected by the event of the showing and the collective experience of being part of an audience.

The data that is available on works of art and cultural objects is constantly being updated, revised and reconsidered. The latest attribution is not necessarily the correct one, and it would be too much to expect someone starting out as an art historian to be fully cognizant with all the articles on 'a recently discovered…' or 'a newly attributed…' in the specialist Art History journals. What everyone can recognize – beginner and established scholar alike – is that all scholarly writing is cumulative and that what we call facts (dates, information on media and patrons, definitions of subject matter and function, location) are not innocent of meaning. They are packaged in an act of communication (in a book or an article or a lecture) and so become part of an argument. How these arguments shift and change, and what interest and investment underpin them, is the object of art historical inquiry in its own right. Historiography (the study of the history of writing history) is important for art historians concerned with the history of writing about art and architecture. And how we approach this, too, is determined by how we are positioned in our own time.

What we might term holistic ways of studying art, understanding it in the light of cognate expressions in other media, have been well established during the past thirty years. For example, the arts of death and burial (including commemorative sculpture, funerary art and artefacts, mourning

dress, rituals associated with death and dying) have been the focus of many studies that draw on a range of disciplines. Examples of publications addressing artworks in relation to the cultures of death might be Robin Cormack's *Painting the Soul: Icons, Death Masks, and Shrouds* (London: Reaktion, 1997) and the catalogue edited by Emmanuelle Héran, entitled *Le Dernier Portrait* (The Last Portrait), that accompanied the exhibition at the Musée d'Orsay in 2002, which includes deathbed portraits and post mortem photographs. A further example would be the area of historical and metaphorical conceptualization of the body, whether in visual art or in literature (see, for example, Natalie Kampen, ed., *Sexuality in Ancient Art*, Cambridge: Cambridge University Press, 1996; or Tracey Warr and Amelia Jones, *The Artist's Body*, London: Phaidon, 2012). These studies challenge the idea of a sexually fixed biological body that is always the same. They set out to explore the way different individuals and groups in the past – and the present – have envisaged parts of the body (interior and exterior) and have constructed ideas of a body as something that works coherently (while made of different bits) and that images ideological concepts such as 'the State' or 'Revolution'. This has happened partly as a result of an intellectual trend of the 1960s called structuralism (which encouraged scholars to look for common elements and motifs in diverse chronological periods) and partly as a result of increasing interest among scholars in the human and biological sciences in the role of gender as a cultural determinant. Our sex is biological, but how we understand and articulate our difference one from another is a question of gender. A further contributory factor to these changing academic interests is undoubtedly the phenomenon known as postmodernism, which recognizes a loss of established patterns of meaning in the late twentieth century and which is concerned with fragmentation as central to human subjectivity. The point is that scholarly and academic areas of study do not just evolve; they are always a result of some collective (even if unrecognized) concern in the present. You can read more about this in the next chapter.

Art historians, then, whatever their approach or method, take a critical view of the way that data is presented and published. Works that may be out of date in terms of the data they impart may still be of interest as historiography. Crowe and Cavalcaselle's massive book on the Italian Renaissance may appear definitive, but it is important to realize that it was written at a time when incomplete information was available about the material condition of works of art and about their documentary history, and it is, therefore, less than factually reliable even though we may admire it as a milestone in art criticism. Similarly we may read Roger Fry on Cézanne because he writes beautifully and has marvellous insights into drawings and paintings made by that artist. At the same time we need to ask ourselves, in view

of the fact that his book was written in 1927, whether Fry might not have revised his view had he been aware of some of the paintings and drawings of Cézanne which were then unknown or had he had the benefit, for example, of recent discussion about the relationship between Cézanne and the seventeenth-century French artist Poussin. Sometimes a writer's views on art may be simply so quirky as to be interesting because of who said them: this is true of the novelist D. H. Lawrence, whose *Etruscan Places*, published posthumously in 1932, projects his own ideals of sex and human figures onto the wall paintings he saw while travelling in Italy but which also contains the memorable observation that 'A Museum is not a first-hand contact: it is an illustrated lecture. And what one wants is the actual vital touch.'[4]

In other contexts art historians might well be avidly reading Crowe and Cavalcaselle and Roger Fry, while at the same time trying to locate their descendants and read their manuscripts, diaries and letters in the hope of discovering more about how these connoisseurs and writers worked. One branch of Art History is concerned with changes in taste and in how the history of art is constructed as a sequence of conceptualizations – or linked ideas and interpretations – about the past. How these early art historians worked, what methods they evolved, and on what bases they made their judgements is of profound interest, therefore, to art historians for the facts themselves and for an awareness of why we think about certain kinds of art in the way we do now.

A historiographer looks at texts not for what they tell us about particular artists, their lives and their works, but in order to recognize and analyse the historical and theoretical premises on which the writer based his or her discussion. Historiography is more than the kind of concern with artists' writings as an extension of their art or the art of their time (Sir Joshua Reynolds's *Discourses*, for example, or Diderot's Salon criticism) that is often termed Art Theory in course material. Unlike Art Theory, historiography examines the principles underlying the construction of the discipline and thus both helps us to be more discerning about the kinds of argument being marshalled in support of any given body of material and enables us to recognize what sort of Art History is being written and why. Many of the assumptions upon which current expositions of the history of art are based derive, as I have suggested, from celebrated texts written and published in the eighteenth century or earlier. They are, almost without exception, based on Western traditions of art which are understood to originate in Greece and Rome and exclude, therefore, the very different premises upon which the art of China, Japan, Latin America, the Indian subcontinent, Oceania or Africa is based.

An increasing awareness of these issues is resulting in a rethinking of the categories of period and style definition that used to dominate. Likewise,

attention is being paid to the transmission of ideas and ways of making things look a certain way (style) across cultural boundaries. The concept of cultural hybridity – that is, the amalgamation of bits of different cultures into something new – has enabled art historians and anthropologists to find a framework for studying, for example, how the impact of Western cultural artefacts upon an African tribal society results in art forms which do not need to be understood as debased but can be understood in terms of how, for example, the Coca-Cola can may be assimilated and reinvented in a different cultural context. Likewise there has been much effort to redress the culpable and destructive disregard of the Western nations for the art of those areas they colonized; there is, for example, a commitment to the study of Aboriginal art in Australian centres of learning, and the Australian National Gallery now has extensive collections of indigenous art, ancient and contemporary. But if galleries and museums are intent upon policies of inclusivity, art historians have responsibilities towards both understanding geographical location (Australia today looks as much or more towards its Pacific neighbours such as China and Vietnam as it does towards its commonwealth British historical connections) and taking account of multi-ethnic populations.

Race is a way of defining human subjects which is determined culturally and politically rather than by fixed characteristics or geography (though that is often the way the term is used by political and social commentators). The African-American artist Kara Walker uses the technique of silhouette cutting, a medium associated with bourgeois Victorian leisure, to reconstruct an excoriating visual narrative of the history of black people; here it is not simply the visual characteristics of the figures she cuts or the stories she tells that signify but the startling and seemingly inappropriate anachronistic medium that she has adopted. The question of race as a way of shaping unspoken meanings is thus one that art historians address – and not merely when dealing with obviously non-European material.

In the UK, cities such as Birmingham and Manchester with large ethnic communities are mindful of the importance of presenting their citizens with all aspects of their artistic heritage, however diverse in medium and genre that may be. Art historians, in their ambitions for a new global history of art, try to take into consideration not only the history of objects and buildings but whose tradition they are part of, and who is looking at them. A portrait of a 'nabob' (the name given to English and Scottish employees of the East India Company under colonial rule) that includes native servants is a part of several different traditions, depending on which represented figures one is considering, where the painting is (or was) hung and who is looking at it. Art historical scholarship in the area of subaltern or postcolonial studies – that is, the study of cultures that were shaped by colonial occupations – is thriving. Thus, for example, Kay Dian Kriz, in her book *Slavery, Sugar,*

and the Culture of Refinement: Picturing the British West Indies 1700–1840 (New Haven and London: Yale University Press, 2008), explores the relationship between British society and the Caribbean through visual representations, explaining how particular notions of civility were constructed through imagery and the circulation of goods.

Because the discovery and authentication of works of art has played such an important part in traditional Art History, and because the first writers of Art History sought to demonstrate that the art of their time was more successful than that of previous ages, there has been a tendency for the art historian to be preoccupied with development and 'progress', with what one artist bequeaths to the next in the way of subject or style. Thus much of the art of the past has been seen in terms of one artist climbing, as it were, on to the back of his predecessor. This view of the art of the past (or indeed that of the present) as a great chain in which A leads to B which leads to C (or Cimabue leads to Giotto and Giotto leads to Masaccio) unhelpfully implies that art in some ways gets 'better'. Moreover, there are artists who do not contribute to an easily recognizable development of this kind and who, therefore, get left out. Botticelli did not fit into the developmental principle devised by the Renaissance historian Vasari, and consequently his work was neglected and almost totally unknown to generation after generation until, as I pointed out earlier, he was 'rediscovered' in the nineteenth century.

Art History has concentrated on great and acknowledged (mainly male) masters of the past. Certainly it is essential for us to know as much as possible about artists such as Michelangelo or Delacroix who have produced large quantities of innovative and outstanding work, but the disadvantage of the great master approach is that it tends to isolate the artist from the context of ideas, beliefs, events and conditions within which he or she lived and worked, as well as from the company of other artists. It may well be that in some instances the identity of a group may be obscured by the treatment of an individual. Thus an overall view in which the artist is seen in relation to his or her period is the price that is sometimes paid for detailed documentation about the work. Such an approach also assumes some kind of simple link between the artist as a human being and the work that we have on view.

In the 1970s a debate developed about what elements of language, cognition and unconscious and subconscious dynamics are at work in the complex and only partially understood relationship between any human subject and an experience triggered by the imaginative act of another human subject. This debate drew on already existing discussions in linguistics, philosophy, anthropology, film and literature. The consideration of these kinds of issues is given the general label 'critical theory' or 'postmodernism',

though many different things are encompassed by these terms. Theory seeks an explanation of the why and how of recognized forms of visual experience and collective types of historical explanation. It is now intrinsic to most serious writing on the history of art and artefacts, though those who practise a theorized Art History are still sometimes vilified by a conservative heritage lobby, for whom Art History remains the apparently unproblematic assemblage of facts. To give a simple example, Giotto's frescos in Assisi are based on the life of St Francis. A historical explanation for this would be something to do with the power of the Franciscan order and the need to give an illiterate audience a visual equivalent to sermons they would hear from the pulpit. An art historian working on Giotto might address how the artist composed his compartments in a sequence, one of which you see here (Figure 3.4), which subjects he selected and what pigments he used. An art historian interested in theory would, however, ask questions about narrativity itself – that is, about what happens in story-telling, how things which are *not* said or shown may be as powerful in communicating a series of ideas as the things which *are* said, how readers or viewers make sense of a whole from a series of partial clues that make up a story, why and how human subjects in the West at different times desire stories to be told, what the structural relationship between the beginning, middle and end of the story might be, and what different stories have in common.

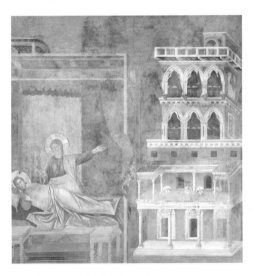

Figure 3.4 Giotto, *Dream of the Palace Scene 3 from the Legend of St Francis*, fresco, 1297–9, Upper Church, San Francesco, Assisi. Reproduction by permission of the Syndics of The Fitzwilliam Museum, Cambridge. © The Fitzwilliam Museum, Cambridge/Bridgeman Art Library.

Similar debates have taken place about what constitutes history – debates which echo and are informed by discussions in contiguous disciplines. Attention is paid not only to things that are known to have happened but to evidence of desires and aspirations. Marxist historical analysis in the 1960s was of major importance in bringing about changes in art-historical practice. Many art historians who have never read a word of Marx and who would certainly not describe themselves as Marxist have, whether knowingly or not, taken class, labour and the economic structure of capitalist society into account as determinants in the production of art, whether it be in the Renaissance or in the present day. The rise of Banksy from anonymous outsider commenting visually and with brutal directness on the world around him to an artist whose graffiti are prised from walls under cover of darkness to be auctioned to collectors merely serves to illustrate just how complex are the relationships between art and the societies in which it is produced.[5] The residents of the London borough of Haringey who campaigned to prevent a 'stolen' Banksy mural critiquing child slave labour from being sold to a wealthy collector had probably never been accustomed to thinking of a local landmark as connected to the economics of art as investment or of the issues of ownership raised by graffiti. Not only the object but also the events surrounding it are what would be of interest to an art historian.

So, popular traditions, 'low' art forms and mass communication now receive serious if limited attention from art historians. At the same time, more attention has been paid where relevant to the reception of all artworks in their own time and to studying how a visual image can provide a ground for the making of meanings within a given society – meanings that may or may not have anything to do with the apparent subject matter or narrative of the image. For the social history of art (as this sort of enquiry is often called), a *fête champêtre*, or a courtly picnic scene, by a Venetian sixteenth-century painter or by a French eighteenth-century painter may be a rural idyll of upper-class love and pleasure but may also, at one level, be understood to represent and therefore reinforce the power relations between women and men and between different classes within the society which produced the image. The countryside is not neutral but carries with it, by implication, its absent counterpart, the presence of the city and the court. It goes without saying that the discrediting of organized state Marxism by regimes in Eastern Europe during the early 1990s does not devalue the inspiration that scholars have drawn from the theoretical writings of Marx, who was one of the great historical thinkers of his era.

A feminist Art History, as it evolved in the 1980s, brought to light hitherto neglected or unknown women artists and encouraged debate about women's art practice in our own day. Do women get a fair share of exhibition time and space? Do they get serious treatment from the critics? Are there areas

of human experience that are peculiar to either sex and justify a separatist approach to the production and display of art? Genres such as flower painting and media such as ceramics and embroidery, which have traditionally been the province of women, now receive more sustained attention and a critical historical appraisal that places them in relation to other forms of artistic production. It is no longer possible to view Mary Cassatt as an appendage to her friend Edouard Manet or to see Artemesia Gentileschi as merely an arm of her father, Orazio Gentileschi. Artists who happen to be women are no longer ghettoized but get a substantial share of the public stage: contemporary artists such as Gillian Wearing, Cornelia Parker and Tacita Dean simply see themselves as artists, while the key information about Rachel Whiteread and Zaha Hadid is that they are, respectively, a sculptor who often works on a very large scale and an internationally renowned prize-winning architect.

The analysis of images of women and men, whether in advertisements or in paintings that are time-honoured and familiar landmarks in the canon, was revolutionized by analysis informed by feminist-inspired approaches to gender in the 1980s and 1990s. In particular, attention to acts of looking (sometimes influenced by work in film studies that sought a viewing position for women free of the narratives of subjugation of female stars on the screen) yielded analysis informed by distinctions between voyeurism, a colonising gaze, a glance and other viewing positions. In Mieke Bal's critique of writing about the female nude, the work of representation (what makes the image alluring) is described as disappearing behind the object represented. As she succinctly puts it: 'The awareness of one's own engagement in the act of looking entails the awareness that what one sees is a representation, not an objective reality, not the "real thing"'.[6]

A major contribution of feminism to the study of the history of art (and one which is now often overlooked or disregarded) was to open up to scrutiny the entire edifice of Art History as a discipline, inviting challenges to its assumptions, its methods, its objects of enquiry, since all of these have been constructed within a patriarchal Western society. The notion that feminist Art History is concerned only with women artists or images of women is a misapprehension. Feminist Art History has drawn on work in Women's Studies (which as an interdisciplinary field brings together many of the humanities disciplines) to examine gender as a shaping and defining category in cultural formations. Thus, for example, in architectural history a scholar might ask how different parts of a house were disposed according to separate gender-specific functions – women's quarters, men's spaces – as well as according to a hierarchy of class – servants below stairs, family above. Here gender can be understood as the organizing determinant in the matter of social space. Questions such as this involve a consideration of power; it is the category of difference – those distinctive characteristics that empower one group while

defining the other as in a dependent relationship – that works to establish what are understood as certainties by the societies that consume works of art. Cultural forms – paintings, sculpture, furniture, and so on – through the way in which they make available sets of associations or images in specific contexts, can establish those differences which are not biological but are socially produced and reproduced. Thus work on Renaissance *cassoni* or marriage-chests has examined the imagery of violence that appears on decorated items of furniture, containers for the bride's dowry, in relation to Renaissance legal and domestic requirements with regard to the social relations of marriage.

Architectural historians are concerned with questions such as how the style of buildings changes, what the relationship is between the appearance of a building and its function, what part is played by sculpture and other decorative devices, how the final building evolved from its early plans, how the building relates to its environment, who built it and why, who paid for it, who used it, what it feels like as a three-dimensional work of art, and many similar questions. The object of an architectural historian's interest may range from a grand baroque palace, such as Blenheim in Oxfordshire, or a cathedral to the characteristic dwellings of cotton-workers or miners in Lancashire or Yorkshire. Most architectural historians begin as art historians but, as with Design History, the discipline of Architectural History soon becomes very specialized, with its own technical vocabulary and its own methodologies. Indeed, approaches to Architectural History are as various as those to Art History, and the capacity of architecture to arouse strong feelings has been amply demonstrated in recent years in Britain, where the heir to the throne has taken a special interest in the relationship between past architecture and present-day practice. Nevertheless, the association between Architectural History and Art History is a firm and generally productive one. After all, buildings are the most universally experienced part of our environment, although the destruction of fine buildings from the recent as well as from the remote past in every town and village is depressing evidence of our inability to notice and understand what is around us in time to halt the inexorable 'progress' of the developer. Many architects have also been painters and sculptors; it is unwise, for example, in studying Michelangelo's painting and sculpture to omit his activities as an architect. Moreover, architectural design, planning and the development of the environment necessitate considerations of power, politics, government, patronage and ways of living that also have far-reaching implications for historians of all varieties.

The great house or planned public building, with its combination of architecture, landscape and decorative art (as well as the paintings hung

in its rooms), has frequently been seen as the total expression of a single philosophical, political and aesthetic point of view. For example, a building such as Chiswick House in London attracts the architectural historian and the art historian. The paintings, sculpture and interior detail in this house might be the subject of individual study by art historians, and the structure of the house might command the attention of the architectural historian. Landscape gardening is a subject of special interest to the student of the eighteenth century, and the grounds of Chiswick would, therefore, be considered as visual works of art in their own right. If we approach the study of a great house with this largeness of vision, there is a chance that we shall see 'Parts answ'ring parts … slide into a whole', as the poet Alexander Pope expressed it when writing his epistle 'On the Use of Riches' to his patron, the architect and owner of the house, the Earl of Burlington.

On the other hand, a house and its estate may be the result of diverse building and collecting activities by different owners at different times in the past. If so, it will demand a slightly different approach if we are to ascertain what was created when. But the point about studying the house and all that goes with it in its totality still remains. When we look at the complex growth of an estate, whether it be within one man's lifetime or over many generations, we are considering questions of patronage: which artists, architects and gardeners were chosen, what they made, how much they were paid, where the money to pay them came from, how they were paid, and so on. By piecing together all the available information and analysing it in the light of theories of consumption and production, we may establish an account of that elusive aspect of the historical which goes by the name of 'taste'.

The same principle applies in the study of, say, a new town development of the 1960s or a garden city of the 1950s and in the study of ecclesiastical buildings, the appearance of which is subject to constant change according to shifts in theological thinking, developments in techniques of building and the vicissitudes of government and governing policy. Take, for example, the church of the Gesù Nuovo in Naples, which, built between 1584 and 1601 on to the façade of a Renaissance palace, contains a rich treasure of frescos and ecclesiastical objects and which has an interesting political, theological and social history. In order to appreciate all this fully, the building must be studied as though it were a living organism. In the case of a new town, employment and leisure patterns, use, wear and tear, ownership and social mobility would all need to be taken into account.

It is in the study of taste and patronage that the art historian and the social historian most frequently interact. One of the art historian's most difficult tasks is to account for the popularity of certain subjects, styles and artists at certain

periods. To achieve this, both reliable factual data (often economic in character) and an ability to interpret imaginative acts of communication are needed. One might, in fact, very well argue that the distinction between the historian and the art historian is a false one. But if the historian is not a drudge neither is the art historian an aesthete who depends on the historian to make the discipline of Art History academically respectable. Art historians need to do their own research, and, while they are complementary, the two disciplines are not inter-dependent. Historians can learn much about conventions of image-making and how imagery and artefacts are agencies that have a shaping role in politics and society. Indeed, historians are increasingly recognizing cultural forms as crucial evidence for understanding the past, alongside traditional evidence in the form of data (as with census returns, acts of parliament, treaties, baptismal records, and so on). This new-found respect is sometimes described as 'the visual turn' or 'the material turn'. It is equally true that Art History has more to do than simply see history as a background to art.

The acts (or artworks) we have been discussing may be used as evidence by historians, though this, as we shall see, creates its own problems. But art historians, as we discovered right at the beginning of this chapter, cannot just be art appreciators; they have to be in a position to unravel and evaluate the meaning of a work of art in its historical context, including when this context is contemporary. Thus, for example, Margaret Iversen, in her detailed analysis of Maya Lin's Vietnam Veterans Memorial in Washington, DC, examines the commission and the reception of this public sculpture with its freight of powerful emotion.[7] Only by doing their own historical research can art historians begin to understand how a work of art looked to people who saw it at the time it was executed, to the patron who commissioned it and to the people who saw it.

The historian of taste or fashion also faces the problem of working in several media. The greatest private patrons of the past, those who were responsible for commissioning so many of the paintings that now hang on the walls of our national galleries (thanks to wars, revolutions and economic difficulties in Europe), bestowed their beneficence and their orders not only on painters but also on craftsmen, musicians and poets. In discussing indi-vidual patrons we do, of course, have to tackle the concept of beneficence rather than taking it as a given. The idea of the disinterested collector con-cerned only to enhance the cultural heritage by a large donation to a public institution is prominent in Western mythology. Banks and financial institu-tions today regard philanthropy as an investment in their 'brand' image. And, with the withdrawal of much public funding, the work done by an organization such as the Bank of America, which since 2008 has supported conservation of works of art and community art projects, is undoubtedly very valuable. Even so, an art historian would need to bear in mind that, at the final count, the choice of what is to be conserved or bankrolled is the

philanthropist's. Donations by art collectors ensure for them a place in history. Robert Lehman, who left a major collection of European painting and decorative arts to the Metropolitan Museum of Art in New York, is commemorated for perpetuity in a way it is hard to imagine being superseded, since an entire wing of this vast museum, a wing containing a suite of rooms that replicate his home, is named after him:

> Robert Lehman assembled his collection with scholarly knowledge, astute connoisseurship, and skilful negotiation of the art market. Upon his death in 1969, he bequeathed 2,600 works to the Metropolitan Museum with the stipulation that they be exhibited as a private collection, reflecting his belief that 'important works of art, privately owned, should be beyond one's own private enjoyment and [that] the public at large should be afforded some means of seeing them.' A new wing, erected to display the collection, opened to the public in 1975. The Robert Lehman Wing includes a central, skylit gallery surrounded by a series of rooms intended to recreate the Lehman family residence. Velvet wall coverings, draperies, furniture, and rugs evoke the ambience of private interiors and serve as a backdrop for this extraordinary collection.[8]

Gifts such as Robert Lehman's are generous acts indeed and serve to enhance the access of people who do not buy and own works of art to visual culture from the past. At the same time, as professional art historians, we must make ourselves aware of the forces of financial investment – and the powerful need of one country to possess and control cultural products of other nations – that also underpin the activities of those who care for quality and beauty. We need, moreover, to be aware of the implications of the movement of works of art across national and cultural boundaries, whether between East and West (in the sense both of the Orient and Occident and of the former communist bloc and the Western markets) or between the so-called developed and undeveloped nations.

We have been talking as though the history of taste is concerned solely with aristocratic patrons such as the Habsburgs or those possessed of gigantic wealth such as Lehman. Mass culture, as we have remarked, is also an area of study proper to the art historian. This is evident when we look at the development of cheap methods of reproduction (such as lithography), or at the influence of the World Wide Web, when we examine the response of the public to works of art after the inauguration of regular open exhibitions in the nineteenth century or the way in which the poster became such an important medium for artists in Germany in the 1930s, or when we look at how fashion and apparel have not only been an area of creativity in their own right since records began but also provided inspiration to artists working in

the so-called high art genres. We might cite Gainsborough's interest in fashionable dress of his day or Man Ray's preoccupation with fashion garments.

There exists no single line of enquiry we can label Art History. This much will have become evident. Indeed, the reader may well feel that we have evaded the basic question: 'What is art?' Part of the purpose of this book is to show that there is no single answer to that deceptively simple question. The fact is that once we apply ourselves to the question of what art is we become philosophers rather than art historians. Philosophy, and particularly that branch of philosophy which deals with aesthetics, has made a contribution to the discipline of Art History. The art historian's role has always been, however, to elucidate the work of art, not least contemporary art, relating to its socio-historical context rather than raising it out of time and defining it or 'appreciating' it as a disembodied work of genius. Anything that a body, past or present, regards as art should be treated as art.

The question of what is a legitimate line of enquiry remains, as I indicated in Chapter 1, a contentious one. If design historians are discussing the evolution of the characteristically shaped and packaged food-mixer or beer can, what should be the range of art historians? Should they confine themselves to architecture – in which case, should everything from monasteries to 'public conveniences' be included? – to easel painting, to sculpture, to fresco, and to the decorative arts such as tapestries and ceramics? Or should they use their expertise upon other sorts of visual communication: advertisements, film, Jack Vettriano (whose *Singing Butler* is the best-selling print in the UK) and mass-produced artworks, clothing and the more ephemeral aspects of our visual experience, such as sports events, or those in which no individual or group seems to have had control, such as the cityscape we see around us every day? Part of the answer lies, as has been indicated earlier in this chapter, in whether or not quality is an issue at stake. But even if art historians agree, say, that it is recognized French painting that is the object of study (for example, that which has, through whatever means, withstood the so-called test of time), they may still disagree about whether these paintings should be viewed as discursive (telling us things, conveying ideas) or sensuous (expressing feeling and transmitting materiality). What is vital in all this is that art historians should, whatever their agenda, know and be prepared to communicate what that agenda is and how they propose to deal with it.

One manifestation of the development of Art History as a discipline during the second half of the twentieth century is the ever widening range of material which the art historian is expected to discuss and interpret. Another is the lively debate about how this material ought to be used by art historians and by those specializing in other disciplines, such as Sociology, Psychology, History and Anthropology. Is a tribal mask a wonderfully crafted object

whose aesthetic impact demands that it be displayed on a wall, or is it a part of a complex culture, offering evidence of ritual practices and patterns of belief? Anthropologists, because of the nature of the origins of their discipline in work with cultures that are not primarily literate, usually have respect for non-verbal forms of communication. But the reverse is often true in other areas of the social sciences, where visual texts are often treated in an impressionistic and ahistorical way that would never be the case with written documents.

From psychologists and philosophers such as Ernst Gombrich and Richard Wollheim we have learnt how to understand more of the processes that make up what we call perception – in other words, how we see things and what part our seeing and learning and knowing plays in the making and reading of pictorial images. With the help of psychology, archaeology and chemistry, it is possible for us to begin to know a little more about what colour has meant in people's attempts to communicate pictorially through the ages. Around the millennium a small number of art historians turned their attention to the neurosciences in an attempt to find answers to how the brain works with regard to creativity and visual response. Whether such work is consonant with the relativity of culture and history is a moot question. Demographic historians (who study population growth and the patterns of change in life-expectancy, the distribution of the population by age and sex, etc.) have enabled art historians to ground their knowledge of medieval culture more firmly. We need to know about demography in order to understand, for example, the attitudes of parents in earlier ages towards their offspring. And we need to know about these attitudes in order to understand forms of representation such as dynastic family portraits or images of wives or children. Legal historians can offer art historians a source of information about property (whether land or goods and chattels) which informs work on both the fine and the decorative arts. The list could go on, serving to demonstrate the interdependency of the humanities disciplines as well as the breadth of Art History.

Freudian and post-Freudian psychoanalytical techniques have been drawn on by art historians in an attempt to reach a greater degree of understanding of the meanings of works of art and how we 'read' them. While there are obvious dangers in imagining that an artist, long dead, can be, as it were, resurrected for the analyst's couch, works of art themselves, supported by reliable biographical data, can be recognized as having latent as well as manifest meanings. Scenes of beheading (for instance, John the Baptist) may thus be interpreted, using Freud's case histories, as narratives of castration, while Freud's theory of the uncanny (or *unheimlich*, meaning unhomely, in the German original) is a widespread point of reference in explaining the unsettling effect of certain kinds of images in which an anticipated pattern of familiar references to the world is disrupted or presented in a particular light – as, for example, in the work of the American artist Edward Hopper (1882–1967).

In the case of artists who were themselves interested in psychoanalysis (as with Salvador Dali), art historians have productively mined the writings of Freud. However, using psychoanalytic theory more widely, critics may object, is transhistorical – it applies a theory devised in late nineteenth-century Vienna to a body of material produced in a different time and place and interpreted by a scholar in yet a third time and place. It also treats the individual rather than society. The proponents of this method argue that it is Freud's theory (rather than his clinical method) that is drawn upon, and that this theory provides one of the richest ways of approaching cultural experience as structured according to laws (the laws of representation, narrative, mythology, fantasy, and so on), thereby enabling scholars to move beyond the idea that in commenting upon a representation of something they are commenting on the thing itself, to reinforce a point made earlier. An image of an eagle is not the same as an eagle. It also permits scholars to move outside the bounds of the commonsensical approach to culture which proposes that all is clear and evident and there is no meaning that is not already obvious. This denial of ideology has been particularly tenacious in Art History in contrast, say, to Language and Literature.

While Freud and Lacan (in reinterpreting Freud) have both been accused of misogyny, their work has been used extensively by feminist art historians, thus pointing up the need to distinguish between these authors and any general view of their work, on the one hand, and the use that may be made of certain themes, on the other. In the case of Freud, his insistence on sexual difference has been a mainspring for art historians seeking to account for visual forms in patriarchal society. In the case of Lacan, his argument about the construction of gendered identity through culture – as well as the role of vision in that construction – has proved particularly inspirational.

Psychologists have helped to demonstrate the superior power of the visual image over the written or verbal description in arousing immediate and strong responses. This goes some way towards explaining why the visual arts (especially painting) have always had an important propaganda value. Art as propaganda has always been as much the province of the social historian as of the art historian, but collaboration can be very productive. A portrait of a ruler may have been intended by its subject as a piece of propaganda, but it is still the result of an imaginative act on the part of the artist. The art historian who ignores historical facts does so at his or her peril. Goya's painting *An Episode of 3 May 1808: The Execution of the Rebels in Madrid* (Prado) demands to be read within the context of the historical event which provoked the picture and which is cited in the title. Whether or not Goya personally witnessed this event (extremely unlikely) is much less important than the ways in which what he represented constituted a response to a common cultural perception of what did, or could, happen.

Pictorial documents are very seductive; they can so easily appear to enliven the historian's text. How dangerous it is, however, for the historian to assume that pictures from a given period can provide an authentic record of how life was lived or even details such as what people wore! We know, for example, that in the eighteenth century Gainsborough painted a number of sitters dressed in the seventeenth-century fancy 'Van Dyck'-style clothes. It is thought that he kept a collection of such clothes in his studio for his fashionable sitters to pose in, although he usually preferred them to wear their own clothes. Dutch seventeenth-century portraits sometimes contained deceased, as well as living, members of one family. Genre paintings from the same era are often thought to record faithfully how people lived at that time. But we now know that Jan Steen's *School for Boys and Girls* (National Gallery of Scotland) is an allegory of the school of life in which different parts of the painting represent different human vices or virtues. It may also bear some resemblance to the appearance of a Dutch schoolroom in the seventeenth century, but, since it appears the intention of the artist was to provide not a mirror image of what he observed but a commentary on life, it would perhaps be

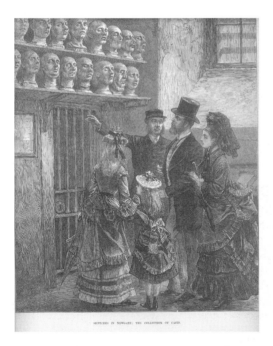

Figure 3.5 Sketches in Newgate: The Collection of Casts, wood engraving, *Illustrated London News*, 15 February 1873, p. 161.

dangerous to assume this to be the case. Even with what we might regard as documentary reportage we find convention at work. In photography, and in Realist art, the reality effect is the result of a carefully produced organization. It has been demonstrated, for example, that a journal such as the *Illustrated London News*, which presented itself as documentary (Figure 3.5), in fact used and reused stock images, introducing rioting crowds, a family group or a royal procession into a variety of urban backgrounds as the current situation demanded.

Paintings can provide factual information of the sort the historian is seeking. Joseph Wright of Derby depicted in great detail an eighteenth-century air pump in his painting *An Experiment with an Air Pump* (Figure 3.6). But in using the contents of paintings such as this as historical evidence we must employ much discretion and caution, checking all other known visual and verbal accounts and making sure we understand as far as possible the intellectual and imaginative climate within which the artist worked (the history of technology is relevant here), as well as the historical and ideological situation of which the incident depicted is a part.

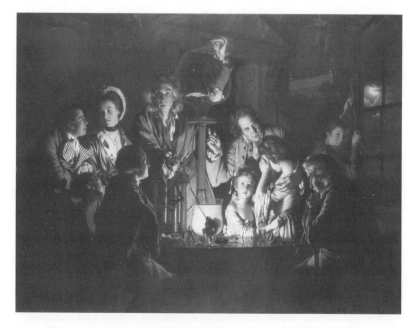

Figure 3.6 Joseph Wright of Derby, *An Experiment with an Air Pump*, oil on canvas, 1768, National Gallery, London. Reproduced by courtesy of the Trustees, The National Gallery, London.

The same painting may be analysed by an art historian using a method associated with structuralism, seeking to identify the deep structures within a work independent of its apparent narration. The components of the image are thus seen as signs; they carry meanings that may be independent of, or even in contradiction to, the apparent subject of the painting. In this particular work there are ten figures, but most of these figures have at least one eye in shadow. A discussion of this characteristic, possibly relating it to hands and spherical containers, might lead to a discussion of this painting (whose subject matter is science and history) as a discourse upon blindness and sight. Semiology (the science of signs) is derived primarily from language-based art forms but is nevertheless a theory and a practice that has directly or indirectly made an impact on the study of paintings and is widely encountered in film and media studies.

There are many close ties between Art History and Literary History too. The friendships that are known to have existed between artists, writers and musicians (Cézanne and Zola, Reynolds and Johnson, Titian and Ariosto, Delacroix and Chopin) should have ensured that art historians are keenly aware of what each discipline can offer. There are also the poet-painters or painter-poets such as William Blake, whose work demands to be considered as a whole. The study of paintings which treat subjects from literature and, connected with this, the field of book illustration, can be extremely rewarding for art historians, especially if one literary text is followed through a variety of pictorial interpretations. It would be interesting to trace, for example, narrative cycles based on Ariosto's stories in the Renaissance period in Italy or paintings that derive from a reading of Malory's *Morte d'Arthur* in England in the nineteenth century. But questions such as 'How can the artist transfer to the static medium of paint a story which is expressed through a time sequence in literature?' require a theoretical basis for exploration. The relative powers of painting and poetry have been discussed since antiquity, and academic journals such as *Word and Image*, *Representations* and *Paragone* (meaning comparison in Italian) are testimony to this abiding interest. A clear understanding of the characteristics and limitations of different media – of linguistics, line and colour – and an awareness of the functions of painting and literature is essential for this kind of work.

Reading is, like looking, historically located. Art historians ask questions about the relationship between words introduced into pictures (as in medieval manuscript illumination or the collages of Braque and Picasso, where pieces of newsprint become part of the image) and the spoken as opposed to the written word (as in the work of the German-born Kurt Schwitters, in which scraps and cuttings of printed ephemera are layered; Figure 3.7). The shifts and associations, differences and complementary characteristics between written and spoken and between written and imaged depend on a complex set of historical conditions at any given moment in time. Recovering these relationships may lead to a radical reappraisal of the meanings of a given image.

From what I have said in this chapter it will have become evident that there is no single route and no single object for the art historian. The skills that are

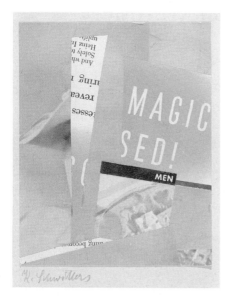

Figure 3.7 Kurt Schwitters, *Magic*, printed papers on paper, 1936–40, Tate. © Tate, London 2013/DACS.

needed are many, but so are the intellectual rewards. Like any other discipline (the word is apt), Art History demands commitment, dedication and lots of hard work: looking, reading, asking, searching. Once you start, you seldom want to stop. The following chapters are intended to help those who have made a start to proceed on their way.

Notes

1 Brian Sewell, London *Evening Standard*, 21 February 2013.
2 Hal Foster, 'Preposterous Timing', review article, *London Review of Books*, 8 November 2012, p. 12. The author then goes on to discuss two recent books that work with the idea of creative anachronism.
3 Joanna Woodall, *Anthonis Mor: Art and Authority* (Zwolle: Waanders, 2007), p. 98.
4 D. H. Lawrence, *Etruscan Places* (London: I.B. Tauris, 2011, p. 198).
5 See 'Sale of "stolen" Banksy mural cancelled at 11th hour', www.guardian.co.uk/artanddesign/2013/feb/23/banksy-missing-mural-auction-stopped.
6 Mieke Bal, *Reading Rembrandt: Beyond the Word–Image Opposition* (Cambridge: Cambridge University Press, 1991), p. 142.
7 Margaret Iversen, *Beyond Pleasure: Freud, Lacan, Barthes* (University Park: Pennsylvania University Press, 2007).
8 www.metmuseum.org/about-the-museum/museum-departments/curatorial-departments/the-robert-lehman-collection (accessed 28 January 2014).

4 The language of Art History

The language of art itself is not traditionally speaking verbal. The caveat is necessary as many art objects (classical sculpture, illuminated manuscripts, printed and illustrated books, and modern conceptual art – as with a relief from imperial Rome or the works of Ian Hamilton Finlay or Richard Long) may include verbal inscription as an essential ingredient. The relationship between words and images is extremely complex, partly for cultural reasons (we use words to communicate about imagery), partly because the outline shape of, say, a tow-away vehicle which is strictly speaking an icon or image can function in the place of a series of words ('If you ignore the parking restrictions in this area your car will be towed away!') (Figure 4.1), and

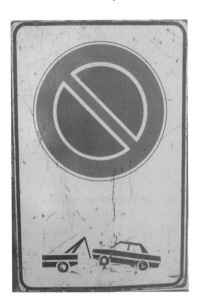

Figure 4.1 'No Parking' sign, Lucca, Italy, 2013. Photo courtesy of the author.

partly because a letter or word is also a shape and may function as part of a composition of different shapes as well as a signifier to which is attached a particular concept. Thus the word JUG inscribed within an image field may work as three varied and related curving vertical forms, and at the same time it may trigger for the literate viewer the concept of a container for liquids.

This chapter is, however, intended not to explore these questions of semantics (the science of meaning) but rather to provide some helpful commentaries on the kinds of Art History writing undergraduates are likely to encounter. My examples are not exactly chosen at random and they are not comprehensive; they are selected not because I regard them as especially compelling (though some may be just that) but because they typify some of the ways of using language that serious scholars have devised. Readers should also bear in mind that these are excerpts taken out of context, so this is an artificial manoeuvre (language is inseparable from meaning) devised to isolate language usage. You will be reading whole chapters or whole books, but learning to be vigilant about how authors write will help your overall understanding

Modern Western societies hold the written word in high esteem; it is legal tender in a way that the spoken word is not. Scientists making discoveries must publish them before they can claim any validity for their experiments. Even today, when e-publishing is accelerating in academic presses (and self-publishing on the internet has been made easy), writing a book to be published in hard copy is still regarded in the academic world of the humanities as the apogee of a scholar's career, even though it may take three or four years to get a book from manuscript stage into print and the same scholar may have expressed him- or herself equally cogently in articles in journals or magazines or online, where the delay between writing and reception is shorter and the medium is one which may reach a wider audience.

The debate about the future of books notwithstanding, students ignore hard copy at their peril, perhaps especially in relation to a discipline such as Art History where so much depends on high-quality illustrations. Students – and this cannot be said often enough – run the risk of factual error and gross misrepresentation if they rely on the unregulated and unchecked resources made available by Wikipedia and other internet sites. They are very seductive – available at the click of a mouse – but they are no substitute for a book or an academic article. And if you are reading books online it is still necessary to check what edition you are looking at and whether it is complete, since pages are sometimes missing. There is more on electronic resources in the next chapter. While art historians, like other scholars working in the human sciences, have become more conscious of the ways in which writing determines meaning, and now take account of the question of the authorial voice (how the position of the author *vis-à-vis* his or her

subject shapes the transmission of information), it remains the case that many readers go to texts to extract 'knowledge' without thinking about the layers of language – collective and personal – within which their reading takes place.

As with other disciplines, Art History has developed meta-languages, special ways of communicating with other people in its group. Within such meta-languages certain points cannot be made or can be made only in a very roundabout and lengthy way. There are dangers that any specialized terminology may be inaccessible to a reader who has not learnt it stage by stage. While there are cases of unnecessarily elaborate and obscure language in art-historical writing, it is all too easy to dismiss as jargon writings that appear difficult at first reading. Yesterday's academic obscurities are tomorrow's bywords, and criticism based on the 'jargon argument' often originates in intellectual laziness or resistance to new ideas. Those, for example, who accuse art historians who are interested in theory and method of inventing and purveying unnecessarily obscure ways of saying things fail to recognize their own meta-languages simply because they have lived with them for forty years or more and they have become an orthodoxy. New ways of thinking about things engender new ways of saying things, and sometimes it takes a while both for the forms of language to settle into a recognizable clarity and for people to familiarize themselves with the terminology. There is a reputable place for populist writing which puts accessibility before all else, but the place for it is not in the writing up of serious art-historical research. There has been a sea change in the past twenty-five years, and students signing up to History of Art courses should now expect to find a Methods and Approaches, a Historiography or a Theory course (or a combination of all three) as an obligatory part of their undergraduate work. Think of it as learning to drive an old-fashioned car – you need to know which pedals do what and where the ignition is.

The passage below is from a 'classic' text, a canonical commentary on Cézanne from a writer who would be regarded as of an old school of art-historical writing untouched by changes in the discipline. Notice, however, how many words and phrases (those I have placed in italics) are short-cut means used by the writer in an effort to establish what he perceives as changes in the painter's work. Many would require explanation for a reader not already familiar with art-historical terminology:

> The *shut-in masses* of the houses of the terrain in the *foreground* still remind us of the *walled type of painting* of the preceding years, and especially of the 'Railway Cutting', but the lightness of the colouring is not *impressionistic*, it already contains essential characteristics of Cézanne's specific *colour treatment*. This is true also of the later pictures from this period, in which the *block-like solidity*

is abandoned and the *looser construction* and lighter colouring represent a distinct approach to *impressionistic effects*: in proportion as the *contours*, the *modelling* and *chiaroscuro* are replaced by the *homogeneous impressionistic brushwork*, the *structure of the colouring*, based on small component parts, acquires a new *solidity*. In the course of Cézanne's development, a constant return to his own older *forms* and a juxtaposition of different methods of painting are characteristic, and this peculiarity, which makes the arrangement of his works in chronological order so difficult, is particularly frequent in the works which he produced from about 1874 to near the end of the seventies. In the famous *still-life* with the fruit-dish in the Lecomte collection, which can be dated at the end of the seventies, we have probably the first picture in which Cézanne achieves his *ultimate pictorial form*. Naturally his art undergoes plenty of changes even after this, but we can nevertheless speak of a certain *definitiveness*, for the most important principles of *representation and form* remain from this time on unaltered.[1]

In Novotny's writing on Cézanne, we see the meta-language of Art History in use. A word such as *chiaroscuro*, which is borrowed from Italian and used widely in European writing on the history of art, means literally 'brightdark' and is employed to describe the variations in tone from dark to light in a painting. But Novotny does not put it in italics because it is fully absorbed into the meta-language. Certain terms, such as 'still-life' and 'impressionistic', belong to the visual arts because they were originally coined to describe particular kinds of painting. We may also find them employed metaphorically to describe literature or music. In general, language is a vast common pool and, excepting strictly technical terminology, words are shared by the humanities disciplines. Consider, for example, these two statements from reference books reprinted many times:

In the storm music into which the ensuring trio is incorporated, brilliantly atmospheric music whose economy of means is again masterly, Verdi by a stroke of genius uses the humming of an offstage chorus to represent the sound of the wind, thus anticipating Debussy by half a century. *Graphic phrases for flute and piccolo represent lightning.*[2]

The first works of a young poet are more frequently expressions of the intent to be a poet than exercises of a poet's powers. They are also, almost necessarily, derivative; in Keats's case the influence of Spenser is pervasive, not the homely, English, and moral Spenser, *but the cultivator of the enamelled and the musical.*[3]

'Graphic' means, in dictionary terms, 'pertaining to writing', 'delineating' or 'diagramatically representing'. Yet in Osborne's description we can easily apprehend, if we listen to the music he is writing about, the quality of vividness that distinguishes the notes of the flute and the piccolo in the final act of Verdi's opera *Rigoletto*. In the second passage, 'musical' does not surprise us as an adjective, since poetry is an oral medium dependent on sound, as music is. But 'enamelled' is a different matter. The writer is not, we assume, thinking of a 'vitrified coating applied to a metal surface and fired' (the dictionary definition) but, rather, wishes to convey to us a decorative object in the manner, perhaps, of the Limoges enamellers who used the technique we employ for making functional saucepans to create luxury art objects in the late Middle Ages. He therefore assumes in his writing an understanding of historical relevance and comparability. He is using 'enamelled' in a visual sense to describe words, but the sense is also that which would have been understood by Spenser writing in the sixteenth century.

Now let us look at some more recent writings. Here the authors tackle another very celebrated (canonical) case from the history of Western art, one that, like Cézanne's landscapes, has challenged art historians to understand and interpret the ways in which meanings are conveyed by marks on a canvas. There have been many attempts to explain what is happening in the foreground of Holbein's *The Ambassadors* (Figure 4.2). This is one:

> Across the floor of the *picture space*, or, rather, slanting across the *figurative space* above it, Holbein has painted a detailed but indecipherable smear. For the spectator standing back to the wall in a position to the right of the painting the smear is *readable* as the *anamorphic representation* of a human skull. The device is a *memento mori*, a reminder of the contingency of all that the picture represents and particularly of the mortality of the two men. While we confront the painting as a picture, the skull is *ontologically irreconcilable* with the main *illusionistic scheme*. Its *mimetic form* is perceptible only when the painting itself cannot properly be seen. Yet, once the identification is made, because the *symbol* is inscribed across or on the *illusory surface* of the painting, its signification overrides or cancels the significance of what is depicted in the painting. Like scare quotes around a sentence, it shifts the *truth value* of all that the surface contains, including all that may be seen as evidence of competence and accomplishment, and does so as a function of that same *literal surface* upon which all else is inscribed. How strange a thing to conceive; something which could only be realized if the painting were irreparably transformed – the carefully achieved illusion of its instantaneity, its '*presentness*', damaged beyond repair by the representation of its contingency. Is it a relevant question to ask whether this damage is or is not *aesthetic*

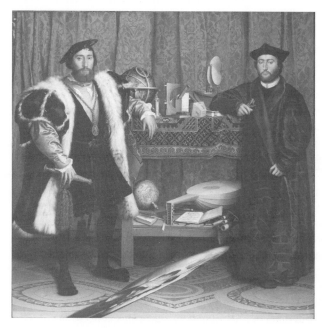

Figure 4.2 Hans Holbein the younger, *Jean de Dintville and Georges de Selve* (*The Ambassadors*). Reproduced by courtesy of the Trustees, The National Gallery, London.

ruin? Perhaps the point is that the ruination of the aesthetic whole goes to the possibility of a *transformed aesthetic*. The change which the skull represents is only integral to the painting, that is to say, from a *perspective* in which the status of the painting, and perhaps of pictorial representation as a whole, is cast into serious doubt.[4]

Like Fritz Novotny, Charles Harrison is concerned here to prise open the experience of looking at imagery which conveys to viewers an experience of space. Harrison postulates a single unspecified spectator, standing in a certain position to view the canvas. This spectator is, it subsequently appears, himself, though the use of the term 'we' allows both the sense of a guiding interpreter and a disclaimer that it is a personal and individual experience that is being described rather than a general and universal one. What interests Harrison is how this painting demands two different ways of looking, one of which cancels out the other. It is a well-known game, and galleries where anamorphic paintings hang (paintings containing a

distortion of perspective that produces a monstrous effect which can only be corrected by looking at the image from a certain angle) often provide instructions for viewing, stools to stand on, and so on.

Harrison's use of words and phrases such as 'mimetic' and 'truth value' are part of a meta-language of criticism. But what distinguishes his analysis from that of Novotny is that Harrison is not content merely to identify the visual characteristics of this form of illusionism in all their complexities, nor is he concerned to trace them to a particular moment in an artist's career or to see them as manifestations of a certain period form of visual cleverness or bravado; rather, he demands to know the effect of such a feature (the introduction of an anamorphism into a conventional perspectival composition) upon the overall aesthetic.

In other words, Harrison presents as problematic and dynamic the relationship between the anamorphic skull and the area of the image in which it is depicted. This happens at the level of meaning as conveyed by the image as a whole. So, instead of having a portrait of two ambassadors in which Holbein has happened cleverly to have inserted an optical trick for the viewers' amusement, we have a dialectic (an argument) about life and death and, simultaneously, about the creation and the destruction of ways of persuading us that we are looking at real life when we are looking at flat surfaces with marks of paint on them. So ultimately Harrison's concern is not with Holbein or with perspective and paint (as Novotny's is with Cézanne) but with representation as a set of possibilities, laws and practices.

The Ambassadors is a much-loved painting often already familiar to visitors to the National Gallery in London. Television programmes and popular history about the Tudors as well as Hilary Mantel's award-winning novels[5] make us feel we know the people represented in portraits of this period. It may be useful therefore to introduce here another two short passages from works that analyse *The Ambassadors* as a way of demonstrating that even what seems recognizable and instantly 'knowable' is in fact extremely complex. So here is a passage from a technical report on Holbein's painting:

> The rug, seemingly complex in its treatment of colour, texture, the play of light on the folds, and the depiction of the signs of wear and tear to the fabric, is in fact a fairly simple piece of painting. Holbein used a very dark grey *underpaint* for the whole of the rug and exploited its *optical effect* in the final image by applying over it a loosely connected network of small square slabs of red, yellow, blue, white and grey paint to represent the knotted threads. Virtually the whole of the design is constructed in this manner. The use of *highlights* has been confined to the part of the rug concealing the upper shelf, the ribbing along the border, the painted stitches denoting

repair and the plain border hanging at the left. The *surface paint* makes use of *vermilion, red lake, azurite, ochre, white* and *black* to represent the knots.[6]

Some of what is being defined here is dependent upon highly specialized knowledge (based on chemistry) and specialist equipment: the language here is of necessity technical with the naming of pigments. But it is interesting to notice, firstly, how reading such a piece draws our attention to details (such as the wear and tear visible on the rug) that we might never have observed and, secondly, how the conservator himself draws attention to the mismatch between what appears visually complex and the actual material means by which that impression is produced.

It is the non-human elements in *The Ambassadors* that interest two other scholars who are concerned with what they term the making of identities. Pointing out that the title of the painting is a modern invention, they focus on the disparateness (they use the term 'hybridity', borrowed from Anthropology and ultimately from Botany) of the objects depicted. Here, for example, is what they say about the clothes worn by the sitters:

> Yet it is only the sitters' clothes that relate them to France. Jean de Dintville, on the left of the picture, is a lay aristocrat, and as such wears the *robe courte*; Georges de Selves is a bishop and wears the *robe longue* of ecclesiastics and lawyers. Moreover, Dintville wears around his neck the Order of St. Michael, otherwise known as the *Ordre du Roi*, which was instituted by Louis XI in 1469. With the exception of the clothes, the objects belong not to the world of the visiting ambassadors but to Holbein's Anglo-German circles in London.[7]

If we are tempted to dismiss the whole of this discussion by declaring that verbalizing about the visual arts is pointless because, had the artists believed their artistic statement could best be made in prose or verse instead of paint, they would have chosen that medium, or because it is the materiality of art that is its statement and words are irrelevant, it is worth reminding ourselves that language is fundamental to our creative lives as individuals. It enables us to communicate with one another. Indeed, it has been argued that language precedes thought and that without language the conceptualization of objects is impossible. It is, moreover, the all-pervading medium of academic and cultural debate at whatever level and in whatever circumstances. Language is used by a group of people after a football match to communicate and compare their experience of the game just as it is by a group attending a private view at a London commercial gallery. Writing

seriously about any subject is a creative act in itself and requires a skill and awareness that are consciously and deliberately acquired.

In previous ages, before the advent of multiple photographic repro-ductions in books and magazines and on the internet, the greatest respon-sibility of the critic and art historian lay in describing the appearance of works of art and architecture. Indeed, the earliest art historians adopted a particular mode of rhetoric called (from the Greek) ekphrasis to praise the visual through the verbal. In the nineteenth century, when newspapers began to be more widely available, page after page of the popular press was filled with verbal evocations of pictorial art for the benefit of those who could not attend exhibitions. In some cases, these descriptions pos-sess intrinsic literary qualities which entitle them to be considered as works of art in their own right. Here, for example, is the French critic Denis Diderot, a contemporary of Chardin, writing about one of the art-ist's still-life paintings. His description was for circulation in manuscript to an international circle of cultivated aristocrats rather than for the pub-lic at large.

> The one you see as you walk up the stairs is particularly worth your attention. On top of a table, the artist has placed an old Chinese por-celain vase, two biscuits, a jar of olives, a basket of fruit, two glasses half filled with wine, a Seville orange, and a meat pie.
>
> When I look at other artists' paintings, I feel I need to make myself a new pair of eyes; to see Chardin's I only need to keep those which nature gave me and use them well.
>
> If I wanted my child to be a painter, this is the painting I should buy. 'Copy this,' I should say to him, 'copy it again.' But perhaps nature itself is not more difficult to copy.
>
> For the porcelain vase is truly of porcelain; those olives are really separated from the eye by the water in which they float; you have only to take those biscuits and eat them, to cut and squeeze that orange, to drink that glass of wine, peel those fruits and put the knife to the pie.
>
> Here is the man who truly understands the harmony of colours and reflections. Oh, Chardin! What you mix on your palette is not white, red or black pigment, but the very substance of things; it is the air and light itself which you take on the top of your brush and place on the canvas.[8]

We could not see precisely what Diderot saw if we looked at the picture he describes, but we can nevertheless, even reading in transla-tion, learn much from writers such as Diderot in the eighteenth century

or Hazlitt in the nineteenth – men who acquired their linguistic skills without the aid of photographs to remind them and their readers of the appearance of objects – about the power of language to describe as well as to interpret what is seen. The original passage is in French, but even in translation it retains much of its gusto and individuality. We may not wish to cultivate the declamatory tone of Diderot, but there is, on the other hand, no reason why writing about art (or indeed writing about literature or biology) should not exploit all the subtleties language has to offer and give pleasure as well as enlightenment to the reader. The reason it does so relatively rarely is that it is extremely difficult to describe a work of art.

Writing of the ekphrastic and explicitly subjective kind is especially a feature of writing about contemporary art. Here, for example, is Achille Bonito Oliva on the Italian artist Enzo Cucchi (b. 1949):

> In Cucchi's paintings and drawings on paper *that caress the wall*, all the *voices fade into signs* that allude to the possibility of *halting on the threshold of the image*, which means the place of form and hence of beauty.
>
> The artist Cucchi has chosen to *dream a dream of art* that runs through many *territories that unravel* through strings of images and solar forms made up of fragments and unexpected gleams, of constant return as well as distancing and sinking in a place that *seems to belong to all*. The magical territory of the artist is illuminated by an inner gaze that glows with its own light, strengthened by *an eye that possesses the dual ability to look and look at itself*.[9]

Here the writer does not enumerate or describe the visual characteristics of what he is looking at. Admittedly the splendidly produced dual-language publication in which this appears has lots of high-quality plates. Nonetheless we recognize that what is going on here is the production of a series of figures of speech in a poetic equivalent to the image which is constructed as a magic space into which the viewer might step – cross a threshold. Drawings cannot literally caress a wall and they do not have voices; these are metaphors which the author uses to suggest that the work of Cucchi has a life of its own. The idea of dream licenses certain illogicalities of language (can a territory 'unravel'?) in the interests of conveying a subjective impression of the work while insisting that the work seems to belong to all – and is therefore, we may assume, accessible. In the final sentence of my excerpt, Oliva resorts to a familiar trope, that the artist has a particular 'eye' – meaning, of course, not his biological eye but his faculty of perception. Of course we acknowledge that an artist's ability to

see things in a particular way is what lends their work its special idiom and individuality, but the reduction of an artist to 'an eye' is also a way of sidestepping an awful lot of complicated issues about subjectivity and the objects of an artist's look.

The extent of descriptive writing in an art-historical text may depend on the familiarity of the objects being discussed to the assumed audience of a book. A person writing about non-Western art for a Western audience will need to go into far more detail probably than a person writing about an Impressionist painting, and they may in all likelihood want to explain what the differences are between what we understand in the West as art and the objects of their particular study. Thus Howard Morphy, an anthropologist who writes about art, explains to a reader more accustomed to a Western concept of 'art' how Aboriginal linguistic usage helps to understand the relations between pattern-making and myth:

> The distinction between natural and cultural designs must not be too rigidly conceived, as things which are called *miny'tji* are all believed to be the result of consequential action; *miny'tji* are meaningful designs. [...] The design on the back of a turtle is seen as its design in much the same way as the design painted on a human body is seen as belonging to and representing a clan. A myth, for example, explains the origin of the pattern on the turtle's shell, how it was put there, and why it takes the form it does.[10]

In Art History dealing with canonical works in Western art, we often meet with a tradition of writing that is predicated upon the act of describing as a supposedly neutral process of identification and as a necessary preliminary to all forms of analysis. This passage on a painting by Carpaccio presents a seemingly objective and impersonal assessment of what we see when looking at *The Return of the Ambassadors to England* (*ca.* 1495, Venice Accademia):

> The Ambassadors arrive back in England, and deliver St. Ursula's message to their master. The prince is so enamoured of her that he agrees to accept her conditions. The large building in the background is probably meant to represent the royal palace, and various aspects of its design – the triumphal arch at the centre, the free-standing figure on the roof, and the marble relief inlays on the walls – suggest that Carpaccio was attempting to create a specifically pagan type of architecture. The relief on the right hand side is adapted from a bronze plaque by the Venetian sculptor Vittore Camelio, of which versions now exist in the Ca'd'Oro in Venice and the Victoria and

Albert Museum in London. It represents two scenes from the life of Cupid: on the left he is educated by Mercury, with Mars looking on; and on the right, he is held up by his mother Venus, while Vulcan forges him a pair of wings at an anvil. Perhaps Carpaccio intended the theme of Cupid as a commentary on the love of the English prince for St. Ursula. To the right of the palace is a walled garden of the type quite common in Carpaccio's Venice.[11]

Here the author interleaves a brief account of the legend of St Ursula on which the painting is based with a register of details represented in the work: characteristics of the building, a walled garden, etc. From this description he tentatively infers the possible intention of the artist to create an environment associated with particular values (non-Christian even though this painting is about a Christian saint). The analysis proceeds to open up layers of interactive meaning as the author identifies represented within the architecture depicted a relief that existed (and still exists). As this also tells a story, the author relays to us this story (from the life of Cupid) depicted within a painting that depicts another story. This is perhaps like fileting a painting, opening out the contents for us to view and doing so on the basis of prior and well-informed data. We need to remember, however, that choices have been made in this register and that there will be other elements that the author may have chosen not to mention or may even not have noticed (though in this instance the author is clearly doing a very thorough job).

Much writing on medieval art, influenced by Erwin Panofsky (1892–1968), one of the founding fathers of Art History, falls into this category. A listing of the features located in an image is followed by their identification. The writer then proceeds to an analysis of the cultural meanings of those features or motifs. This requires the language of iconography, which remains prevalent, especially (but by no means exclusively) in writing about medieval art.

Iconography simply means the art of illustration, and iconology is the study of visual images. An icon originally meant a portrait, but the term 'iconography' is now applied more broadly to any group of visual images that possess a specific and identifiable literary meaning. Iconographical studies are usually characterized by a wide range of linguistic and cultural references, as the writer traces the modifications and shifts in the meaning and form of an image through different ages and in different countries. The language of this kind of writing can be obscure and present considerable difficulties even to an experienced reader. Writers often assume, quite unreasonably, not only a knowledge of several foreign languages but also an extremely broad cultural background. This passage (in which I have underlined certain things) is

from one of Panofsky's books (first published 1955, reprinted many times); it is typical of iconographical Art History in that the passage quoted occupies in the published text only a quarter of the space of one page, the other three-quarters being taken up with long and detailed footnotes in support of the assertions made in the text:

> In the *Abduction of Europa* as in the *Death of Orpheus*, then, <u>Dürer had gained access</u> to the Antique by retracing what may be called a <u>double detour</u>: an Italian poet – perhaps Politian in both cases – had translated Ovid's descriptions into the <u>linguistic and emotional vernacular</u> of his time, and an Italian painter had visualized the two events by setting in motion the whole apparatus of <u>Quattrocento</u> *mise-en-scene*: satyrs, Nereids, cupids, fleeing nymphs, billowing draperies and flowing tresses. It was only after this twofold transformation that Dürer was able to appropriate the classical material. Only the landscape elements – trees and grasses, hills and buildings – are independent of Italian prototypes; and the way in which the space is filled, from beginning to end, with *tätig kleinen Dingen* is thoroughly Northern, in spite of the fact that many of those 'busy little things' are classical satyrs, she-Pans and Tritons.[12]

The key to the language and the meaning of this passage of writing lies in the words of the first sentence: 'Dürer had gained access'. An iconographic argument is convincing only if the writer can persuade the reader that the artist in question could have known or seen certain 'prototypes'. From these the whole chain of connection stems. There are a number of linguistic clues in this passage to the sort of scholarly method that is being employed. Notice the reference to 'a double detour', suggesting a complicated journey, and to 'linguistic and emotional vernacular', an abbreviated way of describing a complex literary transformation.

The characteristic argument of the iconographical study stems from a wide range of learning; thus the writer's main problem is how to put his material over to a reader unpractised in History of Art. Panofsky endeavours to overcome this problem in two ways. In the first place he divides his material into two sections; it is possible to read only the text, to take for granted that he has sufficient supporting evidence for the suggestion that it was possibly Politian who translated Ovid into the 'linguistic and emotional vernacular of his time'. On the other hand, the scholarly reader may refer to the footnote on this subject. In the second place, Panofsky assists his reader to a certain extent by offering complementary clauses. We may not know that 'Quattrocentro' is the Italian way of describing the fifteenth century – the 'fourteen-hundreds', we would say. We might have difficulty

with '*mise-en-scène*' and might quite reasonably ask why the author, since he is writing in English, could not simply say 'stage setting'. On the other hand, assuming that some of his readers will not know what constitutes a fifteenth-century stage setting, Panofsky proceeds to give us a list of some of the ingredients: satyrs, Nereids, and so on. The German phrase in the last sentence (Panofsky's native language was German) is translated as 'busy little things', which makes one wonder whether, although the phrase serves to remind us that we are dealing with a Northern, German artist, it was really necessary in the first place.

In the following passage a more recent writer on medieval art takes a rather different approach. This passage attempts to explain how people in the Middle Ages might have viewed gold; it does not assume that gold meant the same then as it does today, but it uses a very contemporary (and even colloquial) language to convey this:

> Because gold remains a *status symbol* today, we can get a sense of how medieval observers might have feasted their eyes on its shimmer, aware, in even the most exalted statue or panel, that it was '*worth its weight in gold*'. Gold was, like so many symbols, a signifier of either of two opposed extremes – good and bad. That the 'idols of the nation are of silver and gold' made them even more heinous because the pagan gods had been the focus of excess luxury and misspent wealth. There is also the important historical context explored by Marc Bloch, who shows that there was a dearth of gold in Western Europe in the twelfth and thirteenth centuries compared to the rich resources of Byzantium and Islam. This shortage of actual gold coinage must have affected how people saw it used in art objects both to glorify, in its rarity, the King of Kings and to denigrate the avaricious pagan's *filthy lucre*.[13]

Camille is determined to be 'user-friendly', and he opens this passage with an appeal to his readers through their own experience: advertisements for gold watches and necklaces are a familiar part of Western culture. He then works around the everyday saying 'worth its weight in gold' to make the point that, in the context of which he is writing, this was probably literally true. But it is the symbolic worth of gold that concerns him, so he moves on with short quotations to make the point that then, as now, the supply of this commodity affected the way people saw it. His concluding the paragraph with a reference to 'filthy lucre' reminds us, again, that our everyday sayings have their origins in the far-distant past. Camille's use of language thus serves to link his audience in the present with the events of the past which he is examining.

All writers have a perspective on or an approach to what they are dealing with. This is true even if they disclaim any approach or if they offer an account so apparently magisterial and authoritative that it seems to be universal truth rather than one of many possible arguments. In writing about the art market, for example, the language employed is often that of sociology and economics, suggesting absolutely quantifiable certainties, verifiable data, and so on. Here, for example, is a short paragraph from a study of how and why certain artworks are bought or stolen:

> *In total*, the price increases caused by the rise in the American *demand* for art leading to more theft is responsible for some, but possibly rather minor negative *external effects* (and these are partly compensated for by the positive external effect of better preservation). Exactly the same effects would occur if art *prices* rose owing to increased European demand. It must then be concluded that there is little reason to argue against the international market in art on the basis of the *externalities* produced.[14]

We should notice how the use of phrases such as 'in total', with which the passage opens, convey the idea of an absolute overview, a summation of facts. This is the language of Economics; we are told of 'demand', 'external effects', 'price', 'effect'. This is the language of materialism, of things that can be traced in terms of cause and effect.

In more nuanced writing about art markets, an author will carefully set out both his or her methodology and its limitations, explaining how he or she arrived at this particular means of analysis and the questions it is hoped it will answer. Here, for example, is a scholar tracking the taste for paintings in eighteenth-century auctions, focusing on patterns of consumption:

> The concept presented here, that of paintings as bundles of individual characteristics, merges with current theory on consumer habits. The economist Kelvin Lancaster introduced the concept of bundles of characteristics in the 1960s, and scholars subsequently have applied this innovative idea to art consumption. They argue that paintings, in both the past and the present, are bought not only as artworks in and of themselves, but because they represent specific combinations of constituent characteristics. Valuating and pricing paintings on the primary and secondary art market thus is a result of an individual assessment of the separate attributes. A crucial element is that these characteristics are not always inherent in the painting, or intentionally put in by the artist. As

we have seen with the buying trends pertaining to seventeenth-century paintings in the resale market for art in Antwerp and Brussels, auction attendees imposed these characteristics on the paintings, regardless of whether or not they were intended by the painter. As such, these characteristics were employed by customers in their buying behaviour and are crucial for understanding taste patterns.[15]

Art historians have traditionally been concerned with precedents. One of the first concepts that many students seize upon in their early reading about History of Art is the idea of influence: who borrowed or inherited what from whom. The concept of influence has of recent years been subject to a pretty thorough scrutiny, as have the reasons for the powerful hold it has had on generations of art historians. None the less, the question of the antecedents, association and special qualities of works of art still concerns art historians. In the following passage from a book which was published in 1973, but which has been frequently reprinted and remains widely recommended by teachers of undergraduates, the author employs no apparently specialist vocabulary, no meta-language of art history; his writing is, none the less, deliberate and controlled and makes an effect through conscious linguistic manipulation:

> In the *decades after 1848*, the examples of *Courbet and Baudelaire*, and the different *responses to politics* they *embody, stayed obstinately alive*. It is curious how many of the *best artists*, later in the century, tried to combine those responses, however at odds with each other they seemed. Manet in the 1860s, for example, *paying homage* to Baudelaire's disdain for the public life, but aping Courbet's, and *hoping against hope* – or so the viewer feels face to face with *Olympia*, or *looking on* at the *Execution of Maximilian* – for a public picture, a picture to state exactly what its audience did not want to know. Or think of Seurat in the 1880s, keeping silent about politics, in spite of the anarchism of his friends, *staking his claim* to artistic precedence with all the pedantry of a later avant-garde; but *producing* the *Grande-Jatte* or the *Chahut*, images of joyless entertainment, cardboard pleasures, organized and frozen: pictures of fashion, and thus of the place where public and private life intersect.[16]

The language of Art History is here the language of the present, the language of continuity. At least, that is the effect the author seems to be endeavouring to achieve. The construction of the first sentence is striking, dealing as it does first with the period, then with the two individuals,

Courbet and Baudelaire, both established as representative of a 'response to politics', and, finally, with the continuity of this response, which is expressed with an active verb in the phrase 'stayed obstinately alive', which one associates more usually with a person than with a response. It is the use of active verbs and, frequently, the present tense that gives this passage (exemplary of the social history of art) its persuasive power, its sense of a continuous process: 'embody', 'paying homage', 'hoping against hope', 'looking on' (a phrase which suggests succinctly both the way in which we as viewers look at Manet's *Execution of Maximilian* and the relevance, the contemporaneity, of the event portrayed in the picture), 'staking his claim' and 'producing'. Various words are used by Clark provocatively. 'Best' artists, for example, is likely to arouse vigilance in the reader, though few would disagree that Manet and Seurat, and the examples of their work that follow, are good artists and successful paintings.

Clark exploits the capacity of language to surprise by leading the reader to expect one thing but then giving the opposite or, at least, the unexpected. The reader wants to know in the third sentence what Clark means by 'public', but the definition of a 'public picture' that is provided – 'a picture to state exactly what its audience *did not want to know*' (my italics) – is the inverse of what might have been expected and appears perverse. In many ways the language of this art-historical writing is challenging; it is also not without ambiguity. Indeed, Clark exploits ambiguity. In the last sentence of the passage, it is not clear whether 'cardboard pleasures, organized and frozen' is a description of the content of Seurat's paintings or the style and technique in which they are executed. The author does not distinguish between subject and style because both are understood. Perhaps most important is the evident determination of this author to avoid art-historical jargon. The linguistic problems raised by the use of words such as 'politics', 'public' and 'private' remain, but at the very least this writing is accessible to someone outside the discipline of History of Art.

A different kind of authoritative language is used by writers who, conscious of the point I have made that all writing on Art History has an approach or a perspective, make the stating of their position paramount. In other words, they do not assume that we will simply be able to infer where they are positioning themselves *vis-à-vis* the text, the artist, the work (and this is how they would put it, rather than *their* artist, *their* text...), but state prominently their own relationship to the objects they analyse and to the writing they are undertaking. This results in language that has been found by some art lovers, accustomed to basking in the vicarious descriptive pleasures of evocative, ekphrastic writing, to be polemical, stern and unyielding.

But writing of this kind has contributed significantly to the development of the discipline and, though it may be very challenging for beginners, it is important to know that it exists and eventually to work to understand it. Here, for example, is a French philosopher and semiotician (one who analyses linguistic signs) commencing an analysis that interrogates two texts, one verbal and one visual:

> What does it mean to paint oneself? What does it mean *to write (about) oneself*? In what follows these two questions will be played off against each other, just as they will be made to work in tandem. More precisely, we are interested in the crossing over of what is read first in a text and then seen in an image, *in the exchange between two semiotic substances and forms of expression and content, between the two media of enunciation and visual representation*: the imagistic, the written and linguistic. What does it mean to show oneself (to make oneself visible) so as to be read? What does it mean to proffer oneself for reading (to write the self) so as to be seen? In Montaigne's '(Preface) to the Reader', unlike Dürer's 'Martyrdom of Ten Thousand', the slippages between the terms of the visual and the textual are too apparent to be considered nothing more than an *expression of the discourse's metaphorical values*. Our attempt to bring visual representation and written representation into dynamic interaction – not just painting, but the painting of the self, not just writing, but the writing of the self – gives rise to a theoretical and methodological occasion allowing us to grasp with greater rigour and precision *the manner in which these two sets of signifiers function*.[17]

Notice here how the author puts certain words and phrases in parentheses (in brackets). This invites his readers to recognize the complexity of what may at first sight seem simple and unproblematic. To write about oneself seems perfectly straightforward (we all think we know what an autobiography is), but once that 'about' is sidelined – kept in play but isolated and so drawn attention to – we are reminded that the connection between a writer and what is written is not at all straightforward, and, since Marin's concern is how words and images interact, the same is true of a painter and what is painted. Throughout Marin draws on semiotics, or the science of language, in order to work with the elements that two pieces in different media have in common. In the last sentence of the section I have quoted (from a much longer paragraph), the term 'signifier' indicates the separation between the form which the sign takes and the signified or the concept it represents. Drawing on the output of the linguistician Ferdinand

de Saussure, theoreticians working with pictorial and verbal texts propose that signs may be words, images, objects, sounds, etc., but the argument is that these things have no intrinsic meaning until we give them a meaning, and then they become signs. So, for example, a rose is a signifier the signified of which might be horticulture or love or the Virgin Mary or a part of the female anatomy, depending on where it is used. The word 'discourse' halfway through the passage is also an indication of how Marin is going about what he has set out very clearly as a series of questions. The theory of discourse (originating with the work of Michel Foucault) is not about what one person says but about what is communicated in diverse ways across an area of interest. So we might speak of the discourse of physics or the discourse of modernism.

What we have to remember is that anyone engaging seriously in writing Art History is engaging in a struggle to relate what the French philosopher Jacques Derrida has described as decisions about the frame, about what is external to internal description, or (to put it another way) about how far we are able to interpret anything. When individuals are struggling to find new ways of doing things, languages are being borrowed, adapted, forged, and words are nailed to a masthead to signal the identity of a ship sailing what the mariners (or writers) regard as uncharted waters. So words, in this sense, signal the intellectual affiliations of the writers, as well as conveying to us information or ideas, arousing our interest or our opprobrium. To say language indicates to which party or club the writer belongs would sound cynical or pejorative – and this is not what I intend. The 'political correctness' of some forms of writing may be obtrusive. My wish, however, is not to endorse this but to convey the way in which art-historical language serves many purposes, and one of them is to indicate: 'This is where I (or we), the writer(s) stand in relation to the material we are writing about and these are the academic fields of enquiry where we think we have allies.' This may involve an implicit riposte to another party, a challenge, or a reply to an unnamed opposition:

> In Watteau, *a whole narrative structure insists* on meaning but at the same time withholds or voids meaning. Let us take the example of this characteristic theatrical costuming. In the theatre, such clothing is part of a general system of conventionalised costumes with exact dramatic and signalling functions. The diamond-patterned costume signals Arlequin, the baggy, white, ruffed costume signals Pedrolino or Gilles, the black cap and gown signal the Doctor. But outside *the frame of the stage*, in a *fete champêtre*, such *signalling costumes* lose their semantic charge, and having lost that original

meaningfulness take on all the *sadness of depleted signs*. Again, the configuration which appears both in the musical analogy and in *the biographical emphasis of the Watteau literature*: a sign that insists on a signified which is absent, disconnected from the present signifier, at the same time that sign makes the claim for a powerful and attractive signified (melancholy) that is nowhere stated in the painterly signifier.[18]

In this passage the reader again confronts the language of semiology; the meta-language of structuralism has been substituted for that of Art History ('a whole narrative structure') and, unlike in the previous passage, this language is used in relation not to a particular work or group of works but to an artist. The object of study is no longer a particular painting or genre; nor is it, in the conventional sense, the life and work of Watteau. Bryson is concerned with exposing the relationship between what we know of Watteau from the way he has been written about ('the biographical emphasis of the Watteau literature') and what we see on the picture surface. Somewhere between the two a meaning is produced. The question is 'How?' The sadness of Watteau's paintings has always been acknowledged, but Bryson tries to explain this without recourse to the subjective response of the individual viewer (e.g., this picture has a sad feel to it; it makes me feel sadness). To do this he treats the ingredients of the picture's stories as signs for something outside the picture. The theatrical clothes *signal* certain meanings on the stage, which, Bryson indicates, is as much an artificial structure as a picture ('the frame of the stage'), but those meanings are lost when the context is a country picnic (*fête champêtre*). It is characteristic of semiological analysis to discard the notion of a painter making a meaning, embodying it within an image. In this passage the subject of the active verbs is not the artist but the narrative structure, which means not only the painting as object but the frame of reference in the world in general ('a whole narrative structure insists …'). The reference to 'the sadness of depleted signs' suggests the kind of absurdity and bathos that semiologists dealing with visual material can fall into. Nevertheless, in employing a system of analysis which makes a distinction between an image on a canvas ('the signifier') and the meanings it carries ('the signified'), Bryson is able to theorize a problem in Watteau – that is, to point to an underlying principle at work which, it is argued, accounts for the recognized mood of the paintings.

A very great deal of publishing on imagery in the past twenty years has been in the area of photography. The following two examples demonstrate how opposing approaches to a single medium take on very different languages in dealing with their objects of investigation. The first addresses

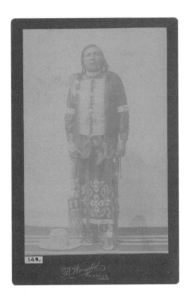 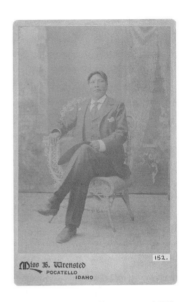

Figure 4.3 (a and b) Benedicte Wrensted, *Pat Tyhee in Native Dress, ca.* 1898,
and *Pat Tyhee after Conversion, ca.* 1899, cartes de visite,
albumen prints, Washington, DC, Smithsonian Institution,
National Anthropological Archives, Eugene O. Leonard
Collection. Reproduced by kind permission of the National
Anthropological Archives/Human Studies Film Archives at
the Smithsonian Institution.

two developments in photography that took place in the last part of the
nineteenth century (Figure 4.3a and b).

> One [photograph] consists of the tamed savage, different types of
> which appeared during this period. The first is to be found in the post-
> cards printed in 1872 depicting Henry Morton Stanley – the explorer
> who found Dr. Livingstone in the heart of Africa … together with his
> young servant Kalulu, who unfortunately died at the age of thirteen on
> a Congo expedition. The scene represented with typical African setting
> reconstructed in the studio is *literally* one of submission, without any
> attempt at masking it. The other *typical depiction* of the subject can be
> described as *'before' and 'after'*, as shown in two photographs taken in
> a different geographical and cultural area, but whose *ideological prem-
> ises* were basically similar to those of images linked to the colonisation

of Africa. They are two portraits of Pat Tyhee, an American Indian of the Shoshone tribe, taken at Pocatello, Idaho, by a female photographer of Danish origin named Benedicte Wrensted, who emigrated to the United States in 1894. While the background remains the same, the subject undergoes radical changes, in the sense that in one picture he is dressed in the American Indian tradition (or rather *according to the codified image of that tradition*), and in the second photo, probably taken the following year, he is wearing Western dress, after becoming a Christian. Religion and culture were assimilated following subjugation, the education of the *'noble savage'* was complete and he could be part of civilised society.[19]

This author is concerned to group what he is examining into types and thus identify 'traditions' and 'ideological premises'. While the word 'politics' is nowhere used, it is clear from the way the author is at pains to remind readers that representations of this kind work according to cultural codes and are organized according to belief systems and bodies of doctrine in society at large (that is, according to ideology). I have drawn attention to the word 'literally' because here it is used correctly – the author really does mean that the photographic subjects were subjugated by the process of posing and photographing them – but it is extensively misused in conversation and is one of those words students might do well to avoid in essays. I have also italicized a number of words in inverted commas, or what are often called 'scare quotes'. This is a way in which writers can indicate that they are using a term in common parlance but one to the meanings of which they do not themselves subscribe. So here the term 'noble savage' derives from eighteenth-century Enlightenment interest in ethnically diverse peoples and the qualities of nobility that were ascribed to their untutored lives in natural settings. The idea of 'before' and 'after' pictures is similarly a cliché that is useful as a shorthand way of describing something but which needs to be approached with caution. Students who use lots of scare quotes are likely to be upbraided for laziness in not being more precise about their terminology.

The difficulties of analysing imagery – one of the traditional preoccupations of Art History in an age that recognizes the power of language and the impossibility of a single point of view – has led art historians to address very precisely the relationship between medium and meaning. In the case of photography, the immediacy of its relation to reality (what is termed indexicality) has not created an objectively identifiable consensus about what any photograph means. While a photograph replicates some thing that exists or existed (the term often used is 'denotative'), it is also personally invested by the viewer and is thus 'connotative'. In other words, viewers do not see it as

neutral. Here is a passage from a book about photography the very title of which, compared with my last example, indicates a different approach and use of language. I have underlined rather than italicized here as the author herself uses italics:

> Several photographers who have emerged in recent years – many of them featured in *The Anxiety of Photography* – are invested in examining and upending another paradox of the medium: how its primary function as a producer of two-dimensional imagery has largely supplanted aspects of its <u>material properties</u>. Interested in more than the image *per se*, these artists' practices have turned our attention to the <u>processes of photographic production,</u> and specifically to the physical and material attributes of the photograph *as an object*. Employing a range of photographic techniques, both <u>analog and digital</u>, these artists in some sense <u>deconstruct the medium</u>. This allows them to consider photography's component parts – the numerous chains of events that must occur prior to the existence of the final image or final grouping (or series) of images. The outcome is oftentimes decidedly <u>tactile</u>, the works resisting the <u>slick surface</u> and inevitable remove of the photo-as-image. This breakdown between the <u>opticality of the image and the haptic potentiality of photography</u> results in slowing down our reading of the photograph, often confusing our assumptions about the fundamental nature of the medium and how photographs operate in the world.[20]

'Analog' (in UK English, analogue) and 'digital' refer to the two techniques of producing photographs. This passage is striking in contrast to the previous one in that the author is concerned not to convey an authoritative single interpretation of a photograph but to question the very nature of how photography works as a medium. Words such as 'material', 'property', 'tactile', 'surface', 'process', 'production' and 'haptic' (meaning the quality of being able to touch) all direct us as readers away from the opticality (the quality of what is to be seen and looked at) of the image and towards the photograph as a physical artefact.

This last passage has introduced us to some of the technical language employed by art historians addressing a particular medium. The materiality of works of art is, as this author demonstrates, not separate from their meanings. Writers on technique often use quite specialized language, but Art History students can quickly accustom themselves to the more basic and commonly used terms. So, to conclude my examples, here are two authors writing in quite different ways about colour; the first is an art historian and the second a museum conservator accustomed to reaching a non-specialist audience.

In order to economise on ultramarine, painters would often lay in an undercolour using a cheaper blue *pigment* such as *azurite,* with a layer of ultramarine only at the surface, as in both the sky and Virgin's robe of Perugino's Certosa di Pavia altarpiece. *Azurite,* another mineral, is more widespread than *lapis lazuli;* it occurs in Italy, France and Spain, and there are large deposits in Germany and Hungary. It was very widely used in painting until the end of the seventeenth century, when sources of supply in Europe became uncertain. *Azurite* needs to be coarsely ground for use, otherwise its colour becomes pale, and it usually possesses a distinctly greenish tone, a disadvantage when painting skies. The colour of *azurite* is perhaps best appreciated in the slightly turquoise blue settings for certain of Holbein's portraits such as the *Lady with a Squirrel and a Starling.*[21]

In this passage, rather like a cookery book, we are advised how pigments (the word used for the substances from which paint is made) are prepared and what their material characteristics are. But also, as in a geological analysis, we are told where the mineral from which azurite is made is found, and this is situated historically. Finally we learn that pigments vary in price and painters sometimes have to economise, so we have also in this passage a language of economics. The second passage is part of an analysis of how the contemporary artist Gerhard Richter uses colours in his 2007 work *4900 Colours*:

There is not a single moment in the history of painting – or so it seems with hindsight, at least – where colour has not been ultimately defined by *contiguity,* the specific *context* in which *it has had to perform* for a particular religious or secular demand, and the *circumstantial functions* that it has had to assume (the scientism of Post Impressionism, for example). We might remind the reader for the moment only of the *historicity* of blue: from the colour representing virginity and sanctity, the *cerulean* was *recoded* in the symbolism of the later nineteenth century to acquire the qualities of the spiritual *azur* (for example Odilon Redon). Fifty years later, in the hands of Yves Klein, it would end up as *a patented claim to embody the spectacle of pure dematerialisation.* It is precisely this innate ambivalence of the *semiotic status* of colour that has made it a subject of perpetual *contestation* in twentieth-century art.[22]

This author is also concerned with the history of colour. He too includes a technical term for a pigment (cerulean is a kind of blue), but his language – almost without the reader noticing – endows colour with agency – that is, with the ability to effect change. Thus colour has 'had to perform' and 'has

had to assume'. There are some short-cut keywords that signal clearly the author's priorities here: 'contiguity' (which he then defines as a specific context, though we might also pick up here the association with closeness), 'circumstantial functions' (by which he seems to mean the particular conditions, ideological or professional, that give rise to the use of colour in a particular way and which are somehow different from context – perhaps in being less fixed), and, instead of 'history', the word 'historicity', a dense and complex term but one which signals that the author regards history not as undisputed truth but as events that claim attention as having happened and which simultaneously are not accessible in undisputed form. Finally, having given us examples of how colour can be, as it were, harnessed to mean various things, depending on when and in whose hands it is used, Buchloh concludes that colour in the work of Yves Klein (1928–1962) becomes something totally abstract that does not refer to anything in the world. The use of the word 'patented', associated more with industrial design, is slightly shocking but suggests the uniqueness of this artist's use of colour, as well as, perhaps, something of the competitiveness of abstract expressionists. And so, after this somewhat breathless romp through from the Renaissance to the twentieth century, the author reaches his conclusion – that colour has always been slippery with regard to what it refers to and what it means (blue for the Virgin, blue as a symbol of some more abstract kind of spirituality in Redon). The use of the word 'contestation' signals that this is by no means a matter of each artist quietly developing his or her own way of using colour, but that colour is fraught with disagreement, claim and counter-claim – a veritable battlefield.

This chapter has been concerned with tracking the kinds of writing students are likely to encounter when studying History of Art at university level. I have looked in detail at *how* art is written about across a range of texts, from the deeply traditional to the highly innovative. In the next chapter I shall address the business of reading, whether in hard copy or online, and I will sketch out some of the different kinds of publication (whether actual or virtual) that you are likely to encounter as an undergraduate in Art History.

Notes

1 Fritz Novotny, *Paul Cézanne* (Vienna: Phaidon Press, 1937), pp. 18–19; italics here, and in quotations throughout this chapter, are mine unless otherwise indicated.
2 Charles Osborne, *The Complete Operas of Verdi* (London: Gollancz, 1969), p. 257.
3 William Walsh, 'John Keats', in *From Blake to Byron*, Pelican Guide to English Literature, vol. 5, ed. Boris Ford (Harmondsworth: Penguin, 1957), p. 224.

4 Charles Harrison, *Art and Language* (Oxford: Blackwell, 1990), pp. 197–8.
5 Mantel's *Bring up the Bodies*, a sequel to *Wolf Hall*, won the Man Booker prize in 2013.
6 Martin Wyld, 'The Restoration of Holbein's *Ambassadors*', *National Gallery Technical Bulletin*, 19 (1998), p. 5.
7 Ann Rosalind Jones and Peter Stallybrass, *Renaissance Clothing and the Materials of Memory* (Cambridge: Cambridge University Press, 2000), p. 47. Authors' italics.
8 Denis Diderot, 'Salon of 1763', trans. and repr. in *Sources and Documents in the History of Art: Neoclassicism and Romanticism* (Englewood Cliffs, NJ: Prentice-Hall, 1970).
9 In *Cucchi*, ed. Doriana Comerlati (Milan: Skira, 2008), p. 119.
10 Howard Morphy, 'From Dull to Brilliant: The Aesthetics of Spiritual Power among the Yolngu', in Howard Morphy and Morgan Perkins, eds, *The Anthropology of Art: A Reader* (Oxford: Blackwell, 2006), p. 304.
11 Peter Humfrey, *Carpaccio* (London: Chaucer Press, 2005), p. 60.
12 Erwin Panofsky, *Meaning in the Visual Arts* (Harmondsworth: Penguin, 1970), pp. 284–6. Authors' italics.
13 Michael Camille, *The Gothic Idol: Ideology and Image-Making in Medieval Art* (Cambridge: Cambridge University Press, 1989), p. 260.
14 Bruno S. Frey and Werner W. Pommerehne, *Muses and Markets: Explorations in the Economics of the Arts* (Oxford: Blackwell, 1989), p. 122.
15 Dries Lyna, 'Name Hunting, Visual Characteristics, and "New Old Masters": Tracking the Taste for Paintings in Eighteenth-Century Auctions', *Eighteenth-Century Studies*, 46/1 (2012), p. 74.
16 Timothy J. Clark, *The Absolute Bourgeois: Artists and Politics in France, 1848–1851* (London: Thames & Hudson, 1973), p. 181.
17 Louis Marin, 'Topic and Figures of Enunciation: It is Myself that I Paint', in Stephen Melville and Bill Readings, eds, *Vision and Textuality* (Basingstoke: Macmillan, 1995), p. 199.
18 Norman Bryson, *Word and Image: French Painting of the Ancien Régime* (Cambridge: Cambridge University Press, 1981), pp. 71–2.
19 Walter Guadagnini, 'The Journeys of Photography', in Walter Guadagnini, ed., *Photography: The Origins, 1839–1890* (Milan: Skira, 2010), pp. 136–7.
20 Anne Ellegood, 'The Photographic Paradox', in Matthew Thompson, ed., *The Anxiety of Photography* (Aspen, CO: Aspen Art Press, 2011), p. 94.
21 David Bomford and Ashok Roy, *National Gallery Pocket Guide to Colour* (London: National Gallery, 2009), pp. 27–8.
22 Benjamin H. D. Buchloh, 'The Diagram and the Colour Chip: Gerhard Richter's 4900 Colours', in *Gerhard Richter: 4900 Colours*, ed. Hatje Cantz (London: Serpentine Gallery, 2008), p. 61.

5 Reading Art History

University libraries pay gigantic subscriptions to databases and other electronic resources as well as to the ALCS (Authors' Licensing and Copyright Society) for the right to make multiple copies of chapters of books and articles or to make this material available on an intranet or via what is known as a VLE (virtual learning environment), where tutors will post reading lists often including scanned chapters or links to articles. As a student you will be able to access these resources on site or remotely via your library using a password. I will say more about these electronic resources later in this chapter. For the moment we should note that great changes are taking place as I write this, with increasing numbers of books available free on the web[1] and moves by the UK government to break down the current journal subscription system that has operated unchanged for hundreds of years in order to allow open access. However, it has to be said that there remain copyright issues, and as a student you are unlikely to find the key books for your coursework on the internet. Moreover, as there is considerable resistance from professional organizations who publish academic journals and who wonder how they can continue to afford to do so if they cannot charge subscriptions, the current system is likely to continue in some form or other for the foreseeable future.[2] So, however dedicated you are to web browsing, as an Art History student, you will probably find that paper will be a mainstay of your studies.

Locating a copy of a book or an article can be a challenge in these days of diminishing budgets. Because books on art are more expensive than those on most other subjects, the problem is particularly acute for anyone studying the history of art. There is no doubt that, wherever you are studying, it will be to your advantage to work in cooperation with your fellow students when locating copies of essential reading. All serious higher-education institutions now run reserve and short-loan sections where the period any student can keep a book in their possession is restricted. Learning how to use your institutional library is the absolute prerequisite to a successful degree course, and this means not only attending all library tours offered

to you but taking time in a relaxed way to find your way around. If you are uncertain where to find something, do not hesitate to ask. If you are studying in a city, you should take time to locate alternative sources of books and journals, whether in the public library or in neighbouring institutions, where you may not have borrowing rights but you will probably be able to read. Photocopying or scanning is often a solution, though it is important to remember that, if you copy more than one chapter of a book, even for your exclusive use, you will be in breach of copyright laws. All this adds up to the message: plan your reading, prepare in advance, keep ahead of your course reading list, and don't panic! If you fail to locate the reading you need, seek advice. There may be alternatives.

A bibliography is, or should be, rather different from a reading list. The former will probably give a wide range of publications across the area you are studying; the latter will indicate more precisely those texts that are essential reading for your classes. The two may be conflated into one list on which essential items are in some way highlighted. If you are uncertain about what you should be reading or about what any particular citation means, ask your teachers. There is nothing demeaning about asking apparently basic questions. Scholarly literature is, as I have indicated in the previous chapter, extremely complicated, and abbreviations may be found on lists (especially for journals with long titles) that may be indecipherable to a newcomer.

Having secured a copy of your text, find somewhere quiet where you won't be interrupted or tempted to abandon a difficult passage to go off with friends for a drink. Under pressure from students, many university libraries have areas set aside for group work or conversation, but equally they have other areas that are (or should be) silent. Most students coming up to university are initially shocked at the amount they are expected to read in a ten-week term or a twelve-week semester. From a restricted series of set books and some background reading, students find themselves facing challenging lists and bibliographies. Effective reading skills are now essential: though there may be books you are required to read cover to cover, it is much more likely that a section, a chapter, or several different parts will be most relevant to your particular needs. Do not try to read everything in a bibliography. Select and, within that selection, make choices. It is better to read, understand and absorb a limited amount than to rush through and forget hundreds of pages. Use the index to locate key words. Do not try to make notes on everything you read, but write down important headings. Do not copy out whole passages of books; this is a waste of time and sometimes leads inadvertently to plagiarism when someone incorporates into an essay what they thought were notes but which is in fact a transcript. Never write on any book you are reading. Librarians discourage post-it stickers as they can damage pages if left for any length of time.

One well-tried way of reading intelligently is to have a pile of white paper markers by your side and to pop one in at a page when something strikes you as of lasting importance. Write a note on the marker as to why it is important, and when you get to the end review all your markers. If you still think something is significant, organize your notes into a more lasting form on a sheet of paper or on your laptop and file it. Reading outside the prescribed list is not only an intellectual adventure but also desirable, as it will alert you to different points of view. Take care to note the date of publication of what you are reading: knowledge about works of art is constantly being revised; artworks get reattributed and also relocated. Effective reading is the key to being able to profit fully from your course; if you experience difficulties, seek help. All institutions should have free study skills courses for students who find it difficult to adapt to the pace and demands of university. Ask about these if you feel you need assistance.

Depending on how 'techie' you are, and how much advice is available to you, you might begin to think of using some of the available software that allows you to integrate the research process with writing your own bibliography, something you will certainly need to do as you begin to write essays and develop theses or projects. Some, such as www.zotero.org and www.mendeley.com, are free; others, such as www.endnote.com, widely used in academia and publishing and available on a free trial, require a financial investment. Such software can automatically extract citations (which should always be proofread) from library catalogues and databases and will capture a pdf of an article from full text databases or capture the current state of a website. More importantly, these programs allow you to group, annotate and tag citations to make it easy to organize and follow up on research. Such reference management software works brilliantly in conjunction with note-taking and capture software such as Evernote (https://evernote.com). There is also specialist software that enables you, with permission of the lecturer, to record lectures and categorize and annotate the material live or after the event (www.sonocent.com/en/audio_notetaker).

The literature of Art History naturally reflects the diversity of approach to the subject discussed in Chapters 2 and 3. Here, however, we are not concerned in any way to discuss the content of books that are mentioned, to dissect their language or to assess the merit of any particular work. In so far as titles and authors are mentioned, they have been chosen only because they provide suitable examples of certain classes of literature. Likewise those electronic resources I cite are those most likely to be used by Art History students at the start of their studies.

If you want to browse Art History books in a bookshop, you have to be quite enterprising these days, as Amazon is often the first port of call (note

that Amazon.com, the US distributor, has more choice than Amazon.co.uk, and second-hand copies are often available). Blackwell's art and poster shop (27 Broad Street, Oxford) is one of the few surviving specialist art bookshops, along with London's Koenig Books (Charing Cross Road and the Serpentine Gallery) and Thomas Heneage Art Books (Duke Street St James's). Waterstone's on Gower Street, which caters generally for London University students, has relatively good stock, and sometimes independent booksellers such John Sandoe Books, Daunt Books and the London Review of Books bookshop (also all in London) can hold interesting items. A gallery shop may, however, be a better bet. The Gallery of Modern Art in Edinburgh, for example, has an excellent bookshop, and the National Gallery's bookshop is one of the best in London. Certain paperback series of art books – for example, the Thames & Hudson 'World of Art' books and Manchester University Press's 'Rethinking Art History' series, as well as best-sellers such as Gombrich's *The Story of Art* and John Berger's *Ways of Seeing*, may be found in any good bookshop.

The economics of the book trade is not our concern in this work but, in passing, a word of warning seems appropriate. Art books with good colour plates cost a great deal of money to make and their production is still regarded by publishers as catering for a small audience. Once art books are out of print it is often quite difficult to persuade a publisher that a reprint would be worthwhile, and even texts widely used in educational establishments have been known to be out of print for years. This can be a real problem, though it is encouraging that the web-based store AbeBooks, which operates in several languages and claims to have 140 million used books for sale, appears to be doing so well.[3]

What about libraries, then? No library has an unlimited budget and, as the price of books has risen, libraries in any one area have tended to pool their resources and to consult each other about expensive purchases, thus ensuring that two copies of a book priced at £300 (not so unusual in 2013) are not acquired in the same region. It may be necessary, therefore, for a student living in an area where there are perhaps several libraries to check online to locate a particular work as described on the next page.

Most university libraries are 'teaching' libraries. That is to say, their holdings reflect the needs of the courses that are taught there. There are, of course, exceptions, such as the Bodleian Library, Oxford; Senate House Library, London; the John Rylands University Library, Manchester; and the library of the Courtauld Institute of Art, University of London, which are as much reference libraries as collections for undergraduate work. Since the writing of undergraduate dissertations and theses has become the norm rather than the exception, university libraries find it difficult to cater for all the needs of students. Many of the special reference libraries,

such as the British Library, the National Art Library, the National Library of Wales or the National Library of Scotland, get very crowded, especially over the summer. These are copyright libraries – they receive a copy of every book printed in the UK. For these libraries you need to apply for a reader's pass and the books are for reference only. As many books are stored off site you may have to order in advance. These big libraries can be quite daunting but equally they can be inspiring, and you will find librarians willing to help you. Many big cities now possess good specialist art reference libraries. Edinburgh, Manchester, Leeds and Birmingham, for example, all have well-stocked art sections in their central libraries. If you want to keep track of new publications about the history of art, put your name on the electronic mailing list to receive the seasonal catalogues issued several times a year by publishers with Art History lists (for example, Yale University Press, Ashgate and Thames & Hudson) or check the review sections in art journals and national newspapers.

Electronic resources and hard copy

Library catalogues and bibliographies

First among electronic resources are library catalogues. Although most students entering university today are familiar with online library catalogues, the libraries of big universities are extremely complex and their catalogues reflect this. So, even if you think you know your way around, it is worth attending introductory sessions that may be on offer. A student should be able to find out not only whether or not the book they want to read is owned by the library (or on order, or being accessioned) but also how many copies the library possesses, where the title is normally shelved, whether it is in the library or out on loan and, if it is out, when it is due back. Some catalogues list other kinds of material that may be in the care of the library (manuscripts, artefacts, prints). Increasingly many academic and specialist libraries are implementing a Resource Discovery Tool (RDT), which sits on top of a conventional library catalogue and returns results of both hard-copy books and individual journal articles (from e-resources to which the library subscribes) which match the search criteria. The British Library has recently introduced this under its 'Search the British Library' option. One very useful electronic resource is the National Academic and Specialist Library Catalogue (http://copac.ac.uk), which gives details of materials in over seventy institutions in the UK. It will tell you where a copy of the book you are looking for is available as well as giving useful publication details. For journals (or serials, as librarians refer to them), Suncat (www.suncat.ac.uk) is a free tool to allow a reader to locate a specific title anywhere

in the UK. A similar resource enabling the location of library holdings in all formats internationally is WorldCat (https://www.worldcat.org). Details of PhD theses, many of which are downloadable in pdf form, are available from the British Library site at http://ethos.bl.uk/. Art Libraries (http://artlibraries.net/index_en.php), an English-language version of VKK (Virtueller Katalog Kunstgeschichte), is a virtual catalogue for art books. Specialist Art History research institutes, such as the Getty in California, have catalogues which, even if you are far away from the library itself, can be helpful in establishing the range of published material on any topic (http://library.getty.edu/cgi-bin/Pwebrecon.cgi?DB=local&PAGE=First). All these aforementioned sites are on open access.

I have so far talked about library catalogues. Subject bibliographies are selected from across a wide range of different kinds of publication and the work of sifting has in part been done for you. The Getty also provides open access to the *Bibliography of the History of Art* (BHA) and to the *Répertoire de la litterature de l'art* (RILA) at http://library.getty.edu/bha. These citation databases, searchable together, cover material published between 1975 and 2007. The International Bibliography of Art covers earlier publications also but is available only through subscription, so you would need to go to your institutional library for this. Similarly ARTbibliographies Modern (ABM) is accessible online through libraries that subscribe and provides full abstracts of journal articles, books, essays, exhibition catalogues, PhD dissertations, and exhibition reviews on all forms of modern and contemporary art, with more than 13,000 new entries being added each year. Full coverage begins in 1974, when the first volume was digitized, but entries date back to the late 1960s. Although more appropriate to the needs of advanced students, the Getty Research Portal (http://portal.getty.edu/portal/landing) is an address that might profitably be included among your bookmarks, as it is an online search platform providing global access to digitized Art History texts, as well as a vast amount of information on provenance, bibliographies, photo archives and research guides. For students of architectural history, a key database is the library catalogue of the Royal Institute of British Architects (http://riba.sirsidynix.net.uk/uhtbin/webcat).

Reference works

The major reference books used by art historians are now accessible and searchable online. However, you will need to go through your institutional library in order to access them. Chief among these is Oxford Art Online, which incorporates Grove Art Online (*The Grove Dictionary of Art*, 34 vols, ed. Jane Turner, London: Macmillan, 1996), Bénézit (Emmanuel Bénézit, *Dictionnaire critique documentaire des peintres, sculpteurs, dessinateurs et*

graveurs, Paris: Gründ, 1976), *The Concise Oxford Dictionary of Art Terms* (Oxford University Press, 2010) and the *Encyclopedia of Aesthetics* (Oxford University Press, 1998). *The Oxford Dictionary of National Biography* (2004, with regular updates, including famous British artists) is available online through libraries. But it is worth pointing out that all these will also be on open access in hard copy in any good university or city library, as will other useful reference books, such as the *Berg Encyclopedia of World Dress and Fashion*, ed. Joanne B. Eicher and Doran H. Ross (Oxford: Berg, 2010), Michael Fazio *et al., A World History of Architecture* (London: Lawrence King, 2009), Georges Duby and Jean-Luc Duval, *Sculpture: From Antiquity to the Middle Ages* (Cologne: Taschen, 2006 – a further two volumes cover from the Middle Ages to the present day), Lynne Warren, ed., *Encyclopedia of Twentieth-Century Photography* (3 vols, London: Routledge, 2006), David Macey, *The Penguin Dictionary of Critical Theory* (London: Penguin, 2001), Peter Brooker, *A Glossary of Cultural Theory* (London: Arnold, 2003) and many others. The last of these (as well as the aforementioned *Berg Encyclopedia* and the *Encyclopedia of Twentieth-Century Photography*) can also in all likelihood be accessed through your institutional library via www.ebscohost.com/.

For those who read German, there is the *Allgemeines Künstlerlexikon* (AKL), successor since 1991 to Ulrich Thieme and Felix Becker's *Künstler Lexikon*, which began to be published in Leipzig in 1907. The database, the platform for which is www.degruyter.com, and which is accessible through libraries, claims to have information on a million artists. The print version follows the database and, while much is in German, articles are now in their original languages, and so there is a lot in English. Although as a first-year undergraduate you are unlikely to need to search for sale catalogues from auction houses, you might find it useful when you come to write a third-year dissertation to know of the existence of an online list of auction house records (www.oclc.org/support/services/firstsearch/documentation/dbdetails/details/SCIPIO.en.html). A similar service is available from www.brill.com/publications/online-resources/art-sales-catalogues-online. These three databases are available only through major libraries, but the National Art Library holds many of the sale catalogues and is open to everyone on application for a reader's ticket. If you are interested in the history of Christian art there is an open-access database at http://ica.princeton.edu/, and there is an enormously useful open-access database of classical art at www.beazley.ox.ac.uk/index.htm. These are just a few recommended among many possible online resources, which are growing at a vast rate. Undoubtedly there will be others planned, if not up and running, before this book reaches its intended audience.

Access to reference material is evolving with breathtaking rapidity, and undoubtedly in the future major reference works will not only be available

online but also be accessible through application software (or 'apps'). It is already possible to access the glossary (published in 2010) to the forty-six volumes of Nikolaus Pevsner's *The Buildings of England* (first published between 1951 and 1974, the index of which – though not the text – is available via a searchable database hosted by the University of York) through an app for use on a smartphone or iPad (http://yalebooks.co.uk/display. asp?K=e2013012516430528). This may well be where the future lies.

Just because a reference book has been around for a long time does not mean it is not useful, unless of course you are focused on contemporary art. The *Encyclopedia of World Art* (New York 1959–68) remains a useful reference tool despite its now rather distant publication date; it contains substantial single- and group-authored essays on major period and genre topics such as 'Etruscan' or 'Portrait'. It can still be a good place to begin, though it needs to be supplemented with more recent and more specialist publications. Like all big reference books, encyclopaedias are published over a long period; they reflect the priorities of the age and country in which they were produced, and their quality varies according to the individual authors recruited. The *Encyclopaedia Britannica* also contains many useful entries for art historians. A student engaging with Venetian art might do worse than start with the history of the Venetian republic that is published there.

Remember that the *Encyclopaedia Britannica* has been through many editions; if you use early editions you may be working with an authentic historical source rather than with an up-to-date reference book. For example, the entry on 'Architecture' in the eleventh edition, published in 1910–11, runs from page 369 to page 444 and offers a stylistic survey from ancient Egypt to the modern, illustrated with engravings and photographs. The author asks rhetorically what the future of modern architecture will be and prophesies the survival of classical styles along with a greater *rapprochement* with engineering and the decorative arts. We might conclude that he was hedging his bets, but what such a text has to offer is not a 'state-of-the-art' analysis but a genuine contribution to historiography of the sort discussed in Chapter 3.

There exist also reference books providing information on sale prices and exhibitions. And there are directories of museums and art galleries as well as of country houses in Great Britain open to the public. These can usually be purchased for a small sum from a good museum bookshop or consulted in a public library. The most useful of all the (confusingly disparate) directories is the *International Directory of Arts*, published in Germany and the USA by de Gruyter (the latest edition, issued in 2012, is also available as an ebook), which contains vital information including addresses, telephone numbers and emails under headings such as 'Museums and Galleries', 'Universities and Academies', 'Societies and Associations',

'Artists, Collectors, Dealers and Auctioneers', 'Art Publishers', 'Periodicals and Journals', 'Antiquarian Bookshops', 'Restorers' and 'Experts'. Most public libraries hold these volumes in their reference sections, and there are few guidebooks that can equal the detailed information on museums throughout the world and their opening times. So consulting this before setting off on holiday or on a study trip is a good idea.

Dictionaries of signs and symbols, glossaries of art terms and other such specialist reference books are also available in confusing numbers. James Hall's *Dictionary of Subjects and Symbols in Art* (rev. edn, London: John Murray, 1987) is a popular paperback and readily obtainable. It is much used by undergraduates, who may, however, need to go to something more specialized as they advance in their studies. Otherwise what you need will depend very much on what area you are studying. *Who's Who in the Ancient World* by Betty Radice, first published in 1971 and reprinted many times by Penguin in paperback, is, for example, a handy accompaniment to the study not only of antique art but also of periods of classical revival such as the eighteenth century.

Image collections

This is an area in which there have been great changes over the past decade. Both the extent and the quality of digitized images online have improved. Most positive for the discipline has been a change of heart among major museums and galleries, meaning that they now allow not only access to their digitized collections but also downloads of low-resolution images free of charge for academic and non-profit-making use. This has been driven partly by strong pressure from the academic community and partly by the creative commons approach to copyright originating in the USA. It is also a case of arts organizations recognizing they were in a losing battle in these days of Wikimages. Remember, however, that databases are only as reliable as the information that is fed into them; electronically retrieved data can only be a starting point.

Many galleries (where all or a proportion of their collections may have been digitized) offer low-resolution downloads under certain conditions. Among the most useful are the British Museum (a site which is not particularly easy to find – its address is www.britishmuseum.org/research/collection_online/search.aspx) and the Victoria and Albert Museum (which similarly has more than one site – the one you will want is at http://collections.vam.ac.uk). You can also go to one of the big image databases which should be accessible through your institutional library. Chief among these are ARTstor (www.artstor.org/) and the Bridgeman Picture Library's educational arm (www.bridgemaneducation.com/).

There are a number of other image databases at the time of writing that are useful to art historians and free to access. These include www.googleartproject.com/; www.wga.hu/index1.html (which at present is more extensive than googleart); www.picturalissime.com (which is a portal to museum collections all over the world). www.portraitindex.de/ (which contains engraved portraits from all periods and is searchable by type) and www.bildindex.de/ (which is a huge repository of around 2 million digitized art and architecture images from thirteen countries) are hosted by the Philipps Universität Marburg. www.europeana.eu, co-funded by the European Union, is an easily searchable site that has not only images of artworks but also exhibition news.

Old-fashioned repositories of black and white photographs should by no means be scorned as they contain material that never reaches a database. The Courtauld Institute of Art in London has long been home to two major History of Art photography research libraries: the Witt Library (paintings, prints and drawings) and the Conway Library (architecture, architectural drawings, illuminated manuscripts, medieval wall and panel painting, stained glass, sculpture, ivories and metalwork). Both libraries are open to the public for a modest charge. Some but by no means all of their holdings may be viewed at www.courtauldimages.com/. Downloads are free for research purposes but, as with most institutional sites, you do have to register. The National Portrait Gallery and the Warburg Institute in London also both have photographic libraries, the former based on named British individuals and the latter on iconography.

For students of the history of architecture, there are several databases of images of architecture: www.archinform.net/, www.ribapix.com and www.greatbuildings.com/gbc.html, to name but three. Most helpfully, Princeton University has put on the web the advice about databases that it provides for its architecture students. This is a rich resource and can be accessed at www.princeton.edu/soa-vrc/images/online/.

Journal articles

Art History students will frequently be instructed to read articles in scholarly journals. These are often available on open shelves in hard copy, but increasingly such material will be confined to electronic access (see my comments on p. 108). If you are able to get hold of hard copies, it will make for a much pleasanter read with much better quality of illustrations. There is also much to be learnt from browsing journals – if you do this you will discover all kinds of interesting things that you would not find if you were dependent on an online search. In the National Art Library (situated in the Victoria and Albert Museum), as well as in most university libraries, hard

copies of many of the current numbers of journals for art historians are on open display at the entrance to the library. The journals you are perhaps most likely to encounter range from the traditional (*Burlington Magazine* and *Apollo*) to the innovative (*Art History*, *Representations*, *October*), with many in between. All will have things to offer; the traditional journals may focus on new discoveries about provenance or the material aspects of art, while the others may have a more theoretical foundation and cover a range of subjects beyond what is traditionally understood as 'art'. The review columns of these journals and their exhibition listings help readers keep in touch with the discipline. Through your institutional library you will be able to read articles online covering the complete lifespan of the journal. Many will be held on a site called JStor, which is easy to use and from which, once you have logged in, and subject to agreeing certain terms, you can download a pdf. Articles in journals represent the cutting edge of the discipline: some have a longish lead time for publication, but essays tend to appear much more quickly than books. It is also worth noting that some foreign-language titles also publish some of their articles in English.

It would be very difficult adequately to classify the journals for Art History, and it should be noted that many journals that do not specifically address the visual arts carry articles from time to time that may be of great importance to art historians. Among them would be *Victorian Studies* and *Past and Present* (history journals), *New Formations* (sociology), *Feminist Review* and *Renaissance Studies* (literature, history and cultural studies), *Screen* (film studies), the *British Journal of Aesthetics* (philosophy) and the *Journal of Design History*. If you are interested in art-world current affairs, try *The Art Newspaper* (saleroom news, book reviews and international art gossip).

If we consider journals that specialize in visual communication, we might usefully isolate the glossy, large-format international magazines which carry substantial amounts of advertising for the art trade and specialize in high-quality reproduction. Best known is *Apollo*. Distinguishable from these are those journals (not necessarily with a smaller circulation) which carry less advertising and which are informed by an editorial policy attuned more to debate and analysis and concerned less with attribution and classification. Many of these are edited from within institutional Art History departments, some by individuals and others by collectives. They would include *Art History* and the *Oxford Art Journal* (leaders in the UK), the *Art Bulletin*, *Art Monthly*, *October* and *Representations* (published in the USA, the last two being much concerned with literary theory as well as visual communication). Concentrating on particular aspects of visual and material culture are the *Architectural Review*, the *RIBA Journal*, *Word and Image*, *History of Photography*, *Texte zur Kunst*, *Third Text*, *Artibus Asiae*, the *International Journal of Cultural Property* and many others.

Books

The availability of the kinds of books needed by Art History students has been discussed earlier. Books on Art History are much less commonly available electronically than in disciplines such as Medicine or Law, though some more popular works may be purchasable as ebooks. Google books (http://books.google.co.uk/, also available as an app) may sometimes be useful, but caution is needed as often it is not the latest edition of a particular title that has been scanned, and some are incomplete. An easy way into digitized texts (including out-of-print books and articles) is via www.archive.org/. The books you will be recommended to read tend to fall into several groups.

Surveys and general histories

These are the books that students of History of Art usually encounter first; they may be period-based, organized around a notional movement in art, or genre-based (i.e., devoted to the arts and architecture of any given period and country, on a body of work characterized by style, or on a type of art production such as the portrait or landscape painting). They are useful provided the reader appreciates the intellectual constraints under which such publications are produced. Any survey or general history depends upon notions of continuity and development, so it is difficult in such works to challenge received ideas about historical process. Moreover, because they often cover large time spans, they are extremely selective in what they include and tend, therefore, to depend upon a rather broad (and conservative) consensus about what is important and significant. There is an air of the all-inclusive about a book such as *Portraiture* by Shearer West (Oxford University Press, 2004), which covers the fifteenth century to the late twentieth century; for all its usefulness, this may seduce the inexperienced reader and may persuade him or her that whatever is found there represents the whole that can be said. The more popular among such works can be simplistic and misleading and, often many times reprinted by publishers with an eye to quick profits, may not reflect recent scholarship. So look at the copyright page when you take a general history off the shelf and see when it was first published and whether it has ever been revised. Lavish illustrations do not compensate for a superficial or cliché-filled text.

Probably the most famous series of period surveys are the Pelican Histories of Art, first published in the 1950s. The rights were purchased by Yale University Press, which since the early 1990s has issued revised editions in larger format with improved imagery and, in some cases, completely new texts. At the same time the range has been extended to cover China, Russia and the Indian subcontinent.

For a richer and more provocative approach to period study, students will do well, however, to move quickly to a book such as Michael Baxandall's *Painting and Experience in Fifteenth-Century Italy: A Primer in the Social History of Pictorial Style*. First published by Oxford University Press in 1972, this is a classic of its kind, approaching the idea of a period with an unusually questioning mind. A further example of an innovative approach to the art-historical study of a period and place (avoiding a restrictive notion of genre as well as the list-of-artists ingredient of general histories) is *The Rococo Interior: Decoration and Social Spaces in Early Eighteenth-Century Paris*, by Katie Scott (Yale University Press, 1995).

It has been argued (by Rozsika Parker and Griselda Pollock in *Old Mistresses: Women, Art and Ideology*, London: Routledge & Kegan Paul, 1981) that surveys have written women artists out of the history of art. If this is so, a great deal of effort has been expended over recent decades in restoring women artists to the canon, and it is now possible to purchase surveys that deal exclusively with their work (see, for example, Elke Linda Buchholz, *Women Artists*, New York and London: Prestel, 2003) as well as more specialized studies (such as the catalogue of an exhibition held in Los Angeles and Mexico City in 2012 entitled *In Wonderland: The Surrealist Adventures of Women Artists in Mexico and the United States* (ed. Ilene Susan Fort *et al.*, New York: Prestel, 2012). A further criticism might be that surveys tend to concentrate on Western art and overstress post-Renaissance art. Hugh Honour and John Fleming's *A World History of Art* (London: Macmillan, many editions since 1982), however, makes an impressive attempt to balance East and West, ancient and modern.

Books on movements or developments that have been conveniently labelled for posterity (usually by critics rather than by participating artists) are available by the dozen. Studies of Impressionism, Fauvism, Cubism and Surrealism vary enormously in value as regards both the text and the quality of the illustrations. Extreme care is necessary in the choice of these books. It is difficult to lay down hard and fast rules, but there are two useful criteria. In the first place, any serious study of a movement in art should include more than anecdotal discussion of the critical history of the period or group (in other words, what was said by critics and the public about works of art and how the artist came to be given this particular name). These are, after all, labels that have been invented largely for the convenience of 'packaging' and, consequently, simplifying history. Therefore, in the second place, a worthwhile and successful study of a movement in art does not seek to establish uniformity at the expense of contradiction and variety.

The same applies to books on style: the 'baroque' is a label applied retrospectively to art of the seventeenth century that blurs the contradictions and controversies surrounding art forms that broke with classical rules. But it is also a term that has been adopted by analysts of contemporary art and

entertainment. Anyone who has looked at the activities and creativity of a group of artists at any one period of time recognizes the problem that frequently faces the historian. All the participants and objects of study seem so various, so eccentric, so individual that one is bound to ask 'Whatever did they have in common?' The question is simple but the answer is complex. The art-historical study that seeks to iron out differences or to ignore paradoxes in the interests of a neat explanatory account must be suspect. We should, one writer has recently argued, resist a conceptualization of art history as linear periodization and think of baroque 'as a "conceptual technology" that does not simply allow retrospective understanding but actually provokes new forms of historical conceptualization and interpretation.'[4]

Anthologies of primary sources

The expansion of Art History across a range of educational institutions has led to increasing provision of what might be called 'teaching collections'. These are anthologies of historical published material of importance to art-historical study, whether from the distant past or from more recent times, whether written by artists or by critics. These publications give the reader access to excerpts from texts that have turned out to be of particular importance for shaping our ideas about art and its production. *A Documentary History of Art*, edited by Elizabeth Holt (begun in the 1940s but revised and reissued by Anchor Books), was one of the first, and it was followed by *Sources and Documents in the History of Art*, published by Prentice-Hall International in volumes covering different periods and nations and edited by different individuals. The field of British art was well served by Bernard Denvir's *A Documentary History of Taste in Britain* (London: Longman, 1983), while *Art in Theory, 1900–1990*, edited by Charles Harrison and Paul Wood (Oxford: Blackwell, 1992), has texts by artists, critics, philosophers and political and literary figures.

There is now a plethora of such anthologies. I will mention just three. The first, *Art and its Histories: A Reader* (ed. Steve Edwards, New Haven, CT, and London: Yale University Press in association with the Open University, 1998), is an extremely useful selection ranging from the sixteenth to the late twentieth century organized according to subject area (academies and museums, the changing status of the artist, and so on). The second is Eric Fernie, ed., *Art History and its Methods* (London: Phaidon, 1995, and many reprints). The third, *The Art of Art History: A Critical Anthology* (ed. Donald Preziosi, Oxford University Press, 1998), is also organized under subject headings but includes many challenging theoretical and philosophical texts (from Immanuel Kant to Martin Heidegger), all of which are classics but with which undergraduates would probably need some guidance. There has also been a welcome trend in translating and publishing some foundational texts for the discipline in their entirety, as, for example, in

the case of the important *Historical Grammar of the Visual Arts* by Aloïs Riegl (1858–1905) (trans. Jacqueline E. Jung, New York: Zone Books, 2004).

Monographs

People often mean different things when they speak of a 'monograph', but for our purposes it means a study of the work of an individual, a collaborating partnership or a group. It may aim to explore a long period of time or a particular moment: as its title suggests, Mark Crinson's *Stirling and Gowan: Architecture from Austerity to Affluence* (New Haven, CT, and London: Yale University Press, 2012) is not a study which is confined to listing and describing all the buildings designed by a distinguished architect but aims to understand and explain the partnership of two architects between 1956 and 1963. The more famous an artist or architect, the more likely that a monograph will address a particular aspect of the oeuvre (the entire known body of work) or examine relationships between an artist and their contemporaries. So Margaret Carroll's study is titled *Painting and Politics in Northern Europe: Van Eyck, Bruegel, Rubens, and their Contemporaries* (University Park: Pennsylvania State University Press, 2008). Increasingly, monographs are merging with exhibition catalogues, as big shows are accompanied by catalogues that contain far more than lists of works shown and, whether single- or multi-authored, often take on the tasks formerly performed by single-author books.

Catalogues

There are two main types of scientifically presented catalogue of works of art with full historical and physical documentation provided. On the one hand, there is the critical catalogue of one artist's work or of that particular part of an artist's oeuvre in one medium. The examples I am using here as a demonstration of how a *catalogue raisonné* (a reasoned catalogue) works are the drawings of Parmigianino, a sixteenth-century Italian artist, and the paintings of Emil Nolde, who died in 1956. The other type of catalogue is that prepared by a museum or art gallery (or on behalf of a private collector) on a chosen group or category of works in a permanent collection. These are usually selected according to period, school or medium. Typically, catalogues such as these take many years to compile and are published volume by volume, sometimes over many years. It may well be that these catalogues, with their limited market and short print runs, will increasingly be confined to electronic form. However, the British Museum is still publishing magnificent tomes in this category (see, for example, the lavishly illustrated two-volume *Italian Renaissance Ceramics: A Catalogue of the British Museum Collection* by Dora Thornton and Timothy Wilson (2009).

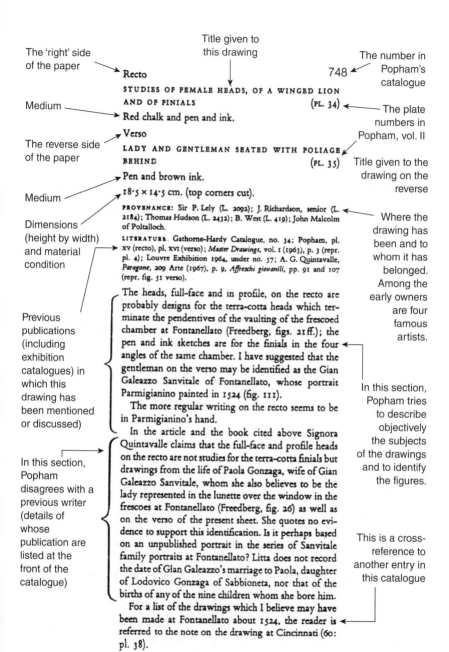

The 'right' side of the paper

Title given to this drawing

The number in Popham's catalogue

Recto 748

STUDIES OF FEMALE HEADS, OF A WINGED LION
AND OF FINIALS (PL. 34)

The plate numbers in Popham, vol. II

Medium

Red chalk and pen and ink.

Verso

The reverse side of the paper

LADY AND GENTLEMAN SEATED WITH FOLIAGE
BEHIND (PL. 35)

Title given to the drawing on the reverse

Pen and brown ink.

Medium

18·5 × 14·5 cm. (top corners cut).

Dimensions (height by width) and material condition

PROVENANCE: Sir P. Lely (L. 2092); J. Richardson, senior (L. 2184); Thomas Hudson (L. 2432); B. West (L. 419); John Malcolm of Poltalloch.

Where the drawing has been and to whom it has belonged. Among the early owners are four famous artists.

LITERATURE. Gathorne-Hardy Catalogue, no. 34; Popham, pl. XV (recto), pl. XVI (verso); Master Drawings, vol. I (1963), p. 3 (repr. pl. 4); Louvre Exhibition 1964, under no. 57; A. G. Quintavalle, Paragone, 209 Arte (1967), p. 9, Affreschi giovanili, pp. 91 and 107 (repr. fig. 51 verso).

Previous publications (including exhibition catalogues) in which this drawing has been mentioned or discussed)

The heads, full-face and in profile, on the recto are probably designs for the terra-cotta heads which terminate the pendentives of the vaulting of the frescoed chamber at Fontanellato (Freedberg, figs. 21 ff.); the pen and ink sketches are for the finials in the four angles of the same chamber. I have suggested that the gentleman on the verso may be identified as the Gian Galeazzo Sanvitale of Fontanellato, whose portrait Parmigianino painted in 1524 (fig. 111).

The more regular writing on the recto seems to be in Parmigianino's hand.

In this section, Popham tries to describe objectively the subjects of the drawings and to identify the figures.

In this section, Popham disagrees with a previous writer (details of whose publication are listed at the front of the catalogue)

In the article and the book cited above Signora Quintavalle claims that the full-face and profile heads on the recto are not studies for the terra-cotta finials but drawings from the life of Paola Gonzaga, wife of Gian Galeazzo Sanvitale, whom she also believes to be the lady represented in the lunette over the window in the frescoes at Fontanellato (Freedberg, fig. 26) as well as on the verso of the present sheet. She quotes no evidence to support this identification. Is it perhaps based on an unpublished portrait in the series of Sanvitale family portraits at Fontanellato? Litta does not record the date of Gian Galeazzo's marriage to Paola, daughter of Lodovico Gonzaga of Sabbioneta, nor that of the births of any of the nine children whom she bore him.

This is a cross-reference to another entry in this catalogue

For a list of the drawings which I believe may have been made at Fontanellato about 1524, the reader is referred to the note on the drawing at Cincinnati (60: pl. 38).

Figure 5.1 A. E. Popham, *Catalogue of the Drawings of Parmigianino* (New Haven, CT, and London, 1971), vol. I, p. 215.

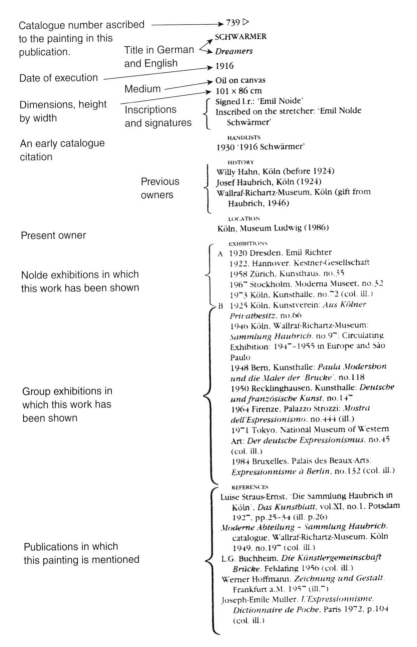

Catalogue number ascribed ——————→ 739 ▷
to the painting in this SCHWARMER
publication. Title in German ↙ *Dreamers*
 and English ↘ 1916

Date of execution ————————→ Oil on canvas
 Medium ————→ 101 × 86 cm

Dimensions, height ⎧ Signed l.r.: 'Emil Noide'
by width Inscriptions ⎨ Inscribed on the stretcher: 'Emil Nolde
 and signatures ⎩ Schwärmer'

 HANDLISTS
An early catalogue 1930 '1916 Schwärmer'
citation
 HISTORY
 ⎧ Willy Hahn, Köln (before 1924)
 Previous ⎨ Josef Haubrich, Köln (1924)
 owners ⎪ Wallraf-Richartz-Museum, Köln (gift from
 ⎩ Haubrich, 1946)

 LOCATION
 Köln, Museum Ludwig (1986)
Present owner

 EXHIBITIONS
 A 1920 Dresden. Emil Richter
 1922. Hannover. Kestner-Gesellschaft
Nolde exhibitions in which ⎨ 1958 Zürich, Kunsthaus. no.35
this work has been shown 1967 Stockholm. Moderna Museet, no.32
 1973 Köln, Kunsthalle. no.72 (col. ill.)
 B 1925 Köln. Kunstverein: *Aus Kölner
 Privatbesitz*. no.66
 1946 Köln, Wallraf-Richartz-Museum:
 Sammlung Haubrich. no.97: Circulating
 Exhibition: 1947-1955 in Europe and São
 Paulo
 1948 Bern, Kunsthalle: *Paula Modersohn
 und die Maler der 'Brucke'*. no.118
 1950 Recklinghausen. Kunsthalle: *Deutsche
Group exhibitions in und französische Kunst*. no.147
which this work has 1964 Firenze. Palazzo Strozzi: *Mostra
been shown dell'Espressionismo*. no.444 (ill.)
 1971 Tokyo. National Museum of Western
 Art: *Der deutsche Expressionismus*. no.45
 (col. ill.)
 1984 Bruxelles. Palais des Beaux-Arts:
 Expressionnisme à Berlin, no.132 (col. ill.)

 REFERENCES
 Luise Straus-Ernst. 'Die Sammlung Haubrich in
 Köln'. *Das Kunstblatt*, vol.XI, no.1. Potsdam
 1927. pp.25-34 (ill. p.26)
 Moderne Abteilung - Sammlung Haubrich.
 catalogue. Wallraf-Richartz-Museum. Köln
Publications in which 1949. no.197 (col. ill.)
this painting is mentioned ⎨ L.G. Buchheim. *Die Künstlergemeinschaft
 Brücke*. Feldafing 1956 (col. ill.)
 Werner Hoffmann. *Zeichnung und Gestalt*.
 Frankfurt a.M. 1957 (ill.7)
 Joseph-Emile Muller. *L'Expressionnisme.
 Dictionnaire de Poche*. Paris 1972. p.104
 (col. ill.)

Figure 5.2 M. Urban, *Emil Nolde: Catalogue Raisonné of the Oil Paintings*, trans.
G. Parsons (London: Sotheby's, 1990), vol. II, *1915–51*.

A catalogue entry should contain, in compressed form, all the important factual data available at the time of publication about any one of a group of works of art. Figures 5.1 and 5.2 show entries from the *catalogues raisonnés* on Parmigianino and Nolde named above. Although there are slight variations in format from catalogue to catalogue, the process of decoding is more or less the same. As new information becomes available, catalogues are revised and supplements are published. Before consulting any catalogue entry, it is as well to look at the front of the book, where you will usually find a list of abbreviations and guidance on accessing and using the information. It is also worth bearing in mind that *catalogues raisonnés* serve the needs not only of museums and galleries but also of auction houses and dealers, who may have sponsored their publication.

As I remarked earlier, big exhibitions are often the occasion for publication of catalogues that contain lengthy essays as well as data on the exhibits. When thoroughly researched and well illustrated, such catalogues are indispensable to the art historian. They can be very expensive, but many exhibitions offer hand-lists of exhibits free of charge, enabling visitors to get around the exhibition and to consult the catalogue in the library later. In principle the exhibition catalogue entry performs some of the functions of the *catalogue raisonné* entry but usually with less detail. It offers, for example, not information on all the known drawings by an artist, but documentation on works of art that have been assembled for display from collections, both public and private, all over the world. The subject of the exhibition may be an artist, a period, a theme or any one of a great variety of other things. There will probably be an introductory essay or essays as well as the entries. It is sometimes the case that an exhibition catalogue is the only item in print on a particular artist, and for contemporary art in particular exhibition catalogues are a uniquely valuable resource. Ideally one should visit the exhibition with the catalogue, but it may be so heavy that you don't want to carry it round with you and, in any case, even long after the show is over, the catalogue remains a rich source of interest and enjoyment. One way of thinking about exhibition catalogues is to see the exhibition as a kind of laboratory experiment in which objects not normally juxtaposed are seen in the same space and the catalogue as the record that survives after the show – which is ephemeral – has ended. A good example of this is the catalogue *In Wonderland* mentioned earlier (see p. 120).

Studies in iconography

Iconography was described by Erwin Panofsky, widely regarded as one of the founding fathers of the discipline of Art History, as 'that branch of the history of art which concerns itself with the subject matter or meaning of

works of art, as opposed to their form'.[5] Panofsky (an example of whose writing we have already examined; see p. 94) identified two stages of study: firstly, the motifs in the visual field have to be identified and classified (iconography); and, secondly, their deployment has to be analysed historically. This latter he terms iconology. Books on iconography usually take a specific theme and trace variations in the presentation and meaning of that theme in the work of different exponents within a given period of time. Alternatively, they may take particular monuments or images and interrogate the subject matter. Many art-historical books employ iconography and iconology as methods among others, though they may expand their study of content way beyond the parameters established by Panofsky. It is usually apparent in their titles that such books are concerned with the subject matter of artworks even if the word 'iconography' is not used (as with, for example, Marcia Kupfer, ed., *The Passion Story: From Visual Representation to Social Drama*, University Park: Pennsylvania State University Press, 2008).

Although iconographical and iconological analysis remains pervasive throughout the discipline, including among modernists, it is still particularly strong in publications on art in early Christian, medieval and early modern Europe because of the programmatic nature of much art produced in societies where religious belief and practice were powerful. A typical example of such a book would be *The Iconography of the Sarcophagus of Junius Bassus: Neofitus iit ad Deum*, by Elizabeth Struthers Malbon (Princeton, NJ: Princeton University Press, 1991). Traditionally, since iconographic study involves charting the incidence of repeated motifs and changes and transitions in meaning, it is backed up by a huge apparatus of footnotes, ranging through a variety of languages and expanding the substance of the main text in all directions.

Theory and method

Some aspects of this type of publication have been covered in the earlier section on anthologies, but theory and method is such a growth area it is worth dealing with it more extensively. Any self-respecting art historian will ensure that they make clear what their methodology is (i.e., on what basis they are collecting their material and how they are drawing their conclusions) and that their work is underpinned by theory; they will demonstrate how the theory works in relation to the examples from 'real life' that they have adumbrated. Whether the theory is convincing will depend on how far the evidence (based on empirical findings) is convincing. Nor will empirical work, meaning that based on experience (and, by implication, lacking theory), stand up to scrutiny on its own. To take an exaggerated and hypothetical example, an art historian assembles a huge amount of

data on Gauguin in Tahiti based on how many canvases he painted per week and with what dimensions. This evidence tells us nothing without a theory, whether it be based on climate (more in the hot season and fewer in the cold), the market (larger canvases mean more money), psychoanalysis (the intervals in the production of canvases represent a masculine and Western response to the female life rhythms of Tahitian inhabitants) or anthropology (the production of canvases as a counterpart of the social and religious rituals or the indigenous population). Theories of viewing and spectatorship (ranging from voyeurism to neurosciences) have been instrumental in moving on discussion of imagery from what amounts to a simplistic 'this is what I see, this is what I like' position. I recently heard a man give a presentation in an art gallery on the subject of contemporary photographs featuring young men and boys. Because he had not worked out any theoretical position for himself (for example, one that posited the photographer's studio as a space of self-dramatization, or one that proposed lighting as a manipulative agency in representations of the body, or one that posited the construction of a relationship between invisible photographer and visible model), he was reduced merely to putting into words what he was showing us on his powerpoint presentation while emoting over certain images of boys that had acquired special resonance for him personally. Unfortunately this is not a way of making convincing arthistorical arguments. Theory is needed for this, even if it is undeclared.

Over the past forty years there has been an explosion of theory in all the humanities disciplines, and it is over theory and its place in the academy that, as I indicated in Chapter 3, the fiercest and most bitter battles have been fought. To sceptics, the theoreticians are self-indulgent intellectuals playing games. To the proponents of theory, their opponents are obstinate and blinkered reactionaries who are satisfied with simple causal explanations. There is no doubt that engagement with theory has enriched Art History as a discipline and that excesses, if such there are, will in the fullness of time appear as mere hiccoughs in the shaping processes of the discipline. History must cohabit with theory and theory with history. The impact of theory on the discipline will be evident to any student browsing through some of the journals I have named.

While the issue of the role of theory and the importance of the work of historians and philosophers such as Giorgio Agamben or Jacques Derrida for students of visual culture remains highly contentious (one of Derrida's books is called, provocatively, *The Truth in Painting* (Chicago: University of Chicago Press, 1987)), theoretical books have long been central to arthistorical study. These are the books that examine the doctrines and patterns of belief, the theories and principles that (it can be argued) informed an artist or a group of artists. Classic studies of this kind are Anthony Blunt's *Artistic Theory in Italy, 1450–1600* (Oxford: Clarendon Press, 1940) and

Rudolf Wittkower's *Architectural Principles in the Age of Humanism* (New York: W.W. Norton, 1949). Magisterial works of this sort are less in tune with contemporary approaches, which tend to allow the disputatious and fragmented nature of intellectual enquiry to show itself. Accordingly, a collection such as *Visual Culture: Images and Interpretations* (ed. Norman Bryson, Michael A. Holly and Keith Moxey, Hanover, NH: University Press of New England, 1994) not only has no single point of view and no unifying language but actually highlights debate by including a response by a different author at the end of each chapter.

There are now many books, some edited, some by a single author, that aim to smooth the way for undergraduates by describing and explaining methods and approaches to working with art-historical material. The terrain is far from level, with some periods and media receiving lots of attention and others none at all. It is, for example, easy to find introductions to theories and methods in relation to the analysis of film but well nigh impossible to find anything similar on eighteenth-century ceramics. And yet undergraduates are universally expected to take courses on theory, methodology and historiography (the history of the discipline). Some books that address these areas are likely to be too difficult for a beginner. Margaret Iversen and Stephen Melville's *Writing Art History: Disciplinary Departures* (Chicago: University of Chicago Press, 2010), for all its merits, is likely to prove a challenge. Among the more user-friendly for undergraduates at the start of their studies are Michael Hatt and Charlotte Klonk, *Art History: A Critical Introduction to its Methods* (Manchester: Manchester University Press 2006), the very useful and accessible work edited by Robert S. Nelson and Richard Shiff entitled *Critical Terms for Art History* (Chicago: University of Chicago Press, 1996, and later editions) and Malcolm Barnard, *Art, Design and Visual Culture: An Introduction* (Basingstoke: Macmillan, 1998).

Books on technique

The most important books on technique are, as far as the art historian is concerned, often those that have been written by artists themselves. Treatises such as Leon Battista Alberti's *Dell'architettura, della pittura e della statua* (originally published as three separate books but available as a collection in English translation since 1755), Leonardo da Vinci's *Trattato della pittura* and Cennino Cennini's *Il libro dell'arte* (all of which are available in modern English translations) are a mine of information on the techniques and practices of Renaissance painters and, since their authors did not hesitate to digress into anecdote, are also very entertaining reading.

Many worthwhile and interesting books on technique were published during the second half of the nineteenth century, when the creation of national

museums in many European capitals lent impetus to scientific and analytical studies of the material of art. Despite its disconcertingly long title, Mrs Mary Philadelphia Merrifield's book. *The Art of Fresco Painting as practised by the Old Italian and Spanish Masters, with a Preliminary Inquiry into the Nature of the Colours used in Fresco Painting, with Observations and Notes* (1846) is readable and informative and, as it exists in a reprint of 1952, is not as inaccessible as at first might appear.

These older books should be consulted and read alongside the more recent reference works on the subject of materials, as their authors were constrained by the technical expertise and the historical interests of the period in which they lived. Perhaps the best known of these is Max Doerner's *The Materials of the Artist and their Use in Painting, with Notes on the Techniques of the Old Masters* (1976, translated and revised). Books that originated as exhibition catalogues for works in particular media have also become useful general texts. Two examples are Marjorie B. Cohn, *Wash and Gouache: A Study of the Development of the Materials of Watercolour* (Cambridge, MA: Fogg Art Museum, 1977), and Susan Lambert, *The Image Multiplied* (London: Victoria and Albert Museum, 1987).

There is a large and highly specialized technical literature on art and conservation, much of it coming from well-endowed museums and foundations in North America. While much of this is necessarily somewhat inaccessible to the untrained, major exhibitions often incorporate this kind of data in manageable form, and a publication such as the National Gallery's technical bulletin can make fascinating reading and enhance one's knowledge of the material construction and condition of works of art. I have included examples drawn from this literature in Chapter 4 (see p. 105). It is, however, important not to be dazzled by science and technology; technical matters are also historical matters when dealing with artefacts and, however wonderful new techniques for dating or for analysing pigments may be, what matters is how we interpret the evidence that such techniques provide.

Notes

1 See www.gutenberg.org/browse/authors/p (accessed 28 January 2014).
2 You can find those journals that are on open access by consulting the Directory of Open Access Journals (www.doaj.org).
3 www.abebooks.co.uk/.
4 Helen Hills, ed., *Rethinking the Baroque* (Farnham: Ashgate, 2011), p. 3.
5 'Iconography and Iconology: An Introduction to the Study of Renaissance Art', in E. Panofsky, *Meaning in the Visual Arts*, many editions.

6 And what are you going to do now?

For Kate Middleton, doing a degree in Art History may have been a stepping-stone to becoming a member of the royal family, but most graduates in the subject have to get a job. When considering what degree course to follow at university, students, and their parents, are naturally anxious about their career prospects. Contrary to popular mythology, Art History (as this book should already have made clear) is a rigorous academic route to a degree. It is not a 'Mickey Mouse' subject, as all those graduates who work in what are loosely termed the creative industries will testify. Moreover, a good degree in Art History does not preclude entering those professions for which a first degree in the humanities is a normal prerequisite (accountancy, the law, management, teaching). As Art History's position in the 'A'-level syllabus looks increasingly tenuous, it is more than ever important that those choosing university courses should understand what careers might be open to them. So this chapter comprises a series of personal accounts by women and men who graduated from Art History courses in universities across the UK and who have made careers in a variety of fields. Some but not all of them went on to a postgraduate degree. Their stories are inspiring as well as entertaining; examples of tenacity and determination, a refusal to be discouraged, a willingness to get work experience whenever and wherever it is on offer, and an ability to be enterprising and to make imaginative leaps abound. All were asked to describe how they reached the position they are now in, what that work entails, and how their Art History degree helped them or has been useful to them. I am immensely grateful to these contributors (whom I term 'participants', for that is what they are) for having been prepared to take time away from their busy lives to help those at the start of their student days to see what things are possible.

Olivia Rickman is Press and Public Relations Manager at the British Museum (www.britishmuseum.org/). She graduated in History of Art from the University of Glasgow in 2004. It was an 'A' level in History of Art that set her on her way:

Ever since I opted for History of Art 'A' level, looking to expand my horizons, the study and enjoyment of the arts has taken me on a thrilling and fulfilling journey. It has been hard work, and I won't pretend I have been well paid, but I have made the best and most interesting of friends along the way; my studies and subsequent work in the cultural sector have always been interesting and stimulating; and these days my job does pay the bills and has allowed me to get involved in projects around the world. I have been extremely lucky with the opportunities I have had, but I do believe that 'the harder you work, the luckier you become'.

Ultimately I followed my passion. Unsure of where my skills lay, I figured that, although not vocational, my degree would give me knowledge I would enjoy and benefit from for the rest of my life. During university I worked my way through student jobs, from distributing leaflets and bar work to administration on arts projects, to earn my beer money and build up my CV. After graduation I gave myself one year to make a career for myself in the arts; beyond that I would do something practical such as a corporate graduate training scheme. After months of research, applications, speculative letters and phone calls I got the DREAM placement: a three-month internship at the Peggy Guggenheim Collection in Venice, which offered a small stipend. This position provided a genuine training environment working alongside fellow arts graduates from around the world and, as a result, was a hugely empowering experience. Inspired, I moved to London to give myself the best chance of finding museum work. I soon learnt that internships and placements were highly competitive, badly paid if at all, and not geared towards on-the-job-training like at the Guggenheim. This is not an acceptable state of affairs, but I do believe things are changing, slowly. In my career I have recruited and managed work-experience positions and have tried hard to make sure that the arrangements are mutually beneficial.

In the first few years of my career I had to work extremely hard in entry-level roles, but in that time I found my niche; I realized I was good at publicizing and marketing museums, an area in which a passion for the subject can take you far! I worked my way through jobs at small museums working with small teams across the organization, meaning I learnt quickly and understood how my input fitted into the overall success of the museum. Today, I work in the press office at the British Museum, managing media coverage and leading on campaigns for major exhibitions. I get to work with some of the brightest

and most interesting people in their field. I have always put myself forward for experiences beyond my role and grabbed (or created) every opportunity to learn and get noticed. Beyond my job, I am on the committee that founded and organizes the annual Cultural PR Conference for in-house press officers across the UK, as well as volunteering at my local National Trust property helping them with their communications. I genuinely love what I do.

Ben Pentreath defies professional categorization but evidently also loves what he does; you can get some idea of the remarkable range of his expertise and interests from his website (www.benpentreath.com/). He is director of Ben Pentreath and Associates and also has a shop in Bloomsbury – a delightful place offering unusual things for your home. He runs an architectural practice, and his website has a section called simply 'Inspiration'. I 'discovered' Ben through the occasional column he writes in the weekend *Financial Times*. Here is what he wrote about himself in response to my invitation:

When I was at school, Canford, in Dorset, I remember being told by my careers master that in order to be an architect I had to do 'A' levels in Maths and Physics. Being neither mathematician nor physicist, I stayed with History of Art, Art, Politics and History. It was only some ten years later that I realized that God created engineers so that architects don't have to do Maths. I went to Edinburgh University, where I started on the Fine Art degree. The Art School didn't suit me (too chaotic) and I reverted to History of Art, but a lot of my courses were in History of Architecture. All the while I was very interested in architecture but had assumed my career would be in restoration, the National Trust or suchlike. While I was at Edinburgh I met – through a university society that I ran – a wonderful architect, Charles Morris, who suggested that it was a lot more interesting to design the history of the future than to restore the past. He offered me some work experience, and I went on to work for Charles for four years. From his office, I moved to the States, where I worked for the young and vibrant firm of Fairfax & Sammons, in New York. After nine years, therefore, I had an extremely practical training – akin to an old-fashioned apprenticeship. Through it all my History of Art stood me in good stead, as I was always going to design buildings that were traditional in nature.

I still can't call myself an architect, but in 2004 I set up on my own and now have an architectural practice that employs fifteen

people in various guises – a drawing office, an interior design studio and, alongside it, a retail store. The fluidity with which we move from one discipline to the other perhaps stems from an innate appreciation of the environment that surrounds us – at every scale, from the city, to buildings, to a piece of furniture. I detest the way in which career choices appear to be straightjacketed at an early age – so that your 'A'-level choices or degree dictate what you might be doing with your life twenty years later. My observation is that all my really interesting friends are making great successes with things that when we were young we really couldn't anticipate. The experience of university, of learning in its own right, is of unimaginable importance. It's only years later that you realize the one thing you really learn from writing your dissertation is handling a lot of complex research – and handing your work in on time. Vital life lessons, but who knew they would be taught in the apparently dusty academic world of Art History?

Lucy Bamford graduated with a BA in History of Art from the Courtauld Institute of Art in London in 2007. During her course she worked as a volunteer at the Handel House Museum and then at Doctor Johnson's House, both in London. Her BA dissertation was on the eighteenth-century English artist Joseph Wright of Derby, and she planned to follow this with a Master's degree. Unfortunately her funding arrangements fell through but, seeing the post of Keeper of Art at Derby Museums advertised, she applied for it and got it. She still holds this position (www.derbymuseums.org/). Here is how she describes her career trajectory:

It is almost five years since my appointment as Keeper of Art at Derby Museums, a position I still hold, and which continues to expand. The focus of my activity is around the museums' internationally significant collection of works by Joseph Wright of Derby (1734–1797), a situation I consider highly fortuitous given that I have long harboured a great admiration of this artist. Indeed, among my first experiences of art were my visits to the museum with my grandparents, alongside an interest in practising art that was encouraged by my father, himself a keen amateur artist, and at school, where I studied art at 'A' level before embarking on a Fine Art foundation course at Loughborough University.

History of Art was not included as part of my state-school education, and I remained unaware of the discipline until my school librarian, herself an art history graduate, brought it to my attention with a copy of Ernst Gombrich's *The Story of Art*. I read the book from cover

to cover and, captivated by my new-found discovery, began to consider the possibilities of pursuing a career pathway into the theory of art. My love of practice continued to win over until theory lectures at Loughborough turned the tables once more. Having started work at Derby Museums as a Gallery Assistant to fund my studies at Loughborough, I was also feeling an increasing pull towards working within the heritage industry.

When I started, the post was part time, and the art collection had been without a curator for some years due to a lack of resources. My first two years were particularly difficult. More than anyone I felt I had to work very hard to prove myself, having entered at a curatorial level without the then obligatory MA in Museums Studies. My BA was an essential component of my success, both as a minimum requirement for the post and as a bolster to my confidence in the workplace through the skills and knowledge I acquired during study. My previous museum work experience, both paid and voluntary, also proved invaluable for the practical tools it provided me with.

I still liken my experience at the museum to one long continual learning curve. Each day is completely different and, though this situation once left me feeling anxious, I now relish the variety of my role. From developing exhibitions and delivering talks and tours, to hours spent cataloguing objects, with unprecedented access to original artworks: I am certain there is no more enjoyable job. Now working full time and holding a key position in the museums' major agenda to improve the profile of Joseph Wright, a job which connects to the health and prospects of my home city and community, I feel confident that my decision to pursue my interest in the History of Art was right for me. Contacts made through my work at the museums demonstrate a similar case for the variety of opportunities and pathways afforded by the study of the History of Art: from auctioneers, conservators, artists and academics, to museum managers, curators and writers, all are testament to the versatility and resonance of the discipline.

A degree in Art History, as Lucy affirms, can lead in many different directions. Like Lucy, Elizabeth Barrett started out as a student in art practice doing a foundation year: 'Thinking there were too many artists in the world was, I think, my first step towards History of Art.' She decided she was better at writing than cleaning paintbrushes, which led her to Leeds University, where she spent 'three wonderfully inspiring years with some great mentors, researching everything from Museum

Studies to the representation of the Holocaust'. Elizabeth graduated in 2001 and is at the time of writing Head of Press at English National Opera (www.eno.org/). She concludes that 'my time at Leeds gave me lots of skills, but I think, most importantly, it gave me a sense of how to be a grown up. I don't think all universities, and certainly courses, necessarily do that. Although I no longer think there are too many artists in the world.' Her route to this post is an exemplary tale of forethought and planning as well as being prepared to seize the initiative and take risks. Here is Elizabeth's story:

> I worked out that I needed to think about careers before I left [university]. Feeling TV producing was the thing, I entered a contest for aspiring sorts, and found myself eventually, at the end of a 30,000-person competition, up against one other candidate. Several trips to the Big Breakfast House later, I let slip in an interview that I'd also been considering an MA in History of Art. Ah. My first Major Learning Curve in the Real World. I recovered from what I thought was the End of My Life reasonably quickly, by thinking about other options. The urge to live in London stronger than the immediate need for a change of direction meant that I happily spent the first two years out of Leeds on a helpline in a children's charity, ostensibly helping people but also making some stark discoveries about the world of work, the non-profit sector and the sacrifices some people have to make to pay rent.
>
> I moved back into the art world via a job at the *Burlington Magazine*, boosted in my application by my connection to the son of a former editor, Herbert Read, who taught me Art History (using contacts works). I started editing catalogues, liaising with contributors and, more amusingly, antiques dealers. The communication side of the role appealed more than the editing, so I wrote to a small PR agency, Idea Generation, and began working for a pittance as an account executive, handling clients such as the ICA. Being promoted to account manager within three weeks was less an indicator of my brilliance and more because the agency needed people who had lived a little bit (by now I was the grand old age of twenty-six). In a year, I had tripled my salary and begun winning new business, writing strategies and managing teams.
>
> I moved on to another visual arts agency, Sutton PR, as a director. I worked with the British Pavilion for the Venice Biennale, Frieze Art Fair, the Manchester International Festival and a big roster of commercial galleries and dealers. When the pace of endless rounds of artist and gallery dinners became more tiring than exciting, I

quit. Liberating, but a bit scary. Luckily for me, the V&A was look-
ing for a Head of Press. The experience was immense: from inside
an organization that you truly believe in, you can achieve great
things and become responsible for many different areas. The job
let me go to the Sistine Chapel for a private hanging of the Raphael
Tapestries and explore things with more depth than is generally
possible. Ironically, it also provided me with the more traditional
decorative arts knowledge that I had deliberately avoided at Leeds
through having concentrated on more exciting things such as post-
modernism and women's studies. Music had always been an interest
of mine too, so moving into a Head of Press role at ENO was also
quite natural when the time came. Here I am working across all
aspects of the organization, and once again learning more, about the
performing arts, and about how to succeed in an increasingly chal-
lenging environment.

As we went to press with this book, Elizabeth told me that she had decided
to move into a temporary position as Acting Head of Communications for
Tate (Tate Modern, Tate Britain, Tate Liverpool and Tate St Ives) in order to
'keep moving and to get back to her visual arts roots'.

Not all students who attend university are in the eighteen to twenty-
three age group. Mature students make up a proportion of most annual
intakes into Art History degrees. Diana Grattan's story illustrates how
it is possible to change course and to start a career later in life. She took
an access to higher education course. Regulated by the QAA (Quality
Assurance Agency for Higher Education), such courses are available
in most cities (www.accesstohe.ac.uk/Pages/Default.aspx) and provide
those who left school early or who do not have formal qualifications
with the means of applying for a university degree course. Diana gradu-
ated from the University of East Anglia (UEA) with a BA in 2007 and
a Master's degree in 2011. She is now Collection Curator at the South
Asian Decorative Arts and Crafts Collection Trust (www.southasian-
decorativeartsandcrafts.co.uk/). Here is how she made her way to this
post:

I left school at eighteen with an unimpressive academic record and
no idea what I wanted to do. Driven neither by vocation nor by altru-
ism, I trained as a nurse at a London teaching hospital but spent
three, extremely happy years doing so. After qualifying, I married
and subsequently spent over twenty years bringing up four daugh-
ters. However, from an early age, art and its associated history had

been an abiding interest. With my children attaining an age of relative independence, I decided that I would like the opportunity to further my knowledge of these subjects in an academically challenging way. To meet university entrance requirements, I did an access course at my local further education college. I studied Art History, English and Cultural Studies as well as statistics and IT, and rapidly discovered the rewards of study.

My undergraduate History of Art degree was taught not as an isolated discipline, as it embraced anthropological and archaeological approaches too. The subjects/modules I chose to study were not coherently related and instead were an eclectic assortment. However, a defining moment came at the end of my second year, when the undergraduates were given the opportunity to work with the Sainsbury Centre for the Visual Arts (SCVA) to design and implement a learning resource area for the upcoming major Francis Bacon exhibition. With this experience began my enthusiasm for the world of galleries and display, which was further enforced by a third-year unit that involved the research, selection and display of objects to be included in an exhibition at the Norwich Castle Museum. During the year between graduating and starting my MA degree, I helped with the next four exhibitions at SCVA.

Assuming that I had little realistic prospect of finding a job in a curatorial capacity or related field, I did not apply for an MA in museology. Instead I chose the 'Arts of Europe', and somewhat to my surprise found myself studying early Christianity and late Antiquity. On a field trip to Tunisia I became fascinated by the Eastern margins of Rome, which led to my research and dissertation on the Han dynasty textiles found in Roman Syria. Shortly after graduation, the position of Collection Curator was created at the newly established charitable trust the South Asian Decorative Arts and Crafts Collection. I applied and was appointed. Despite the trust's specialist interest being in an area and period well removed from the comfort zone of those I had previously studied, I think it is testament to the versatility of a History of Art degree that it provides its students with a raft of transferable skills and the ability to apply these to a myriad of fields. My work experience at SVCA and the contacts I made both there and at the UEA School of Art History and World Art Studies have been invaluable. Furthermore, I get enormous pleasure from working in a field that draws directly on the disciplines, principles and skills acquired from my degree studies, combined with the privilege of extending my knowledge.

One of the things that has been very interesting to me as I undertook the research for this chapter has been to discover how enterprising Art History graduates have transferred into other professional fields after gaining varied experience. Aida Selmanovic studied for her undergraduate degree at the University of St Andrews between 2002 and 2006. She was awarded her Master's in Modern British Art from the Courtauld Institute of Art in 2008. Here is how she describes becoming interested in Art History and how she has employed her transferable skills to move into the field of law:

> My interest in Art History started at an early age when I first set foot in an old dusty museum situated opposite my house in Bihać, Bosnia and Herzegovina. As a medieval town, Bihać was subject to immense changes politically and culturally, and the museum in the old Captain's Tower was a testament to this. I found myself intrigued by the strange objects in the museum, and that natural curiosity has remained ever since. I chose to study Art History at 'A' level along with English and History. The subjects complemented one another and I found myself torn when trying to decide what to study at university. The majority of my peers chose History; it seemed to be the subject that paved the way for professions such as law and consultancy. However, I found myself drawn to Art History and spent the next four years at the University of St Andrews experimenting with different modules.
>
> With the two degrees under my belt, I joined the Serpentine Gallery as an intern. My internship was a gateway to several freelance positions which included researching and writing exhibition reviews for art magazines. I was also fortunate to work for the art dealer Dr Frederick Mulder (www.frederickmulder.com/), where I handled prints by Dürer and Picasso on a daily basis! I spent the next two years working as an Assistant Curator at Tate. Being at the hub of creativity in organizing national exhibitions was an enjoyable experience. I was particularly fond of working with a variety of people, ranging from foreign museums to private collectors.
>
> At the same time, I found myself attracted to the logistical and legal side to art collection and management. The lure of the creative aspect to the exhibition-making process subsided and I started researching the legal profession. I wanted to combine my interest in art and law, so I decided to sign up for the law conversion course at BPP Law School with a view to becoming a solicitor. Although I have come to the legal profession at a later stage of my life, studying Art History at university has equipped me with analytical and research skills, both of which are necessary in the workplace.

The ability of Art History graduates to use the skills they have acquired at university across a wide range of professional activities is illustrated by the case of Matthew Sanders, who graduated with a BA in History of Art from the University of Warwick in 1995 and is now director of the art education charity Magic Lantern and a freelance film publicist. Without, as he says, having had any strong career path in mind, he now has two entirely different jobs: 'the two sit together remarkably well and even overlap occasionally, for example when I've taken Hollywood actors on gallery tours! I could not be happier that my career has come full circle: I was interested in History of Art as a gateway to learning about almost every subject possible, which is precisely what I now demonstrate through my work with Magic Lantern.' So here is how he describes his work and the 'full circle' that has brought him there:

As director of Magic Lantern (www.magiclanternart.org.uk/) I use my History of Art degree every day. We give interactive workshops to schoolchildren and adult groups, including in prisons, homeless centres and care homes, using a variety of techniques to show that anyone can engage with and enjoy art. We introduce people to a huge range of paintings and sculpture and demonstrate that art can help enhance and bring to life any subject, be it history, geography, science or maths, as well as developing life-skills such as communication, observation and confidence. My work with Magic Lantern involves running the sessions as well as managing all aspects of the charity, including fundraising and marketing. My History of Art degree taught me subject knowledge that I use directly in my Magic Lantern sessions and the skill of how to look at paintings, not just who painted what and when. Beyond this, it helped develop essential skills that I have used in every aspect of my career: for example, presenting seminars helped me be at ease with talking to groups of people, and learning to look closely at works of art taught me the importance of attention to detail and not to take things at face value.

While at university I had no idea what I wanted to do. The only industry I was interested in was film. I did not have an actual job in mind, but I loved going to the cinema and thought that fate would take care of the rest. I soon found out that making contacts was the way to get into the film industry, and the most usual way of doing this was through unpaid work experience. I did mine with a small film distribution company and it happened to be in their publicity department. So by accident I became a film publicist. Contacts I made during my work experience led to an assistant's job in the London

Film Festival press office just after graduating in 1995. I spent five years working my way up the corporate ladder at Miramax Films (1995–2000) and nine years at the film publicity agency McDonald & Rutter (2001–10), which became part of Premier PR in 2006. In 2000–01 I spent a year travelling and trying my hand at film journalism in Australia.

My area of specialism is international publicity. This is done mainly at film festivals such as Cannes, Berlin and Venice, where I help launch new films, usually made by independent filmmakers. During the festival, among many varied tasks, I arrange and run the directors' and actors' interview schedules and, as their central point of contact, spread the word to journalists about the films. I've been lucky enough to work with many filmmakers I admire, including Sofia Coppola, Bill Murray, Pedro Almodovar, Walter Salles, Jim Jarmusch, Sally Potter and even former US Vice-President Al Gore! After twelve years of full-time film publicity, however, I also wanted to explore education, as it has always been one of my great passions. Once again I stumbled upon a new career by accident. I met the founder of Magic Lantern in 2005 through mutual friends, and she took me on as one of the team. Little did I know that she was looking for a successor, and in 2010 I took over as director.

Philippa Richards graduated in 2002 from Oxford Brookes University with a BA in History of Art after having done a foundation course in Art and Design specializing in graphic design. When I asked her whether she would be willing to write about her career in publishing, she remarked that she had bought an earlier edition of this book before starting her course in 1999 and found it valuable; like other participants in this chapter, she expressed herself happy to help future students with their choices. Philippa's career trajectory illustrates clearly how tenacity and a willingness sometimes to move sideways or to take stock and relaunch are essential. Like many, Philippa started off with any job she could get. Notice her description of how useful the skills she learnt on her degree course have been to her:

> Immediately after graduation I worked for a health insurance company in the accounts section while I looked for something more suited to my qualifications, and, thankfully, after two years I was offered a job as an editorial assistant on a national wedding magazine. Within another two years I was deputy editor, and during my time on the title I gained fantastic experience learning about magazine publishing and production in depth while writing and developing my own features for

the magazine; I also became its online forum editor. During my first interview for the job I was asked about my degree, and it was apparent from the interviewers' response that, because it was a research-based course, it recommended me for the position – it showed that I had the necessary research and writing abilities. I am convinced that the skills I learnt on my degree have always supported my ability to research and think logically, as well as ensuring I can write to a specific audience and proofread with confidence. It also helped me later, when I returned to study for a Master's.

In 2008, having worked for the magazine for almost four years, I decided that I needed to extend my experience in publishing and applied to study for an MA in publishing back at Oxford Brookes, from which I graduated in 2009 with a distinction. On completion of the MA I was offered a position on a national education magazine based in Witney, where I worked until last year, when it unfortunately closed and I was made redundant. Since then I have been working as a copyeditor in corporate communications for a retail company in Oxfordshire, which includes copywriting and designing. In the future I'd like to move back into magazine publishing, either print or online, or work as a freelance editor.

As you may have noticed, students often come to Art History degrees having first had a go at art practice on a foundation course. Someone who has managed to combine his love of the history of art with his dedication to making art is Chris Otley, Head of Art and Design at Merchant Taylors' School. Chris struggled to decide what to study at university and after a foundation course realized what he really wanted was to pursue a 'more "academic" essay-based degree while exploring visual culture'. His profile shows how the extra-curricular experience you gain while at university can be immensely important, though, of course, where you are makes a difference to the opportunities on offer. Chris graduated from the Courtauld Institute of Art with a BA in History of Art in 2005 and with an MA in 2006:

Throughout my time at the Courtauld Institute I tried to gain a wide range of experience in art-related fields (alongside the weird ones for cash – late-night poker TV production, anyone?). I volunteered for the Somerset House Education Department, giving gallery talks to the public; set up a student life-drawing class; worked for the Inland Revenue Heritage Division (inspecting private art collections); spent a couple of summers working as a tour guide in a Northumbrian castle; curated an exhibition of portraiture by recent fine-art graduates; and

was a curatorial intern at the Wallace Collection. Ultimately, though, I felt that many of the career options overtly linked to Art History (auction houses, galleries, etc.) often had more to do with business than the artwork they allegedly dealt with. Despite my relatively niche interest in British anatomical drawing, I realized that, to me, Art History was essentially about researching, presenting and discussing visual communication in its myriad forms and that, as such, my future lay in teaching.

Encouraged by one of my former school teachers, I applied for a position as an art teacher at a leading boys' independent school and was fortunate to get the job straight from my MA. Being an independent school meant that it was not uncommon for teachers to arrive from a wide range of backgrounds, without a formal teaching qualification. It was certainly a very steep learning curve, but it has proven incredibly rewarding, particularly as I was able to inject less familiar art history into the pupils' fine art education. Art education should encompass exploration of the dual roles of artist and critic, and any initial concerns I had about teaching the practicalities of the former were outweighed by the confidence I had with the latter, given my training as an art historian. I became the head of department in my third year as a teacher.

Teaching fine art inevitably rekindled my enthusiasm for making my own work, which has become deeply connected to the eighteenth-century illustrations I spent so much of my postgraduate degree researching. Increasingly I see myself as an artist just as much as an educator (www.chrisotley.com). I feel incredibly fortunate to have been encouraged as a pupil, and indeed as a student, to pursue my genuine interests rather than those areas incorrectly perceived as the 'safe' options. As a result, my academic experiences at university will, I think, fuel me throughout my working life.

Students enrolled on courses at universities where the emphasis is on practice also have to study some history and theory. So it is interesting to hear how Anna Cady, who graduated in Visual Art from Winchester School of Art in 1998 and then did a part-time Master's degree at Goldsmiths College, found the theoretical work she was obliged to do important in developing her career as a filmmaker. 'I would not have felt confident about approaching Goldsmiths had I not done my BA at a college which put theoretical work alongside practice very high on its agenda.' Anna found this combination later enabled her to approach galleries and curators. Her career weaves together many threads and demonstrates the importance of collaborative work and of seizing opportunities when they arise (annacady.com/):

While at Goldsmiths I got a part-time post at a private (Krishnamurti) school, teaching photography. This gave me experience in teaching and mentoring students. I made excellent contacts there which helped me a couple of years later, when I was given a residency at the Valley School in Bangalore (Arts Council funded). This trip to India was a major project: I experimented with (crazy) vast collapsible pinhole cameras which I designed and made myself. After Goldsmiths I submitted work to 'open' exhibitions at respected galleries and won the fotonet-south bursary to do billboards and to launch my first website. And the Arts Council funded me to work with a poet to improve my ability to write alongside and in parallel to my visual practice. I took on teaching contracts doing workshops for excluded and vulnerable children. Since then I've often collaborated with those who do not find it easy to have a voice in the world, which has been incredibly rewarding. 'It Works Both Ways', a two-year project with Louisa Makolski, who had cerebral palsy and could not speak, was totally life changing for me, and for many who shared in the making or viewing of the work.

The time in India was a breakthrough in terms of the visibility of my work and the development of my practice – I had an exhibition and a book published and I began to use video. Cambridge Film Consortium offered me an introductory course on Final Cut Pro and I began a career more orientated towards film. After the course the students set up an experimental collaborative film group, Neuf (http://neuf.org.uk/wp/). We continue to meet, collaborate and exhibit together. My first film, *Spoons*, was selected for an international film festival in Barcelona. *Farm of Innocence* was selected for 'Figuring Landscapes', which toured internationally – including being screened at Tate Modern.

In 2011 I won a commission from the Institute of Development Studies – Pathways for Women's Empowerment – and Screen South to make a film which I called *30% (Women and Politics in Sierra Leone)*. It is a short documentary combining animation with live action. It was launched on the *Guardian* website and has gone on to the Sundance Film Festival and many other international festivals. In autumn 2012 I had an iBook (for iPad) published about my pinhole work in India, which includes images, text and video called *To See a Different World*.

Studying Art History and Art Theory has definitely helped me to see what the relevance of the work I do will be to my potential audiences and to incorporate those ideas into my proposals. This year I won

a position as artist in residence at Mottisfont, a National Trust property in Hampshire, and have made sixteen films which are installed for six months throughout the house. Last year 250,000 people visited Mottisfont, so my work is gaining a larger audience at last and I'm actually getting paid properly!

As London is the centre of the world art market, careers with the large auction houses or with dealers are open to Art History graduates with the right experience, background and aptitude. Emmeline Hallmark is the daughter and granddaughter of artists and grew up fascinated by art and by objects, including the dusty piles of furniture and paintings she found in the small antiques auction house situated next door to her boarding school and where she took refuge from homesickness. Like many participants in this chapter, Emmeline studied both Art and Art History at school but, believing she would never be good enough to be a professional artist, decided to focus on her fascination with the work of other artists and with antiques. Despite a lonely undergraduate life in London (she missed the countryside and felt a lack of community in such a disparate city), she graduated from the Courtauld Institute of Art with a BA in 1999 and an MA in 2005, having studied the Italian Renaissance and nineteenth-century France, but she soon realized that her limited language skills meant that it would be better to focus on British art. This was clearly a smart decision: she is now head of the British Paintings 1550–1850 department at Sotheby's in London (www.sothebys.com/). Here is her account of the route she travelled to get there:

> After graduating, I worked as an intern at the Peggy Guggenheim Museum in Venice and loved every single minute. Venice was magical and the millennium celebrations of 2000 which I saw there were unforgettable. However, during the day I spent a lot of time telling tourists where the nearest bathroom was, as they had little interest in the art which lined the museum walls, so I decided working in a museum was not for me. At the time I lived with two lovely fellow students who were applying for the Christie's graduate trainee scheme, and I thought I would too, as I had no other plans for when I returned to the UK. We all had passport photos made wearing the same pashmina (they were practically uniform for auction house employees at that time and probably still are). To my eternal (and their) surprise, I was the one offered an interview and even managed to secure a place.
>
> I spent five years at Christie's in the early British paintings and watercolours department and then left to escape the demands of the

deadline conveyor belt and the politics of being a young married female in a very male, old school company; I then returned to the Courtauld to study for an MA, intending to make a subsequent career move into a less demanding area of the art world. I also wanted to learn something about art again – without the financial context and pressure. During my time back at the Courtauld I fully appreciated the luxury of no emails or phone calls and being able to work from home. I was transformed from a young fledgling novice of the art world, who was insecure about what they thought, wrote and spoke about art, into a confident young woman, who would look at a painting/work of art for an hour minimum in order to understand it, and who was ready to face the international art world again, thanks to the support, encouragement, praise and transformative advice of my tutors. Furthermore, despite my dyslexia and the difficulty in researching and managing the volume of notes that needed translating into a thesis (which took enormous amounts of determination and patience), I successfully completed my MA, including a 10,000-word thesis. After graduating I worked as a secretary and soon found myself being lured by the prospect of financial comfort into accepting a job running the Early British Paintings and Watercolours department at Sotheby's. However, I was very lucky as, for a while, I worked with the most inspiring man I had ever met – Henry Wemyss. Although he was so tragically dying of a brain tumour during the time we worked together, he taught me that every single work of art is the product of the emotional response of the artist to a given situation or subject. He reminded me of the art studios and art practice I had witnessed as a child, and I have never looked at art in the same way since.

Seven years and a few world record prices later, many millions of £/$ worth of art having been sold and thousands of objects having changed hands, not to mention having become the youngest female Head of Department and Senior Director in the history of Sotheby's, I have recently demoted myself. The demands of the commercial conveyor belt had threatened to numb and eventually overwhelm the sheer joy and pleasure that I derive from art. Having considered a part-time PhD at the Courtauld in my favourite area of art – the English landscape of the eighteenth century – I realize that publishing is becoming more and more limited and research can be a lonely business (an environment in which I do not thrive). Moreover, I now recognize what my skills really are (i.e., talking to people about art, not juggling volumes of research and writing

about it). Eighteenth-century British art, especially the paintings of George Stubbs, will always be my passion, but I have an enthusiasm for showing others how much pleasure art can give you, whatever your taste and whichever artist appeals to you.

I now hope to work part time for Sotheby's and help look after new and existing collectors, while also sharing my passion and enthusiasm for art with those less fortunate than myself. I will begin a four-year part-time training course to be professionally qualified to 'help' people through art as an art therapist. I hope to be able to combine my professional and subsistence obligations with placements in charitable centres and working with private clients as an art therapist. This will be a time of limited employment and salary potential, and yet I feel the most positive and excited that I have ever been about this career move. Money I realize was not the most paramount factor for me, but was perhaps for others whose opinions I valued over my own.

It has been without doubt my greatest lesson in life that only you know what can inspire and give you pleasure, but remember that you deserve to wake up every day and feel enthusiasm for whatever you are about to do. That is what inspires the very best artists and what leads to the creation of the most ground-breaking masterpieces, and that is, in my opinion, pure success. 'To thine own self be true.'

This chapter is all about careers, and the participants are all in one way or another providing advice to readers who are concerned about their employability. But one has made a career precisely out of giving career advice to graduates. Mark Baldwin graduated with a BA in History of Art from the University of Manchester in 1994 and spent a year working with a tree surgeon in his home town to earn some money while he considered his options. He used the university careers advice service and applied for positions in the UK arts sector. However, despite some job offers, he did not feel suited to the work he encountered. It was then that he took an initiative that was to have a lifelong impact, leading eventually to his current post in Utrecht in the Netherlands:

I pitched an idea to the Head of Art History at Manchester University – to develop employability projects among students in that department and encourage more participation in the region's cultural activity – along with the suggestion that I be employed to implement this. It worked! With great support from the department I applied for special

enterprise funding, which paid for my position over two years. A further two years followed where I became responsible for art history fieldwork, developed a series of cultural internships, and supported the recruitment/admissions team.

My interest in graduate employability led me to the university's careers service, where I then worked for six years as a careers consultant to humanities students, advised the area's creative industries on university engagement, and managed a series of regional employability projects. Later I became interested in working abroad (my girlfriend happened to be Dutch) and subscribed to some international recruitment websites for jobs in Europe. I was offered a position as Programme Manager for the University of Liverpool's online Master of Business Administration degree – based for logistical reasons in Amsterdam – and took the job, which involved a lot of communication and also coaching others. I found that studying in seminars while an undergraduate at Manchester had prepared me for fast and testy dialogue.

Living and working in a foreign country is a challenge and an adventure. For me, the initial bureaucracy was sometimes cumbersome and there was a language barrier, though the positive sense of discovery outweighed those. Managing your transition into another country can be a project in itself, so it does require energy and thought. I took language courses but found daily exposure (radio, newspaper, TV, using public transport, etc.) far better for picking up the basics. Jump in at the deep end! After a year or two I joined the British Council in Amsterdam as a Senior Project Manager, responsible for cultural relations projects throughout the Benelux. Here I realized the importance of cooperation, enterprise and leadership in successful project management. Getting involved in extra-curricular activity while at university is essential if you want to develop those skills early. I had been president of the Whitworth Art Society (the student art society), and this certainly helped.

In 2011 I was recruited to the University College Utrecht, where I have a broad role, including general management duties, student welfare, managing a scholarship fund, innovation support, crisis intervention and policy development. My degree has fuelled a lifelong love of art and set me up for a varied and twisting career. But the world of work changes quickly, and I've found that being alert and opportunistic is more valuable than sticking to a plan. The subject matter of my degree was very useful in kick-starting my career and became less relevant after that. More important were the

skills/aptitudes developed during study, particularly in seminars –
for example, negotiation with others; attention to detail; confidence
under pressure; connecting separate ideas to create a new one. Over
time I've realized I learn best through mistakes and experience,
which make those lessons very personal and thus deep-rooted. A
degree gave me the confidence to get things wrong, which has led
me to the right place!

Like Mark, Rachel Williams capitalized on a series of work experi-
ences and used her initiative to break into a profession that she had not
initially considered. Rachel, as with several other women and men pro-
filed here, took a foundation course and chose to study Architecture at
the University of Brighton but, finding it did not suit her, changed course
and graduated in 2002 with a BA in Visual Culture. The next few years
involved, as she describes it, 'casual work in between long and short trips
away':

I spent a year managing a bar; three months in an American chil-
dren's camp; a year of office administration; eight months TEFLing
(teaching English as a foreign language) in Prague; eighteen
months working as an under-qualified IT adviser; and two years
going halfway around the world. It was while planting my circa
2,000th sandalwood tree in the baking heat of northern Australia
that I suddenly realized the massive variance in the enjoyment of
work, and that I would no longer work jobs involving soil, alcohol
or a reception and instead would seek work that would draw on my
natural aptitudes, knowledge and interests.

So I returned to the UK and chose a new and largish city and sat
down to think seriously about my direction, six years after graduat-
ing. Doing lots of different jobs may not always be the making of a
successful CV, but in my case I found that my string of many and var-
ied occupations had actually given me a myriad of transferable skills,
and having various bits of office experience showed (I hoped) my firm
foundations in professional environments, using a variety of IT, and
effective adaptability to different roles.

I believe it was this, combined with my initial foray into architec-
ture and my subsequent BA, that secured me an interview at English
Heritage for a job in administration/research (www.english-heritage.
org.uk/). Successful at interview, I have not looked back. The sector
is competitive, the pay is mediocre, the people are spectacular and the
subject matter is fascinating. I've had four years in the department

that designates heritage assets as listed buildings, scheduled monuments or registered parks, along with battlefields and shipwrecks. Visual Culture was about critical examination, the interpretation of histories, formulating arguments and communicating through concise writing, all skills which were crucial for, and fully transferable to, this new role.

Ten years on from graduating, I am returning to study on a postgraduate course in Historic Building Conservation, so a return to my initial field. Although my route through the last decade was not what I envisaged upon starting university, it was interesting and varied and, most importantly, left me in a situation where employment prospects were open. My degree was a key factor; without it I'm sure I would have encountered many more closed doors. Were I to have my time over, my choices, broadly, would be the same.

Art History students often aspire to work in museums and galleries; we have already heard about Lucy's work in Derby (a large regional museum) and Diana's with South East Asian Arts (a charity). My final three profiles feature History of Art graduates who have established themselves in quite different types of museum jobs and whose routes into the profession have also been distinctive. One is a conservator, one an assistant curator at a national museum, and the third a research curator at the Royal Academy of Arts. Lesley Stevenson graduated in 1988 with a joint honours degree (History of Art and Theatre Studies) from Glasgow University, during the course of which she had helped put on an exhibition at the Burrell Collection and volunteered at the Scottish National Portrait Gallery. She was attracted to a practical career in the arts, one where she 'would have first-hand experience of dealing with artefacts rather than studying them solely in reproduction', as she puts it. Like other participants in this chapter, she took a little time to decide her route:

I decided on having some 'thinking' time out and, after completing a short TEFL (teaching English as a foreign language) course, spent a year working as an English-language teacher in southern Italy. I then returned to the UK with plans to pursue a career in painting conservation. The post-graduate courses required some hefty preparation, and I signed up for night classes in Chemistry and Italian (two to three foreign languages required), as well as various art courses in order to put together a portfolio of my own work. I was delighted to be accepted on the three-year postgraduate Diploma in Easel

Paintings Conservation course at the Courtauld Institute of Art and started in October 1990.

Studying conservation at the Courtauld for me was an unforgettable experience – stimulating, challenging, hard work but also great fun. As the students are few (an intake of five each year) and the department small, the learning environment is an intense one. Between my second and third year (and funded by a small grant) I toured many of the major museums in the United States, carrying out research as preparation for my final-year thesis. At that time there were numerous internships available, and on graduating I was offered a twelve-month position at the National Gallery of Art in Washington, DC. This provided an exceptional insight into the day-to-day running of a large conservation department in a prestigious, well-funded organization. It allowed me to work with highly skilled and knowledgeable colleagues, to have first-hand experience of working with an exceptional collection and, as a courier, to travel extensively with loans and exhibitions.

Further internships followed for me at Tate in London and then in Edinburgh at the National Galleries of Scotland, working for the National Trust for Scotland. An opportunity arose in 1996 to return to America for a two-year research fellowship, so back I went to the National Gallery of Art in Washington for a second time. In 1998 I returned to Edinburgh for a short temporary contract as paintings conservator at the National Galleries of Scotland (www.nationalgalleries. org/). The post was made permanent a year later, and in 2004 my job was regraded and I became Senior Conservator. Fourteen years later I am still there!

In common with other arts-related career paths, the journey towards a permanent job in the museum world is not usually an easy one, and I was very fortunate indeed with how things worked out for me. Conservation is an ideal choice for anyone curious as to how works of art are made as well as what they mean. In general the field of 'technical art history' (the examination of artists' materials and techniques) is broadening, and therefore the work of the conservator is steadily increasing in importance and, indeed, visibility. In the longer term this should bode well for the profession as a whole and, of course, for new graduates.

Annette Wickham now works at the Royal Academy of Arts in London (www.royalacademy.org.uk/). She was lucky enough to study 'A'-level History of Art at school and then chose that as her university subject,

graduating with a BA from the University of Manchester in 1994. Like many students she was drawn to modern and contemporary art, but after an initial survey course found that she was engaged more with art of the Middle Ages and the nineteenth century. Prevented by lack of language skills from pursuing her interest in Byzantine art while on a Master's course at the Courtauld Institute of Art, she chose to write her dissertation on the representation of Byzantine sites by nineteenth-century artists. She partially supported herself with part-time work. Here is how she describes it:

> While studying I worked as a tour guide at Kensington Palace, which was useful for improving my public speaking skills and general knowledge of British history. I continued in this job after graduating because the income and flexible hours allowed me to take up part-time internships at the *Art Newspaper* and at the Victoria and Albert Museum. At the V&A, I was involved with a campaign to fund the conservation and rebuilding of the Hereford Screen, a masterpiece of Victorian Gothic metalwork. I really enjoyed this work and, when the funding bid was successful, was very pleased to be offered the post of Assistant Curator for the project. This entailed researching the history of the screen as well as general admin, helping to generate publicity and acting as coordinator between conservators, designers, patrons, external consultants and museum colleagues. It was all great experience, but I gravitated particularly towards the research side, and I was very lucky to be able to pursue this interest further through a Millennium Commission Sharing Skills award to co-curate an exhibition about Francis Skidmore, the maker of the Hereford Screen, at the Herbert Museum and Art Gallery in Coventry. In this context I felt that my studies at university in both medieval and nineteenth-century art proved particularly helpful, even though the focus of museum research was more object-based and less theoretical than at university.
>
> In 2002 I joined the Royal Academy of Arts Collections Department as Research Curator to work on a new initiative to fully catalogue, digitize and publish the collections. Historically, the Academy's art works were not documented in the same way as a museum collection, making research a challenging but also satisfying process. The initial purpose of the post was to catalogue the Academy's drawings, designs and watercolours and to explore the impetus behind the formation of its collections. Establishing this base of information has provided a foundation for developing key curatorial activities such

as staging displays, writing gallery and web text, giving talks and lectures, answering public enquiries and providing access to the artworks. In addition, it feeds into other aspects of the department's work, for instance through providing supporting information for funding bids and for the RA's successful applications for Museum Accreditation and Designation status.

Cataloguing has also proved to be a springboard for establishing my own interests within the RA collections, and I have been able to present conference papers and publish articles on some of these topics. Currently, I am coordinating and contributing to a forthcoming multi-authored book about the Academy. This project has given rise to a series of scholars' study days on the history of art education and given me the opportunity to explore my interest in the Royal Academy Schools, researching the development of this institution from 1768 to *ca.* 1900.

In both of these posts I found that administrative and practical skills, such as object-handling, were easy enough to pick up with guidance from more experienced staff. However, my academic background in the History of Art really gave me the confidence to work across extensive and wide-ranging collections and to know how to approach researching an artwork, both in terms of establishing basic information and when taking a more thematic approach. Although specialist knowledge is important, studying different periods and subjects can also be useful, particularly when working as a curator rather than an academic. I felt that having a broad general knowledge of the history of art before specializing gave me greater versatility and a sense of perspective. Studying History of Art at Manchester and at the Courtauld Institute also showed me that there are different types of art historian and different types of art history. While the work I have been involved with in museums is not quite the same as research in universities, I have found the two to be complementary and that my academic background has been very important in giving me an awareness of different methodologies and approaches to art-historical research.

Amy Concannon is an Assistant Curator at Tate Britain (www.tate.org. uk/visit/tate-britain). She graduated with a BA in History and History of Art from the University of Nottingham in 2006 and with a Master's from the Courtauld Institute of Art in 2010, so she has made her way during the post-millennium period of contraction in the jobs market and increasing unemployment. Her story shows what can be done. As she explains, she

opted for joint honours for her undergraduate degree, as she was 'reluctant to close doors on subjects she loved'. It was during a school trip to Liverpool Tate as part of her 'A'-level art course that she conceived the idea of becoming a curator, though she had little idea what that meant. Even opting for History and History of Art was 'a leap of faith', as no one in her family had pursued a humanities degree before and, as she explains: 'although my parents were supportive, there was slight concern about the non-vocational nature of the course. Consultation of this very *Handbook* helped allay those anxieties by demonstrating the relevance of this choice to my desired career.' Amy also tells how, not having studied History of Art at school, it was initially unnerving to meet students at Nottingham with 'A' levels in the subject, but that she soon came to realize it mattered little:

I was driven by my desire to learn and acquired confidence by pursuing the two-pronged mantra of careers advisers: work experience and extra-curricular activities. I worked as a visitor services assistant at the university art gallery and became involved in the History of Art Society. Over the summers I volunteered at a small commercial art gallery and gained work experience on an exhibition installation at my local gallery, Gallery Oldham.

After many unacknowledged enquiries and unsuccessful job applications, persistence paid off when, after graduating, I became a full-time intern on a scheme at the Wordsworth Trust. I was trained to work across the full spectrum of the organization's activities and happily absorbed myself in studying the Romantic period, which had fascinated me at university. Six months later I was employed there to assist curators in the organization of exhibitions and the production of catalogues. This was my vital first step on the curatorial ladder.

Having developed an interest in works on paper through my job, along with a realization that further study was essential for career progression, I embarked upon an MA in eighteenth-century British and French drawings at the Courtauld. Luckily, AHRC (Arts and Humanities Research Council) funding offset my financial concerns for that year, but I knew to keep a watch on job vacancies. I relished the varied and creative role of Exhibitions Officer at Dulwich Picture Gallery, a post to which I was appointed in 2010, but it was my appointment as Assistant Curator there a year later that really excited me. This allowed for further education, this time via a brilliant collection of Old Master paintings and new responsibilities for their display, research and conservation.

Each thread of my experience has been a springboard, with Art History at the root. The grounding in British art and history I gained through my choice of degree modules at Nottingham, my work experience, study of the Romantic period at the Wordsworth Trust, a specialist MA, along with exhibitions and curatorial positions – each step, however small, has contributed to my attainment of the role I stepped into at Tate Britain in June 2012 – my dream job.

Bibliography and further reading

Books

Introductory and theoretical titles marked * should be generally accessible for sixth formers and first-year undergraduates; those marked ** may require a greater familiarity with the history of art.

*Mary Acton, *Learning to Look at Paintings*, 2nd edn, London and New York: Routledge, 2009.

*Anne D'Alleva, *How to Write Art History*, 2nd edn, London: Laurence King, 2010.

*Dana Arnold, *Art History: A Very Short Introduction*, Oxford: Oxford University Press, 2004.

Jane Austen, *Pride and Prejudice*, 1813, any edn.

Mieke Bal, *Reading Rembrandt: Beyond the Word–Image Opposition*, Cambridge: Cambridge University Press, 1991.

*Malcolm Barnard, *Art, Design and Visual Culture: An Introduction*, Basingstoke: Macmillan, 1998.

*Sylvan Barnet, *A Short Guide to Writing about Art*, 10th edn, Boston and London: Pearson/Prentice Hall, 2011.

Samuel Beckett, *Waiting for Godot* (1953; English translation by the author, 1956), London: Faber & Faber, 2010 (and many earlier printings).

**Norman Bryson, Michael Ann Holly and Keith Moxey, eds, *Visual Culture: Images and Interpretations*, Hanover, NH, and London: University Press of New England, 1994.

Whitney Chadwick, *Women, Art and Society* (1996), London: Thames & Hudson, 2012.

Craig Clunas, *Art in China*, Oxford: Oxford University Press, 1997.

Robin Cormack, *Painting the Soul: Icons, Death Masks, and Shrouds*, London: Reaktion, 1997.

J. A. Crowe and G. B. Cavalcaselle, *A History of Painting in Italy from the Second to the Fourteenth Century*, London: John Murray, 1854–96.

*Steve Edwards, *Art and its Histories: A Reader*, New Haven, CT, and London: Yale University Press, 1999.

**Eric Fernie, *Art History and its Methods: A Critical Anthology*, London: Phaidon, 1995.

E. H. Gombrich, *The Story of Art* (1950), London: Phaidon, 2009.

**Jonathan Harris, *The New Art History: A Critical Introduction*, London and New York: Routledge, 2001.

**Michael Hatt and Charlotte Klonk, *Art History: A Critical Introduction to its Methods*, Manchester and New York, Manchester University Press, 2006.

Darren Henley, *Cultural Education in England*, 29 February 2012, www.gov.uk/ government/publications/cultural-education-in-england (accessed 28 January 2014).

Emanuelle Héran, *Le Dernier Portrait*, Paris: Réunion des Musées Nationaux, 2002.

**Michael Ann Holly and Keith Moxey, *Art History, Aesthetics, Visual Studies*, New Haven, CT, and London: Yale University Press, 2002.

*Hugh Honour and John Fleming, *A World History of Art*, London: Laurence King, 2009.

International Directory of Arts, www.degruyter.com/.

Margaret Iversen, *Beyond Pleasure: Freud, Lacan, Barthes*, University Park: Pennsylvania State University Press, 2007.

**Margaret Iversen and Stephen Melville, *Writing Art History: Disciplinary Departures*, Chicago and London: Chicago University Press, 2010.

Amelia Jones and Tracy Warr, *The Artist's Body*, London: Phaidon, 2012.

Natalie Kampen, *Sexuality in Ancient Art: Near East, Egypt, Greece, and Italy*, Cambridge: Cambridge University Press, 1996.

Kay Dian Kriz, *Slavery, Sugar, and the Culture of Refinement: Picturing the British West Indies 1700–1840*, New Haven, CT, and London: Yale University Press, 2008.

D. H. Lawrence, *Etruscan Places* (1932), London: I.B. Tauris, 2011.

Lonely Planet Guide Books

Rosalind McKever, ed., *Careers in Art History*, fourth edition, London: Association of Art Historians, 2013.

Sir Thomas Malory, *Morte d'Arthur* (Caxton edn, 1485), London: Scolar Press facsimile edn with the Pierpont Morgan Library, 1976.

*Robert S. Nelson and Richard Shiff, eds, *Critical Terms for Art History*, 2nd edn, Chicago and London: Chicago University Press, 2003.

Nikolaus Pevsner, *The Buildings of England*, New Haven, CT, and London: Yale University Press, 1951–74.

*Grant Pooke and Diana Newall, *Art History: The Basics*, London: Routledge, 2012.

**Donald Preziosi, *The Art of Art History: A Critical Anthology*, Oxford: Oxford University Press, 1998.

*Matthew Rampley, *Exploring Visual Culture*, Edinburgh: Edinburgh University Press, 2005.

Rough Guides

David Solkin, *Painting for Money: The Visual Arts and the Public Sphere in Eighteenth-Century England*, New Haven, CT, and London: Yale University Press, 1993.

*John Spencer, *The Art History Study Guide*, London: Thames & Hudson, 1996.

*Julia Thomas, ed., *Reading Images*, Basingstoke: Palgrave, 2000.

Giorgio Vasari, *The Lives of the Most Eminent Painters, Sculptors and Architects* (1550), ed. E. H. Blashfield and A. A. Hopkins, London and New York: George Bell & Sons, 1897.

Joanna Woodall, *Anthonis Mor: Art and Authority*, Zwolle: Waanders, 2007.

*Michael Zimmermann, ed., *The Art Historian: National Traditions and Institutional Practices*, New Haven, CT, and London: Yale University Press, 2003.

Journals and Newspapers

Daily Telegraph
Illustrated London News
Journal of Design History
Journal of Material Culture
London *Evening Standard*
London Review of Books
Paragone
Representations
Word and Image

Websites

Arts and Business, www.artsandbusiness.org.uk/

Arts Council England, www.artscouncil.org.uk/

Association of Art Historians, www.aah.org.uk/

London Consortium, www.londonconsortium.com/

National Gallery, www.nationalgallery.org.uk/

National Portrait Gallery, Education Department, www.npg.si.edu/education/exhibitresource.html

Quality Assurance Agency for Higher Education, www.qaa.ac.uk/

Research Excellence Framework, www.ref.ac.uk/

Robert Lehman Collection, www.metmuseum.org/about-the-museum/museum-departments/curatorial-departments/the-robert-lehman-collection

Roche Court Educational Trust, http://rochecourteducationaltrust.co.uk/

Serpentine Gallery, www.serpentinegallery.org/

Tate, www.tate.org.uk

Undiscovered Scotland, art galleries, www.undiscoveredscotland.co.uk/uslinks/galleries.html

Index